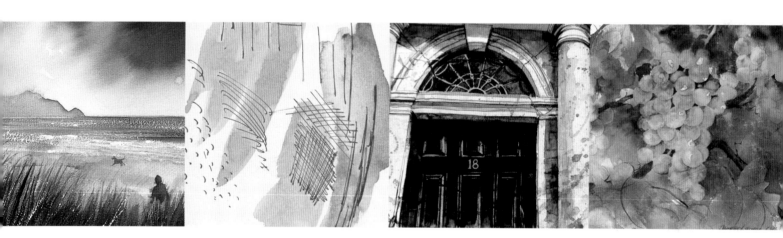

THE NEW ENCYCLOPEDIA OF
WATERCOLOR
TECHNIQUES

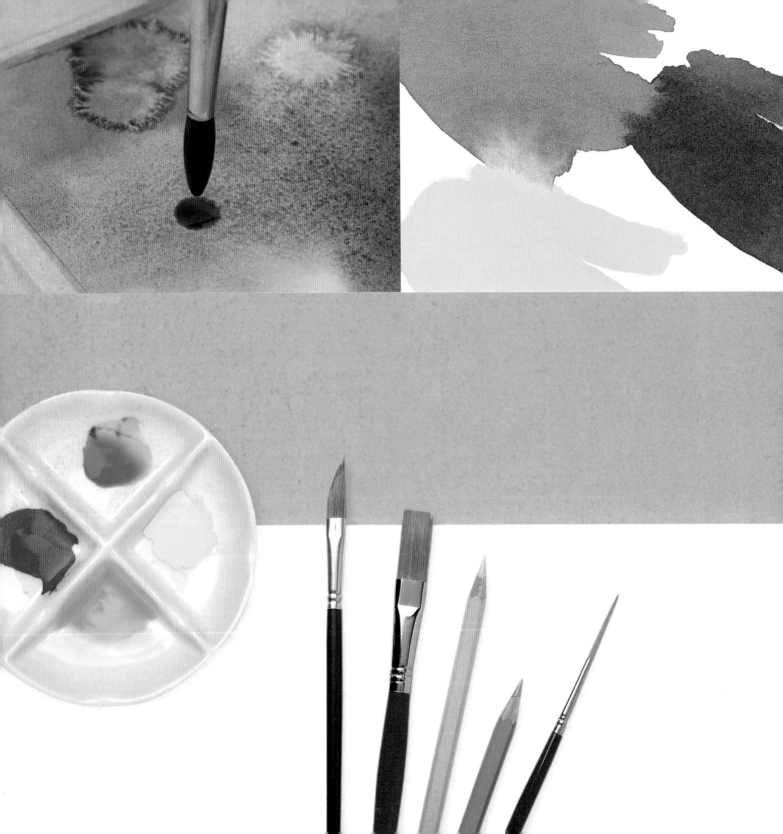

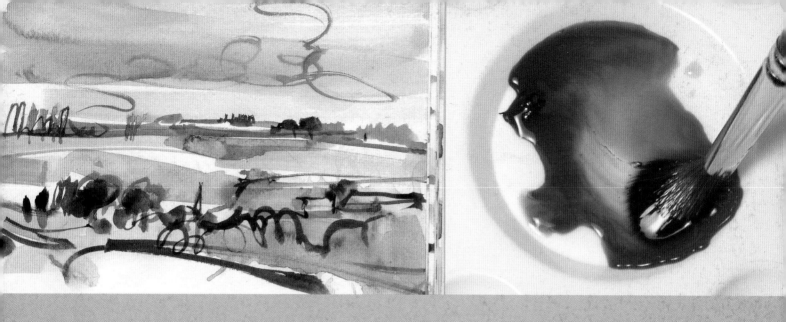

THE NEW ENCYCLOPEDIA OF
WATERCOLOR
TECHNIQUES

DIANA CRAIG & HAZEL HARRISON

RUNNING PRESS
PHILADELPHIA · LONDON

Library of Congress Control Number: 2009943398

ISBN–13: 978 0 7624 4050 4

Conceived, designed, and produced by
Quarto Publishing Plc
The Old Brewery
6 Blundell Street
London N7 9BH

QUAR.EWT2

Project editor: Sorrel Wood
Art editor: Jacqueline Palmer
Designer: Julie Francis
Art director: Caroline Guest
Picture researcher: Sarah Bell
Creative director: Moira Clinch
Publisher: Paul Carslake

Manufactured by PICA Digital, Singapore
Printed by 1010 printing international Ltd, China

This book may be ordered
by mail from the publisher.
Please include $2.50 for postage
and handling.
But try your bookstore first!

Running Press Book Publishers
125 South Twenty-second Street
Philadelphia, Pennsylvania 19103-4399
Visit us on the web!
www.runningpress.com

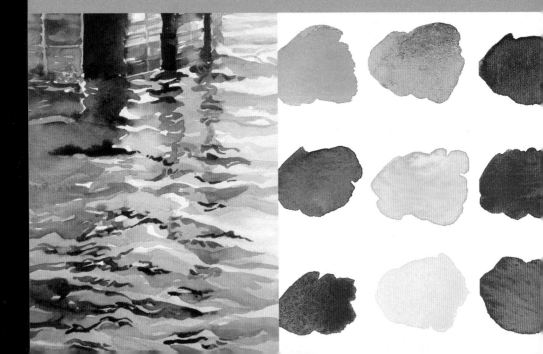

CONTENTS

ABOUT THE NEW EDITION

Artists have been painting in watercolor for centuries, yet this traditional and time-honored medium can also be one of the most exciting and innovative. This third edition of *The New Encyclopedia of Watercolor Techniques* covers the same methods as in the previous editions but offers a wealth of new material too.

The book opens with a gallery of watercolor paintings by a number of different artists, demonstrating the huge array of styles and effects that can be achieved. This is then followed by a new section offering practical information on tools and materials, and advice on setting up a working space and on working methods.

The third chapter is the key section of the book: the techniques. All the traditional methods are shown here, from laying washes and working wet-in-wet to reserving highlights and lifting out, along with more unusual techniques such as spattering, feathering, and creating texture with plastic wrap and aluminum foil, for those who wish to experiment with the medium. Clear step-by-step pictures and text explain each process, and these are often accompanied by an additional gallery piece showing the technique in use.

The techniques chapter also includes useful features not available in the previous edition. Tips flag up points to watch for and suggest how to get the best results from each method; suggested applications offer ideas on where a technique might be most successfully applied; and cross-references link similar processes, to encourage greater creativity and exploration.

This edition includes a new fourth chapter, outlining a number of key principles and practices that every artist needs to know, from understanding color and tone, working with light and shade, and creating spatial depth, through to developing a personal style, knowing the rules of good composition, and dealing with practicalities such as planning the order of your work.

This new encyclopedia includes everything a painter needs to know, and offers those other essential factors too—ideas and inspiration—to encourage you to pick up your brush and explore the delights of painting in watercolor.

GALLERY

The aim of the gallery is to whet your appetite by demonstrating just how versatile watercolor is as a medium. It is suited to every subject, and adaptable to every style. The examples here include minutely detailed architectural subjects, photorealistic still lifes, and flat, graphic depictions of flowers, as well as exuberant uses of washes, glazes, and line.

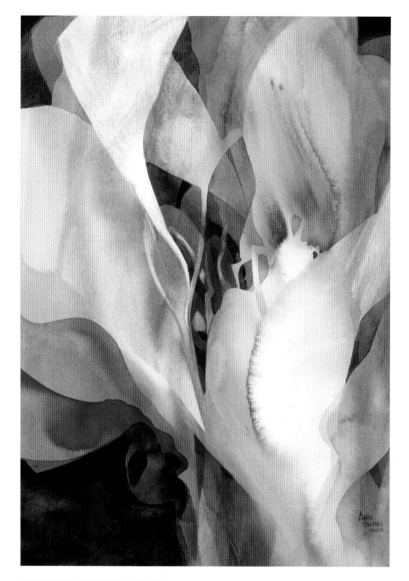

LETTING THE PAINTING DEVELOP
Seduction by Ann Smith
The twin challenges of this painting were first having to work on a very large scale, and second starting without any precise subject matter in mind. Ann Smith has more or less allowed the painting to have its own way, working initially wet-in-wet with a 4-inch brush, then drying the paper and adding more layers until she saw the image beginning to emerge.

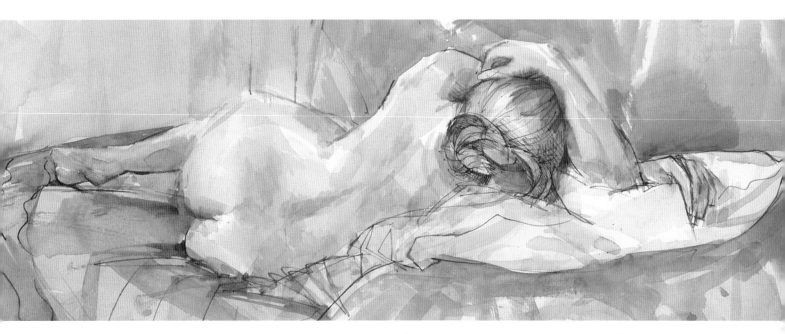

PAINTING FLESH

Back by Keith M. Kennedy

For this painting (above), Keith M. Kennedy has given a lovely softness to the flesh by working with a carefully controlled wet-in-wet technique, using line in places to define the forms and details. Notice how he has brought in touches of vivid red on the hip and buttocks to tie the figure in with the drape below the body.

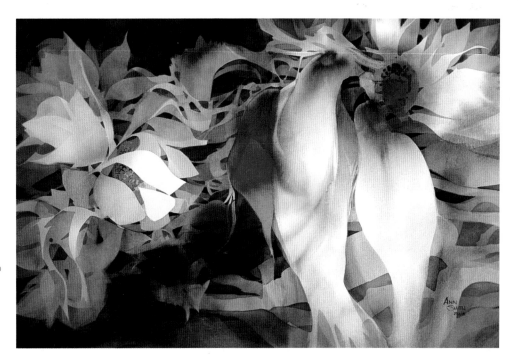

USING GLAZES

Exotic Friends by Ann Smith

This exquisite painting (right) demonstrates one of the key characteristics of watercolor—its transparent luminosity. Ann Smith has exploited this by building her painting up with a series of thin glazes that allow the whiteness of the paper to glow through—the painting looks as if it is almost lit from behind. The dark background throws the glazes into even lighter relief.

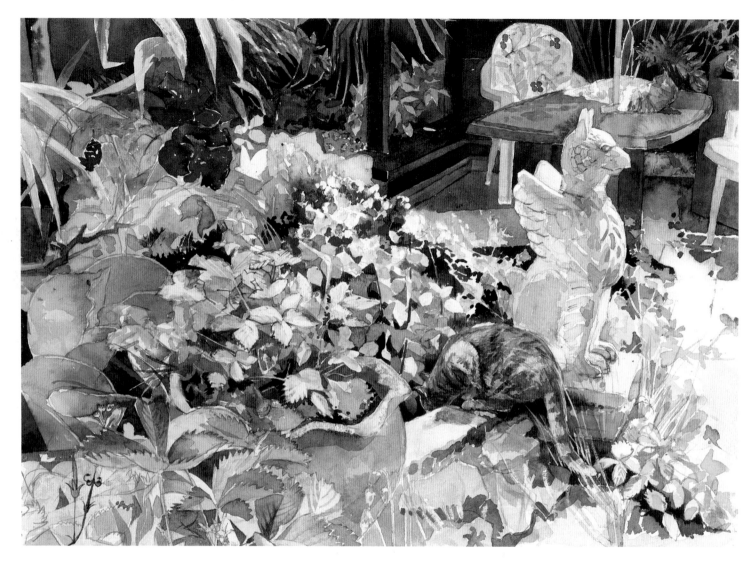

ADDING INTEREST

Tigger and Griffin by Keith M. Kennedy
Often a figure will give a touch of extra interest to a landscape. Here, the artist has used his cat in much the same way, so that the moving animal clearly in search of prey contrasts with the forever immobile stone griffin. The cat provides a strong focal point, drawing the eye into the picture.

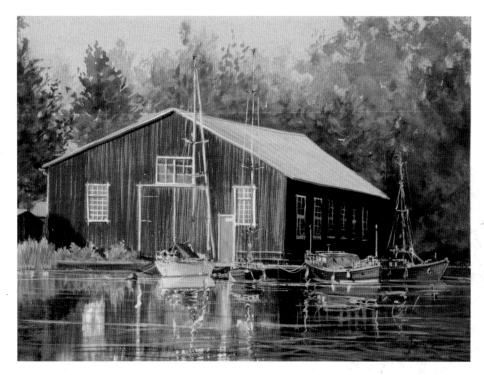

FAMILIAR SUBJECTS
The Old Harbor, Jakobstad by Terry Jarvis
The artist returns to this subject over and over (right), always finding inspiration. As with his other paintings, this picture was completed on the spot, the endless hours of Finnish daylight giving him a major advantage. He has used a range of techniques—wet-in-wet, graded wash, and wet-on-dry—and the use of tonal interchange gives the painting great impact.

EXPLOITING TECHNIQUES
Ionian Paradise by D.R. Gawthorpe
For this carefully planned and highly ambitious painting (left), the artist has used almost every watercolor technique including spattering, dry brush, and various masking methods. The water was built up in layers, and for the final overpainting, acrylic white was mixed with the watercolor.

RENDERING TEXTURES
Sleepers by David Poxon

David Poxon is fascinated by texture, and has chosen his subject (below) with this as his primary concern. He works on heavy paper, using the full range of watercolor techniques including lifting out, reserving whites, spattering, and scumbling. Small highlights are achieved by scratching out.

CREATING HIGHLIGHTS
Contained by Denny Bond

In this almost photorealistic piece (facing page), the artist began by masking the condensation drops on the interior of the terrarium, and determining which other highlights should remain white. Colors and tones were then worked up, using washes and painting both wet-in-wet and wet-on-dry. Finally, the masking was removed and additional highlights scratched out with a knife.

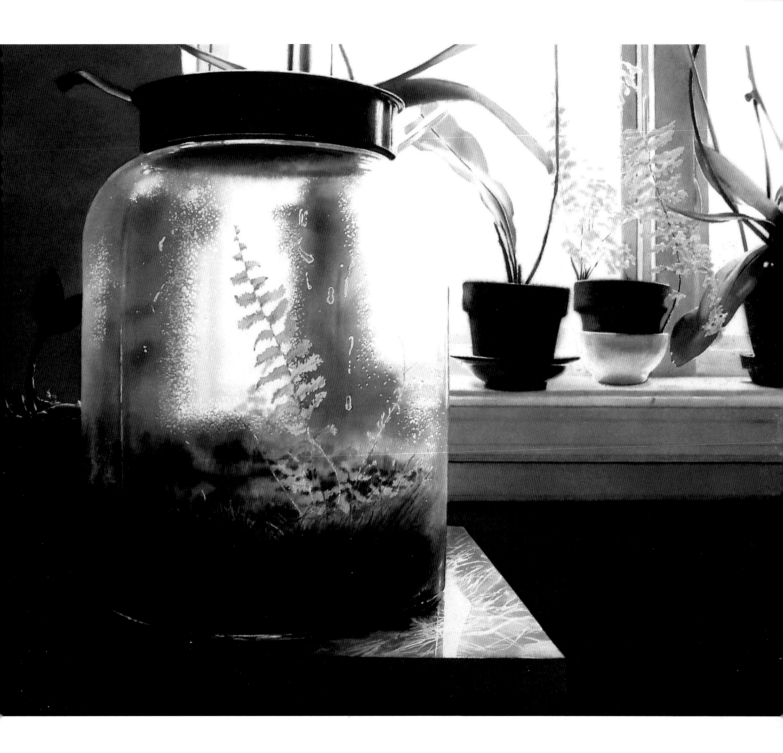

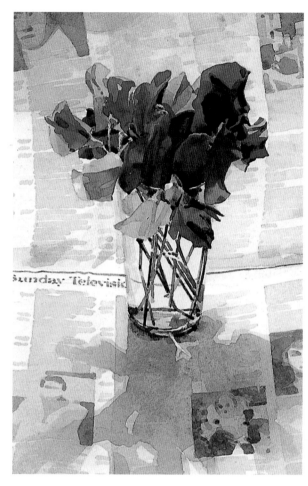

PAINTING ARTIFICIAL LIGHT

Golden Celebration by Sally Robertson

Named after the rose itself, this watercolor (below) is as much about the light as the subject itself. Sally Robertson has used Cadmium Yellow painted wet-in-wet and diffused with magentas for the transitions from light to dark. The highlight on the lamp is the reserved white of the paper, and the roses have been painted petal by petal wet-on-dry.

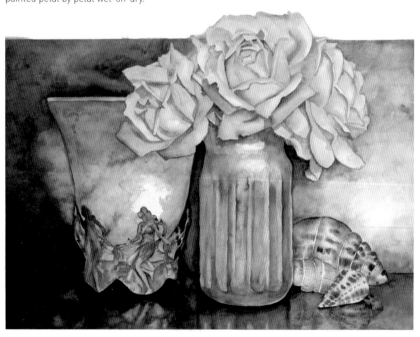

CHOOSING AN UNUSUAL SETTING

Sweet Peas in a Tumbler by Ronald Jesty

We are so conditioned by the idea of "correct" settings for flower pieces and still lifes that the idea of placing a vase of flowers on a newspaper (above) seems almost heretical. But it works perfectly, with the newspaper images providing just the right combination of geometric shapes and dark tones to balance the forms and colors of the sweet peas.

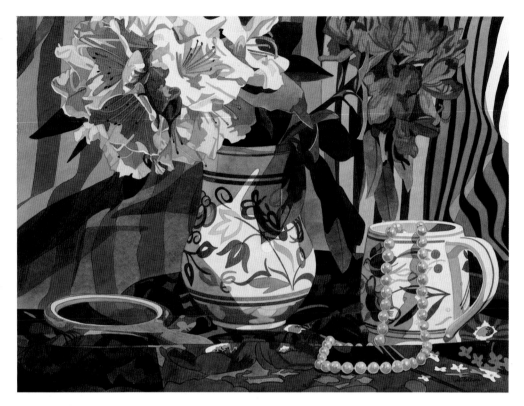

USING INTENSE COLOR

Rhododendrons and Pearls by Marjorie Collins
There is nothing wishy-washy about this dynamic image (left). Marjorie Collins has built up the intense colors by layering, working wet-on-dry. The brightest highlights were reserved as white paper, while the pale pinks on the right-hand blooms were reserved as an initial pale wash, allowed to dry, then painted around with darker tones.

WORKING IN LINE AND WASH

Wild Flowers by Brian Innes
This lively painting (right) reflects the artist's spontaneous response to the subject. Color washes were first laid down to indicate the broad shapes. To give definition to the forms and to describe the detail, the artist then overlaid the washes with an ink drawing. The ink lines do not always follow the shape of the underlying patches of color exactly, but this simply adds to the charm of the picture and reinforces the sense of free brushwork and spontaneity.

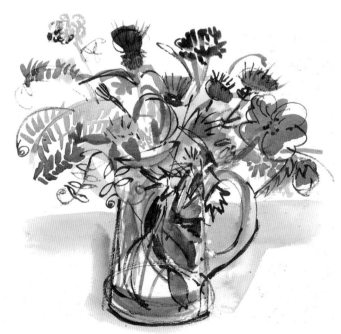

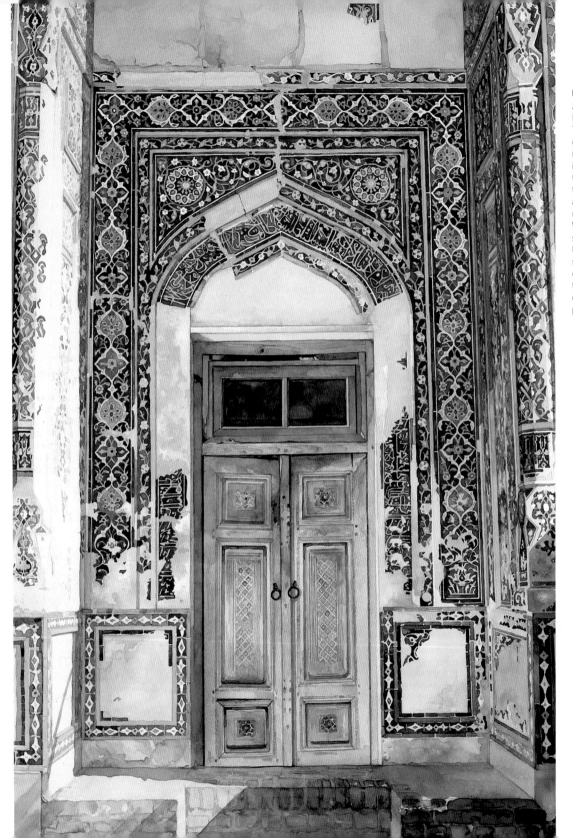

PAINTING INTRICATE DETAIL

Samarkand Mosque Doorway by Moira Clinch

The artist was attracted to the contrasting textures and patterns in and around this doorway. The intricate tilework, the rough, chalky textures of the restored plaster, and the weatherbeaten wood of the door appealed to the artist but required a mixture of painting techniques. Working from a detailed pencil sketch of the tiles, done *in situ*, and later from a photograph in the studio, she used various blues and earth colors to build up the image, using transparent glazes and working wet-on-dry. Sunlit areas of the tiles were painted directly onto the white paper.

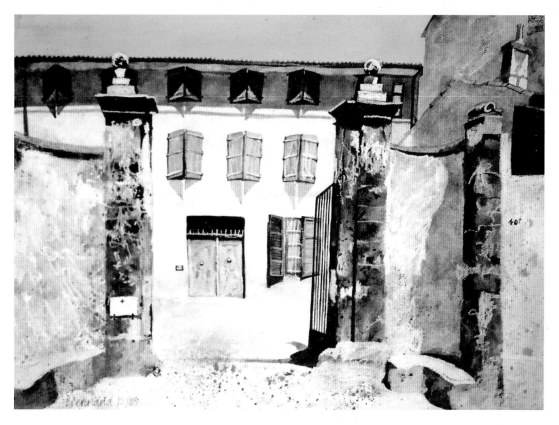

WORKING FROM REFERENCES

Red Cross Hospital, Aix en Provence
by Catherine Brennand
This artist specialized in architectural subjects, and because she worked on a large scale, she used photographs and drawings rather than painting on the spot. In this painting (left), she has used wet-in-wet and spattering to build up the textures and give a lively freshness to the picture.

CREATING TEXTURE

Grand Canal by Catherine Brennand
Here (right) the same artist as above demonstrates a sensitive response to the contrast between the almost tactile texture of the crumbling Venetian walls and the crisply delineated plasterwork around the windows and balustrades.

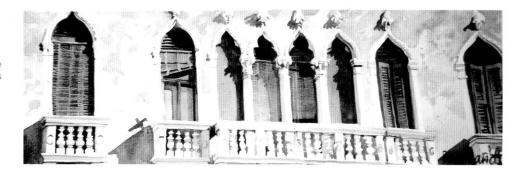

TOOLS AND MATERIALS

Paints, paper, and brushes are the watercolorist's essential toolkit. A sound knowledge of the materials that are available, their uses, and the effects they can produce will make painting a more enjoyable process and ensure better results. There are other practical concerns to consider too, such as caring for tools, setting up a workspace, what equipment to buy—and learning those tips and tricks that can save time and make for greater artistic success. The following pages give information and advice on all the tools and materials the watercolor painter will need.

CHOOSING PAINTS

WATERCOLOR HAS MANY ADVANTAGES OVER OTHER MEDIA AND PERHAPS THE GREATEST IS THAT YOU NEED ONLY A SMALL AMOUNT OF RELATIVELY INEXPENSIVE EQUIPMENT TO GET STARTED. IN FACT, THE ESSENTIAL MATERIALS FOR PAINTING IN WATERCOLOR ARE JUST PAINT, PAPER, BRUSHES, AND CLEAN, CLEAR WATER.

Types of watercolor

Before you buy your paints, you'll need to decide first between tubes and pans. Both have their merits. Pans are easier to carry around because you simply slot them into your paintbox. Tubes have to be carried separately, and the colors squeezed out as needed. Tubes are better when you need to mix up a lot of paint for washes.

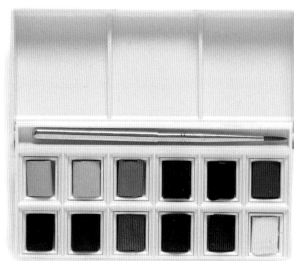

Selection of starter colors: Cadmium Red, Alizarin Crimson, French Ultramarine, Viridian, Yellow Ocher, Raw Umber, Payne's Gray, Lemon Yellow Deep, Cadmium Lemon, Cerulean Blue.

TUBE PAINTBOX

If you have decided on tube paints, there are advantages to keeping them in a box. First, it's a neat way of storing and protecting them; and second, the troughs in the lid can act as a mixing palette. However, you should avoid boxes prefitted with a selection of colors. You won't know whether they are good quality, and you may well find yourself stuck with colors you don't need. It's better to buy an empty box that can be filled with colors that you have personally chosen.

PANS

All watercolors contain gum arabic to keep them moist, so don't be put off pans because you think they may dry up. Pans are available in whole and half-sizes. Try a half-pan if you are unsure about a color. There is a wide range of paintboxes designed to hold pans and half-pans, which can be removed and replaced when used up. Like the tube paintbox, the lid can be used as a palette.

TUBES

Regular tubes of watercolor are quite small. Some manufacturers make larger sizes, but these are not necessary—it takes a long time to get through even a regular tube. Good-quality paints can be kept indefinitely as long as you remember to screw the caps back after use.

Colored inks

ACRYLIC PAINTS AND INKS

As you build up your collection of materials, it's useful to add acrylics and inks to widen the range of results you can achieve. Both media can be used in combination with traditional watercolor, with interesting results. Thinned with water, acrylic paint behaves much like watercolor. Choose water-soluble or waterproof ink depending on the effect you want.

Tubes of acrylic, in standard and metallic colors

Tubes of gouache

GOUACHE PAINTS

Gouache paints are an opaque version of watercolors, which can be used more thickly and sometimes in combination with the transparent colors. Gouache white, in particular, is a useful alternative to Chinese white for adding highlights or thickening paint for certain effects. Gouache is sold in tubes, jars, or bottles.

Bottles of gouache

Zinc White gouache

Titanium White watercolor

Chinese White watercolor

Jar of gouache

IRIDESCENT AND PEARLESCENT PAINTS

Glowing, luminescent watercolor paint has been in use for centuries, but now a whole new range of paints is available to enrich the artist's palette further and produce some exciting and unusual effects

At one time, the artist had few choices with regard to metallic and luminescent effects beyond conventional pigment color. Then, in the 1960s, the automotive industry began developing various mineral-based, interference, and iridescent pigments of great durability.

Now, artists' paint manufacturers use this technology to create new colors—every year new ones are released and others discontinued. These two pages provide a survey of some of the exciting and relatively recent developments within the industry, but you should also regularly check the catalogs and websites of all the manufacturers for their latest launches.

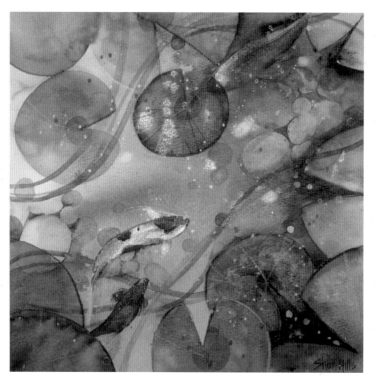

USING IRIDESCENT PAINT

Fish Pond by Shari Hills
In this exquisite painting (left), Shari Hills has used delicate watercolor glazes to depict a watery world. She has then dabbed on spots of iridescent color for the sparkles on the water surface and the sheen where the fish scales catch the light. As with any special medium or technique, a "less is more" treatment works best. Just a few iridescent accents are much more effective than an overall application.

IRIDESCENT PAINTS

Paints that contain coated mineral particles as well as a tinting pigment are called "iridescent." The optical phenomenon of a change in hue occurs according to the angle of observation. The example here shows iridescent paints applied over both a dark band of Ultramarine Turquoise and Napthamide Maroon (above) and white paper (below). Notice how some iridescents fail to cover the dark, whereas others create a gauze-like sheen and nearly disappear over white paper.

INTERFERENCE AND PEARLESCENT PAINTS

Transparent paints that contain uncoated mica particles and are not mixed with another pigment are nearly invisible on white paper. The optical phenomenon of color is visible only when painted over a dark undercolor. Here, nine interference and pearlescent paints have been applied over both dark undercolor and white paper. Notice that all are very nearly invisible over the white paper and only appear when painted over the dark.

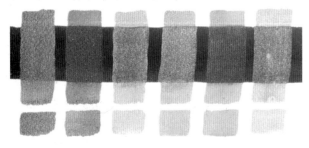

Blue silver Scarab red Sunstone Moonstone Russet Topaz

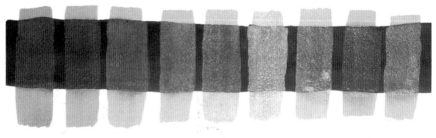

Red Lilac Copper Blue Green Silver Gold Pearlescent shimmer Pearlescent white

MEDIA

A wide range of effects and techniques can be created by simply mixing clean water with good-quality watercolor paint. There are also several watercolor media available, which can be used to good effect.

GUM ARABIC is one of the major constituents of watercolor paint. It not only helps bind the pigment, but also contributes to the transparency and depth of the color. Gum arabic can be added to paint in two ways: a few drops can be placed in the general mixing water, or it can be added to specific washes or mixes only. Adding gum arabic will make your colors more transparent, give them greater depth, and imbue them with a slight gloss. More importantly, it will increase the solubility of the dry paint, making corrections possible.
Advantages: makes a number of textural effects possible, and makes corrections easier.
Disadvantages: over-use can result in paint drying with a gloss finish; heavy use can cause paint to crack when applied too thickly.
Cost: inexpensive, when used sparingly.

WATERCOLOR MEDIUM behaves like—and has similar qualities to—gum arabic, but it also improves the flow of washes. It can be added to the mixing water, or used selectively on individual washes.
Advantages: increases the brilliance and transparency of colors.
Disadvantages: over-use can result in areas of work drying to an unsightly gloss finish.
Cost: relatively inexpensive.

IRIDESCENT MEDIUM adds a pearlescent effect to watercolor. Add when the wash or color is being mixed, or apply over the paint once it is dry. It is shown off to best effect when mixed with transparent colors and applied over a dark background.
Advantages: particularly useful for design and decorative work.
Disadvantages: can contaminate paints, or show up in parts of the work in which it is not required.
Cost: relatively inexpensive.

TEXTURE MEDIUM contains small particles suspended in a gel. It can be mixed with wet paint and then applied, or it can be brushed directly onto paper and then worked over with color. With patience, multiple layers can be built up to create pronounced textural effects.
Advantages: increases the capability of the watercolor medium.
Disadvantages: brushes can be ruined if not cleaned thoroughly.
Cost: relatively inexpensive.

GRANULATION MEDIUM causes watercolor to granulate—an effect that occurs naturally with certain relatively coarse blue and earth pigments that separate out from a wash and settle into the texture of the support, giving a granular, textured effect.
Advantages: gives added drama.

Disadvantages: can lose effectiveness if overdone.
Cost: relatively inexpensive.

PERMANENT MASKING MEDIUM can be used in two ways: it can be applied undiluted onto the support; once dry, the medium is invisible, but it will isolate the masked area and repel any washes painted over it. Alternatively, the medium can be mixed with paint. When dry, it will resist any further washes.
Advantages: does not have to be removed, and thus allows for the creation of complex layers of masking.
Disadvantages: impossible to remove or alter once an area as been treated and masked.
Cost: relatively inexpensive.

LIQUID FRISKET is also known as masking fluid, and is neither an additive nor a medium. It is a liquid latex solution that is painted onto the support. Once dry, it isolates the area from any unwanted washes painted over it. Once the wash is dry, the masking fluid is removed by gentle rubbing.
Advantages: can be applied in any number of ways, and the fluid color makes it is easy to see masked areas.
Disadvantages: may tear the surface if care is not taken when removing the dry fluid from the support. Also, brushes can be ruined if not cleaned thoroughly.
Cost: relatively inexpensive.

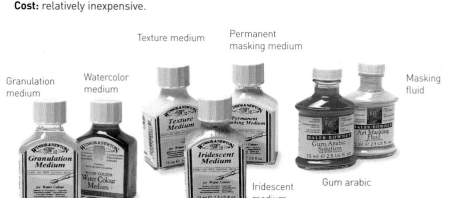

Granulation medium

Watercolor medium

Texture medium

Permanent masking medium

Iridescent medium

Gum arabic

Masking fluid

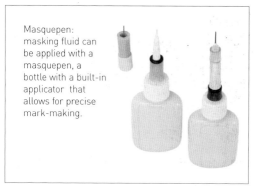

Masquepen: masking fluid can be applied with a masquepen, a bottle with a built-in applicator that allows for precise mark-making.

BRUSHES AND OTHER TOOLS

BRUSHES COME IN A RANGE OF SHAPES, SIZES, AND FIBERS—THE CHOICE DEPENDS ON PERSONAL TASTE AND THE EFFECT THAT THE ARTIST WANTS TO CREATE. BUT BRUSHES ARE NOT THE ONLY TOOLS FOR MARK-MAKING.

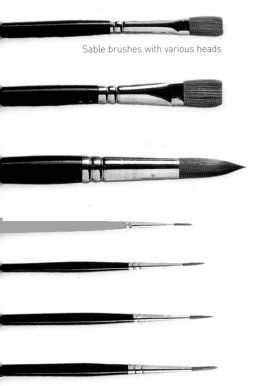

Sable brushes with various heads

TYPES OF BRUSHES

There are three main shapes of watercolor brush: rounds, flats, and mops. All are made in a range of sizes, usually identified by number but sometimes by their actual size (for example, ½in or 15mm). In most lines, the biggest brush is No.12 or No.14, and the smallest No.1, No.0, or even No.00.

As well as size and shape, the fiber from which the brush head is made determines its properties, and you should take this into account when choosing which brushes to buy.

Sable brushes This is the traditional fiber of choice for watercolor brushes. Sable is springy and resilient, and forms firm tips that point well—a top-quality sable brush will return to a point with one flick of the wrist when wet. Sable also carries a large amount of color, yet releases it quickly and cleans rapidly. On the down side, this fiber is expensive. However, if cared for properly, a sable brush should last for years.

Synthetic brushes A much cheaper option, synthetic-fiber brushes mimic many of the qualities of sable. They have their own distinct qualities and can point well, making them useful for detailed work. When changing from one color to another, though, they are more difficult to clean. Successful, long-lasting synthetic brushes (made of nylon or a mixture of nylon and sable) are available, which have some of the qualities of sable but at much lower cost.

Squirrel-hair brushes Also known as camel hair, these can hold even larger amounts of color than sable and therefore are useful as wash brushes in the larger sizes. They lack both the firmness of sable and synthetic fiber and the controllability needed for accurate, detailed work. Their advantage is that they are a fraction of the cost of sable brushes. Composite sable/squirrel brushes are available too; less expensive than sable, they retain some of its qualities for controlled or detailed work.

Goat-hair brushes These large, flat brushes with very soft and long, whitish hairs are also known as hake brushes. They are useful for applying large amounts of color rapidly, yet are gentle enough to cause minimum disturbance to any underlying color. When wet, the long, straight edge of the tip can be used to paint a range of shapes.

Hogshair brushes Traditionally used in oil painting, these firm brushes are useful for lifting color as well as applying large amounts where accuracy is not important.

Chinese brushes A useful and cheaper alternative to sable, these can create detail as well as superb flowing lines.

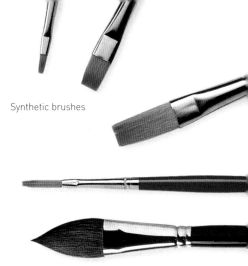

Synthetic brushes

Squirrel-hair brush

Hake goat-hair brush

Hogshair brushes

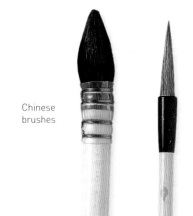

Chinese brushes

TIPS: CHOOSING BRUSHES

• When you are starting out, you don't need a vast range of brushes. One flat, square-ended brush and three rounds of different sizes, in a sable and nylon mix, will be enough to get you going. You can slowly build up your collection, according to personal taste and your pocket.

• Regardless of a brush's makeup, it should be resilient and springy. You can test this by wetting the brush to a point and dragging it lightly over your thumbnail; springy bristles will return to their original position.

• You also need your brushes to hold a good quantity of water. Test by loading the brush with water, then squeezing it out.

TIPS: CARING FOR BRUSHES

• Keep your watercolor brushes solely for watercolor painting.

• Do not leave the heads of your brushes standing in water—you will ruin them. Instead, stand them upright in a jar.

• Rinse your brush under running water after each painting session. Use a little soap if traces of dried color stick to the end near the metal band. Reshape gently with your fingers.

• If you have to carry your brushes around, protect the points. Use an old ruler and a couple of rubber bands to make a splint for them, or use a purpose-made cylindrical container. Keep the brushes upright or the tips may bend.

OTHER MARK-MAKERS

Brushes are not the only mark-making tools available to the watercolorist. There are a range of others, from fairly conventional to experimental.

Sponge A small natural sponge, available from art supply stores, is an extremely useful piece of equipment. It can be used for applying color, laying washes, and making corrections, as well as for cleaning up.

Cotton balls These serve much the same purpose as a sponge, although they do not have the same color-retaining properties and tend to be drier in use.

Cotton swabs These are good for lifting out small highlights, or for doing corrections.

Toothbrush An old toothbrush is the perfect tool for the spatter technique.

Plastic wrap, bubble wrap, aluminum foil Usually found in the kitchen or stationery cupboard, all these materials can be pressed into wet paint to create surface texture.

PALETTES

If you store your watercolor pans or tubes in a paintbox, the lid will be designed for use as a mixing palette. An alternative is an individual palette, with recessed "wells" to hold the color and divisions to separate one color from another. Palettes are available in china or more inexpensive plastic, which is light enough for outdoor work. However, if you don't want to go to the expense of buying a purpose-made palette, you could use an old plate (preferably white and unpatterned, so you can judge the mixes more accurately)—although because there are no troughs you won't be able to keep your colors separate so easily.

OTHER USEFUL TOOLS

• Paper towel—almost essential, for lifting out color, wiping brushes, and general cleaning up.

• Pencil and eraser, for preliminary drawing. A B-grade pencil is soft enough not to indent the paper.

• Pens—felt-tip and India ink nib—for line and wash.

• Gummed tape, for stretching paper (see page 27). Never be tempted to use masking tape for this.

• Craft knife or scalpel, and scissors.

• Wax candles or crayons, for the wax-resist technique.

• Water spray bottle, to soften color or for spraying wet paint to create surface texture.

• Small, flexible palette knife, for mixing color—a preferable alternative to mixing large quantities of a color with a brush, which could shorten its life.

WATER JARS

You will also need a jar to hold water. Old, clean jam jars are fine for indoor work. If you are going to be working out-of-doors, use a lighter plastic pot with a lid.

PAPER

WATERCOLORS ARE ALMOST ALWAYS PAINTED ON WHITE PAPER, WHICH REFLECTS BACK THROUGH THE THIN LAYERS OF PAINT, GIVING IT ITS LUMINOUS QUALITY. IT HELPS TO KNOW THE QUALITIES OF THE DIFFERENT WATERCOLOR PAPERS IN ORDER TO ACHIEVE THE EFFECTS YOU WANT.

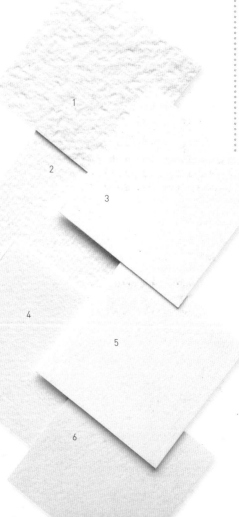

1 and 2: Handmade paper, 3: Hot-pressed paper, 4: Rough paper,
5: Cold-pressed paper, 6: Watercolor board.

TYPES OF PAPER

The finest-quality watercolor paper is made by hand from pure linen rag. These papers are expensive, and if you are a beginner you won't need them. The papers you'll find in your local art supply store are machine-made. There are many different brands, all with slight variations, but they can all be divided into three groups.

Hot-pressed paper This is made smooth by passing it through heated rollers after it is made. Its smooth surface makes it ideal for detailed work, such as botanical painting, but it has none of the pleasing surface texture of rougher papers.

Cold-pressed paper To achieve its characteristic "tooth," or surface texture, this paper is pressed between unheated rollers lined with felt mats. It is the most popular paper and is referred to as "not surfaced," which means it hasn't been hot-pressed. It has a moderately rough texture, just enough for color to drag off the brush and create many useful effects.

Rough paper Not pressed at all, this has a distinctly characteristic rough surface. This rough surface acts as a moderating influence and helps control the flow of pigment, contributing to an even finish, if desired. Alternatively, if pigment is used fairly dry, it can be dragged across the surface to produce many textures. Never underestimate the capacity of even the roughest paper to produce accurate, detailed work, especially on larger paintings to be viewed at a distance.

WEIGHTS OF PAPER

Sheets of watercolor paper come in different thicknesses. These are measured in weight—this is important because it dictates whether you will have to stretch them. The weight of paper is usually expressed in pounds (lbs), referring to the weight of a ream (500 sheets), not to each individual sheet. A thin, lightweight paper may be no more than 90lb, while medium-weights start at 140lb, with heavier weights at around 200lb—although really heavyweights can go up to 300lb or more. As a general rule, any paper heavier than around 200lb can be used without stretching. The paper used in most watercolor pads is 140lb, which you can just get away with using without stretching.

FINDING THE RIGHT SIDE

Not all papers have watermarks but, if they do, this indicates that there is a "right" and "wrong" side. Hold the paper up to the light, and if you can read the watermark, this is the side to paint on.

STRETCHING PAPER

When paper becomes very wet, it has a tendency to buckle, and an uneven flow of paint will result. Often this does not matter, and the very unevenness can add vitality to a painting. At other times, more control is required; if that is the case, it is advisable to stretch the paper first, to ensure a flat, taut surface on which to paint. To stretch paper, you will need a drawing board, gummed tape, a sponge, and a craft knife and scissors.

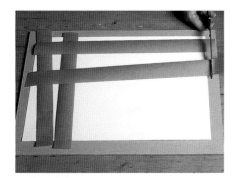

1 With dry hands, cut four strips of gummed paper tape, slightly longer than the sides of the painting paper. Then put the roll of gummed paper away in a dry place—it should always be handled with dry hands. Rule light pencil lines about half an inch from the edges of the paper to help you put the tape on straight.

2 Immerse the paper briefly in water in a bathtub, sink, or plastic tray, turning it over once to make sure both sides are evenly wetted. Place the paper on a board and smooth it with a damp sponge to remove any creases or air bubbles.

3 Run the sponge over the paper strips to just dampen them. Using the sponge, neatly smooth the strips along the edges of the paper, following your pencil lines: The tape should overlap the edge of the paper by at least ¼" (6 mm). Trim the corners. Stand the board upright until the paper is completely dry. You can now paint on the paper. To remove the painting from the board, cut through the tape with a craft knife

PADS OR SHEETS?

The major manufacturers produce their paper in large sheet and sketchpad form. The pads usually contain 10 or 12 sheets, and are available in a variety of sizes. If you are painting a large work, or if you have very specific requirements of the paper, it is better to buy your paper as a loose sheet.

USING WATERCOLOR BOARD

If you have no time to stretch paper, you could use watercolor board, which is simply paper stuck to a firm backing.

SETTING UP A WORKING AREA

PAINTING WITH WATERCOLOR CAN BE A REAL JOY, BUT TO MAKE THE EXPERIENCE AS PLEASURABLE AND SUCCESSFUL AS POSSIBLE, YOU NEED TO HAVE A WELL-ORGANIZED WORKING AREA.

Having a designated area in which to work is an ideal to aim for. Not only will it provide practical storage for your tools and materials, but it will also give your mind the subliminal message that you are taking your art seriously. Artists who work in acrylics or oils have the potential to work big but this isn't usually true of watercolorists, who don't therefore need vast studios in which to paint. If you don't have a spare room, an unused corner or perhaps a well-lit landing are the kinds of spaces that can be put to good use.

Set up your workspace so that you can, as far as possible, look down on the paper you are painting on rather than viewing it at an angle. Distortion in a painting is often caused by the angle at which you are working. It's also important to step back often to assess your work (luckily watercolorists don't need as much space for this as oil painters who often have to stand quite a way back to view their enormous canvases). There is nothing more soul-destroying than finding that the painting you thought looked great close up does not work when seen at a distance.

LAMPS

Working lights need not form part of your "starter kit," but you will need to consider suitable lighting if you intend to work in the evenings. Anglepoise lamps are useful because they can be angled to throw light exactly where you want it. They are available from good suppliers of graphic materials.

LIGHT BULBS

There is no substitute for daylight but it may not always be possible to paint during the day. If you have no choice but to paint by artificial light, avoid working under tungsten lighting; it has a yellow cast and distorts color, flattens tone, and reduces definition, and will make it harder for you to judge what you are doing. When you look at your painting the following morning, it may look quite different from the way it did the night before—and you may wonder why you did not notice that bright color or that rather crude brushwork. Clear, bright, white lighting is a much more effective choice. Fluorescent and halogen are better than tungsten, but the best option of all are the blue, daylight-simulation bulbs that are the closest artificial approximation to daylight. They are available from art supply stores.

TIPS: STORAGE SOLUTIONS

• If you don't have a room or corner set aside just for painting, storing tools and materials can be a problem. One solution is to use one of those storage units on wheels, with drawers in which you can stash items away. The unit can be tucked into a corner or under a table when not in use and—if the top is big enough and the right height—it can double as a work surface when in use.

• To remain in pristine condition, sheets of paper, pads, and card ideally need to be stored flat. Those lucky enough to have their own studios may have space for a plan chest in which to keep such items. If you do not have this luxury, you can use large portfolios for storage. Propped up vertically on their spines, portfolios take up little space and can be tucked out of sight until needed. Available from art supply stores, they come in a range of types and sizes, from the inexpensive to the pricey. Choose according to your needs and pocket.

• Cardboard cylinders or plastic tubes are fine for storing thinner papers. However, heavier-weight watercolor papers might crease if rolled, and are best stored flat.

USING AN EASEL

Watercolor is not like oil paint which stays where you put it—when it is wet watercolor runs. For this reason, you cannot use an easel for watercolor painting in the same way as you would for oils. Unless you actually want the paint to run to create a special effect, the easel should be tilted back sufficiently so that the paint remains where you apply it, but not so flat that it is difficult for you to see your work. Several easel designs have a tilt facility that allows you to adjust your board to a horizontal or near-horizontal angle for working, then adjust it back up to vertical for viewing. If you want to splash out, there are even easels specifically designed just for watercolor work.

Paper towels
Always have these on hand to mop up extra paint or water in a hurry.

Salt
This is a great way to add texture (see pages 88–89).

Light source
Good lighting is essential for any form of painting. The direction of the light source is important too. If you are right-handed, the light should come from the left (and from the right if you are left-handed), or your working hand will throw a shadow on your work.

Organization
Keep loose paints in a large box—buy one larger then you need, as you will probably buy more paints as your skills improve.

A working surface

It may seem obvious but having an adequate work surface often gets overlooked when setting up a painting space. It must be big enough to take water jars, paints, palette, brushes, and any other materials and aids that you need—watercolor is a fast-drying medium so you need everything on hand. Your work surface may have to accommodate your painting board too. If you are painting at an easel, the work surface should be sited close by and be the appropriate height, so that all your materials and tools are easily within reach. If you are lucky enough to have a studio or designated painting corner, you can have a large table solely for this purpose. If not, a kitchen or even dining table will do, covered with newspaper to protect it.

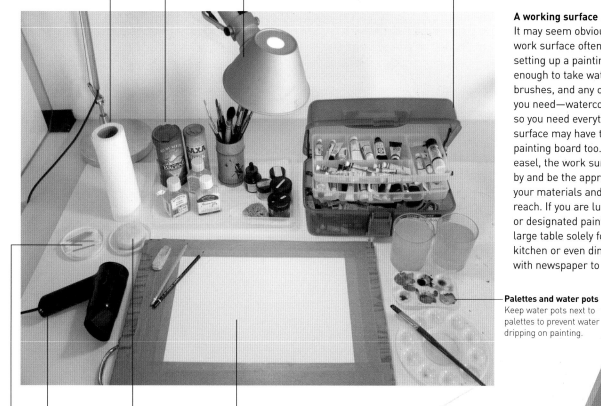

Palettes and water pots
Keep water pots next to palettes to prevent water dripping on painting.

Hair dryer
Useful for speeding the drying process.

Soap bar
For quick cleaning of brushes after masking.

Paper
The paper has been stretched onto a moveable board.

EASEL
An easel is not essential, but it is useful if you like to paint while standing. It must be adjustable so that the paper can lie almost flat. A table easel can also be useful if space is not available.

Cotton swabs
For lifting out paint.

DRAWING BOARD
A board is important for supporting your paper. It needs to be firm—the wood should not be less than 4-ply—and it should be unstained and unpolished. (If it is stained, the stain sometimes comes off on the back of the paper; if it is polished, the gummed paper will not stick when you are stretching your paper.)

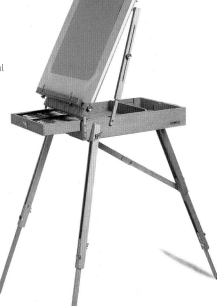

WORKING OUT OF DOORS

WORKING OUTDOORS *EN PLEIN AIR* CAN BE A REAL PLEASURE. HOWEVER, WHETHER YOU'RE DOING QUICK SKETCHES OR A COMPLETE PAINTING, IT NEEDS MORE ORGANIZATION THAN INDOOR WORK.

If you like painting away from home, it might be worth keeping a special kit ready for just this purpose, with all the tools and equipment you will need. Then all you'll need to grab before you go are paints, paper, and brushes. Bear in mind, too, that you are going to have to carry the lot, so avoid anything that weighs too much. And a final word of warning: Be prepared for a little audience—of children especially—to gather to watch you at work. Most will be too impressed by your artistic skills to spot the odd "mistake," so don't let this put you off what you are doing.

CHOOSING A LOCATION

Since you won't want to traipse around with your painting equipment looking for a good place to paint from, it's best to plan this in advance. You could explore the area the day before and choose your spot so that you go straight to it. If you're intending to complete an entire picture rather than making sketches, you might also consider doing the drawing on one day and painting on another. One of the difficulties of location work is coping with changing light; you may think you have the whole day to paint in, but the scene will have changed completely between morning and evening, so you'll have to work fast—remember Monet's haystack series of paintings and how the colors and tones changed depending on the time of day? If you've already done the drawing the day before, you can start on the painting immediately without wasting valuable time.

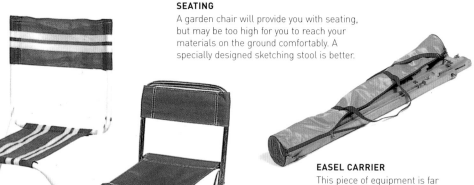

SEATING

A garden chair will provide you with seating, but may be too high for you to reach your materials on the ground comfortably. A specially designed sketching stool is better.

EASEL CARRIER

This piece of equipment is far from essential, but can be helpful if you have to walk long distances.

EASEL

You don't necessarily need an easel because you can paint with your board or sketching pad held on your lap. If you want to invest in an easel, make sure it's light enough to carry easily and that it can be adjusted so that the board is held near-horizontally. There are two main types—wooden ones and metal ones. They both weigh about the same and the height and angle can be adjusted.

SHADE

Watercolors dry very fast under a hot sun, and bright light on your paper will dazzle you, making it hard to see the colors. It's generally best to find a shady spot to work in. However, if you do have to work in the sun, it's wise to wear some form of hat or cap.

PAPER

For small, quick sketches you don't need to stretch paper. Use a watercolor pad or paper attached to a light piece of plywood or hardboard.

EQUIPMENT

You will also need the following pieces of equipment:
- Water container—any plastic bottle will do.
- Water pot—the non-spill ones (red top) are ideal.
- Brush holder—this is not essential but will protect your brushes.
- Paper towels, for wiping brushes, mopping up excess paint, and cleaning up.
- Large plastic bags, to protect your work if it rains.

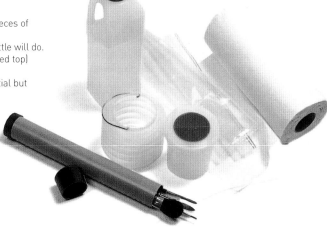

CHECKLIST

When painting out of doors, you won't be able to pop to the cupboard or kitchen to collect something you've forgotten, so you need to be extra-organized. Before you set off, check that you have the following:

- Brushes (you won't need many) ✓
- Paintbox or tubes ✓
- Mixing pans ✓
- Sketching block or light drawing board and sheets of paper ✓
- Thumbtacks, masking tape, or bulldog clips for securing sheets of paper (if using) ✓
- Bottle for carrying water ✓
- Jar or plastic pot for paint water ✓
- Pencil and eraser for preliminary drawing ✓
- Knife or sharpener for sharpening pencils ✓
- Sponges and paper towels, for applying paint, lifting out, and mopping up ✓
- Plastic bag to protect your work from rain ✓
- Sketching stool, or folding chair ✓
- Easel and easel carrier (optional) ✓
- Viewfinder (optional) ✓

USING A VIEWFINDER

When you're faced with a large expanse of scenery it can be very difficult to decide which bit to concentrate on. This is where a viewfinder, made from two L-shaped pieces of card, or a viewing frame—a rectangular window cut in a piece of cardboard—comes in. Hold it up at arm's length to isolate parts of the view, moving it around until you see the makings of a composition. Most artists use a viewfinder; some even take a picture frame out with them to assess how their painting will look when completed and framed!

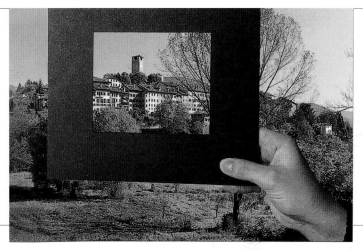

TECHNIQUES

Watercolor can be both a challenging medium and an exciting one that offers huge scope for experimentation and unusual effects. Many techniques have been around for centuries and still form the foundation of watercolor work. These need to be mastered first—without knowing how to lay a wash or work wet-in-wet, for example, little progress can be made. But once you are familiar with these fundamental processes, you can add new ones to your repertoire—exploring wax resist or spattering, for example, or breaking up wet color by sprinkling it with salt—and revel in all the effects that this endlessly adaptable medium offers. This chapter explains the whole range of techniques that are possible with watercolor, from the familiar to the lesser-known.

PRIMING PAPER

UNDERSTANDING HOW YOUR PAPER REACTS TO AND ABSORBS WATER AND PIGMENT IS CRITICAL TO YOUR SUCCESS WITH THE TECHNIQUES SHOWN IN THIS BOOK.

Think of it like this: if you prime wood before painting it, the top coat will go on more smoothly and successfully. It's the same with watercolor. Watercolor can be quite an unforgiving and temperamental medium. Once it is dry, it does not really like to be disturbed, or it will start to move around in ways you might not want. You need to control the flow of the paint by priming the paper first. Priming will not only help you to lay flatter washes or softer graded ones, but will also enable you to judge the receptivity of the paper more accurately.

You can apply this technique either to the whole of your painting—say, if you are going to lay down an overall pale, warm yellow wash for background warmth—or just to a selected area such as a sky.

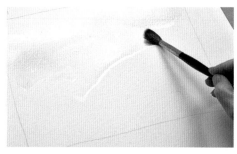

LAYING A WATER WASH
1 On heavy watercolor paper or stretched paper, a large brush is used to apply clean water, with quick, even strokes. Clean water is important in watercolor painting so that reserved highlights and colors remain clear and unpolluted.

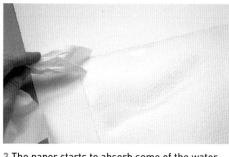

2 The paper starts to absorb some of the water, and some sits on the surface. There should be an even, wet shine on top. If the water starts to puddle too much, you can absorb the excess by dabbing with a paper towel.

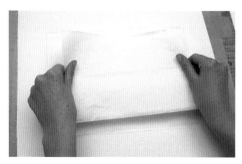

3 If too much water has been applied over a larger area, the excess wetness can be blotted away by carefully placing paper towel flat down onto the paper.

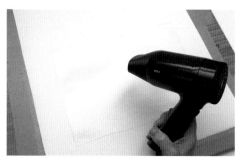

4 If it is a cold day or time is limited, a hairdryer can be used to remove some of the moisture.

Glossy and too wet, water puddling on surface

Dull shine, right degree of wetness

JUDGING THE WETNESS
5 The aim is to let the paper dry to a semi-gloss, almost silk finish. This finish is important as the paint will go down more smoothly. The other reason is that a very wet surface will buckle too much, making it impossible to get a flat wash because the pigment will run into the troughs. Here, some areas are still a bit wet and glossy, but others are at the perfect stage to receive paint.

PRIMING AN AREA WET-ON-DRY

The technique can also be applied to areas of a picture that are already painted. A good sable brush pays off here, as it is so much gentler on the fragile pigment underneath.

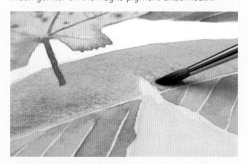

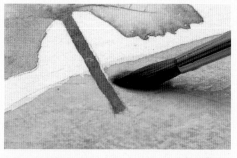

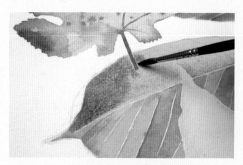

1 The area that is to receive the secondary glaze is allowed to dry. Then, using a brush at an oblique angle so that it doesn't press too hard on the painted area, a layer of clear water is applied.

2 Care is taken to paint the water around and not across the details, or it will "conduct" the paint into those parts.

3 Color is dropped or softly washed on. The wet, receptive paper allows the color to flood evenly over the area and around (but not across) the details.

6 An adequate amount of the desired color is mixed up, then applied as a flat wash. The damp paper surface allows the paint to flow more easily, and makes it easier to move around, than if it was going directly onto dry "virgin" paper. Not only does this produce flatter washes, but variegated washes will blend more smoothly too.

INTRICATE EDGES

The technique is especially useful for painting a clear sky above a complex, detailed horizon. If the paper is dry, it's very hard to paint around the complex horizon line and cover the sky with a flat or even a graded wash before the paint dries.

1 The artist draws in the horizon details, then turns the board upside-down—it is easier to work into the complex outline from below—and paints clear water around the details and all the way to the top of the painting. The paper is left to absorb the water and reach the "silk" stage.

2 The artist lays a blue wash all over the sky, starting at the horizon. The paint flows over the damp area up to the dry edges, then stops. The artist takes care not to get grease from her hands on the paper as this will act as a barrier to water and paint.

FLAT WASH

THE WATERCOLOR WASH IS ONE OF THE BASIC BUILDING BLOCKS OF WATERCOLOR PAINTING, AND THE FLAT WASH IS THE SIMPLEST OF THESE. IT IS THE EASIEST METHOD FOR APPLYING COLOR TO THE PAPER, AND PROBABLY THE VERY FIRST EXERCISE FOR THE BEGINNER IN WATERCOLOR.

BLENDING DAMP WASHES
Company by Denny Bond
The darks of the cows are painted in. An almost but not quite flat wash has been used for the sky—it is slightly lighter and pinker just above the horizon. The background trees were painted while the wash was still damp so that they blend in with no hard edges.

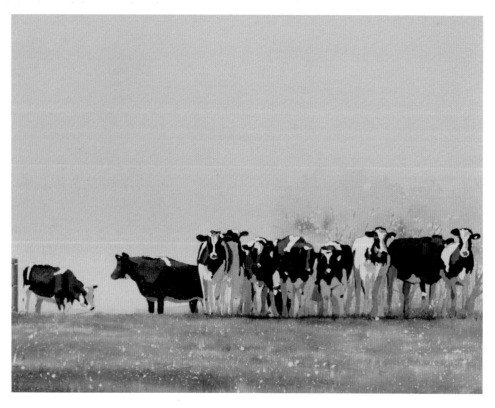

The term "wash" is a rather confusing one, because it implies a relatively broad area of paint applied flatly; however, it is also sometimes used by watercolor painters to describe each brushstroke of fluid paint, however small it may be. Here it refers only to paint laid over an area too large to be covered by one brushstroke.

Before applying a flat wash in watercolor, thinned gouache, or acrylic, the paper is usually dampened to allow the paint to spread more easily. Tilt the board slightly, at an angle of no more than 30°, to allow the brushstrokes to flow into each other—but not so steeply that the paint dribbles down the paper.

Load the brush with paint, sweep it horizontally across the paper, starting at the top, and immediately lay another line below it, working in the opposite direction. Keep the brush loaded for each stroke and continue working in alternate directions until the area is covered.

SUGGESTED APPLICATIONS
• Use for large, flat expanses of color such as skies.
• Apply as a flat base color to work into, wet-on-dry.

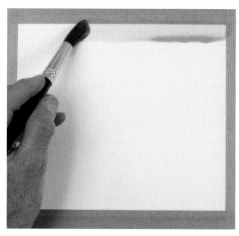

1 Starting with a wide brush, load enough diluted color to make one stroke across the top of the paper. Tilting the board slightly toward you allows the paint to flow downward.

TIPS: PAINTING THE INITIAL WASH

• Choose your brush carefully. A round brush forms a point when wet so should be at least a no.12; a flat brush, such as a hake, will make it easier to get an even result.

• Washes must be applied fast, so mix plenty of paint before you start—you always need more than you think.

• Do not overpaint an area while wet or it will result in an uneven wash.

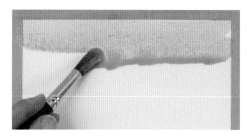

2 Continue down the paper quickly, not allowing the paint to dry between strokes. Work back over uneven lines if necessary to even out any discrepancies in the wash.

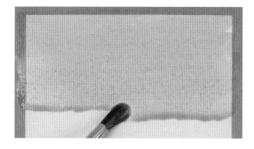

3 Continue down to the base of the paper, tilting the board to encourage even flow of the pigment before it settles.

4 Here the paint has dried to a flat, even finish. Some pigments will granulate and produce a grainy effect. Get to know the paints in your palette before applying them to your painting.

WORKING AROUND INTRICATE SHAPES

Sometimes it is necessary to lay a wash around an intricate shape. You can mask off the shape or you can apply the wash around it. This is easier if you start at the bottom of the picture and work upward, rather than from the top down, so turn your board upside-down before you start. If you are dampening the paper first, dampen it only up to the edge of the shape because the paint will flow into any area that is wet.

SEE ALSO
Stretching Paper, page 27
Masking, pages 70–71
Toned Ground, pages 90–91

USING A SPONGE

Some artists prefer to use a sponge for laying washes. For the most even results, the paper is first dampened with a clean sponge. The sponge is then dipped into the paint before each stroke and dragged evenly from one side of the paper to the other, until the whole surface is covered. Slight streaks where one band of color meets the next will merge as the paint dries. If applied with a sponge, the paint tends not to run down the paper as it can with a brush.

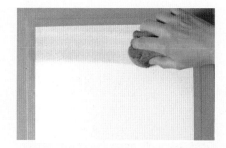

1 A sponge is a useful piece of equipment in watercolor painting. Some artists prefer it to a brush for laying washes. Dampening the paper first gives the best results.

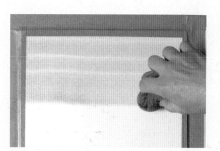

2 Place the board flat to dry. The bands of color will flow together as the paint dries, and any streakiness will disappear.

GRADED WASH

A GRADED WASH IS SLIGHTLY MORE TRICKY TO ACHIEVE THAN A FLAT WASH, BUT IS AN IDEAL TECHNIQUE FOR CONVEYING THE SUBTLE CHANGES OF COLOR AND TONE FOUND IN NATURE.

Colors in nature are seldom flat and uniform. A graded wash, that shifts in tone from dark to light, can give a more realistic effect than an area of flat tone or color.

A graded wash is laid in the same way as a flat wash, the only difference being that more water is added to the pigment for each successive band of paint. It can be difficult to achieve a really even gradation because too much water in one band or not enough in another will result in a striped effect.

When applying a graded wash, keep the paint as fluid as possible so that each brushstroke flows into the one below, and never be tempted to work back into the wash if it does not come out as you wished. If this happens, don't be discouraged—one of the joys of the watercolor medium is its unpredictability; what may at first appear to be a mistake can become one of the defining qualities of the finished picture.

SUGGESTED APPLICATIONS

• Use for large, flat expanses of color such as sky (dark higher up, paler at the horizon) or sea (darker at the horizon, paler toward the shore).

APPLYING THE WASH

1 A graded wash should be applied with a large brush, well loaded with plenty of water and paint. Starting at the top of the paper—where the color will be most intense—a broad band of the paint mixture is applied to the surface. The brush is drawn straight across a couple of times to apply one band of color below the other, as with the flat wash technique. Each new stroke will lift any excess water from the previous stroke.

LAYING A GRADED WASH

France Profond by Roger Pickett

Often, a graded wash is worked vertically, starting with the darkest tone at the top and fading toward the bottom. However, in this painting, the gradation is right to left. The artist first masked out the buildings and foreground, then ran a wash over the sky, with the most intense blue on the right progressively fading to the left. He did not worry too much about getting an even gradation but allowed the paint to dry slightly patchily to suggest subtle cloud shapes.

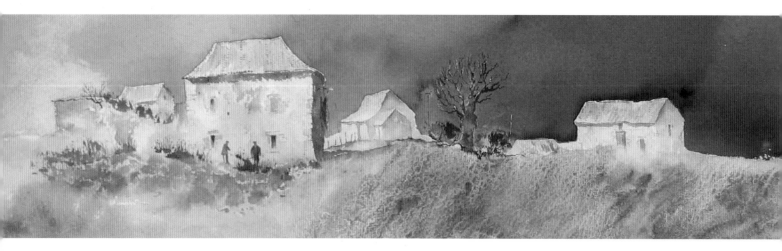

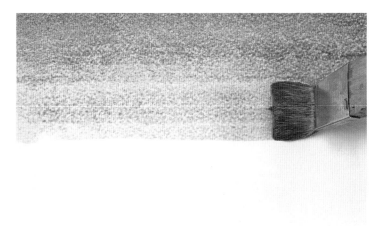

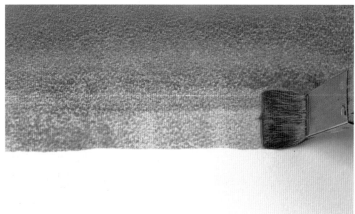

2 The brush is then dipped in clean water (rather than paint), and a band of diluted color is applied below the still-wet previous band.

3 More water is added to the brush for each band of color. Each band will be paler than the one before and will blend smoothly into it.

TIPS: COLOR WASHES

• Because the paint has to become more and more diluted, you will need to have plenty of water on hand for this technique.

• Remember that each wash should be only one step lighter than the previous one, so don't dilute too quickly.

• Don't rinse the brush between bands of color, as this prevents a smooth progression of color flow.

4 The wash is left to dry without working back into it and spoiling the even gradation.

USING A SPONGE

It may be easier to apply a graded wash with a sponge. This gives greater control over the amount of water used in each successive band of color, and thus can give better final results.

SEE ALSO

Stretching Paper, page 27
Flat Wash, pages 36–37

VARIEGATED WASH

A VARIEGATED WASH USES MORE THAN ONE COLOR AND TAKES THE WASH TECHNIQUE ONE STEP FURTHER THAN EITHER FLAT OR GRADED WASHES.

The variegated wash technique is essentially the same as for the other types of wash, but—instead of the single color of the flat wash or the variation in tone of a graded wash—it combines two or more colors. It is less predictable than either flat or graded, but you can achieve very exciting—if unexpected—results by allowing the colors to bleed into each other. Sunset skies are rendered especially well by a variegated wash, starting with blue at the top, blending down into yellow, with orange and red at the bottom. To achieve the effect, sufficient quantities of the colors are mixed on the palette, then applied in bands, one below the other, onto dampened paper. The dampness of the paper does the rest by causing the different colors to bleed into each other.

SUGGESTED APPLICATIONS
• Use for dramatic skies or, using different blues and greens, for expanses of sea.

MAKING LESS SAY MORE
Landscape by Adrienne Pavelka
In her lovely evocation of clouds and hills, Pavelka has deliberately suppressed any detail, letting the large, bold shapes speak for themselves to create a sense of grandeur and drama. She prefers to work on site whenever possible.

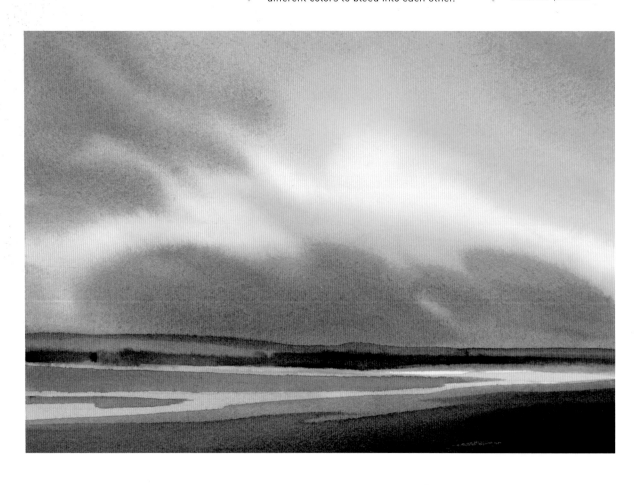

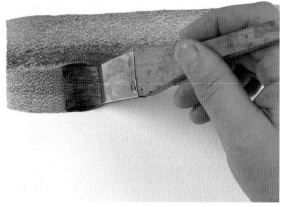

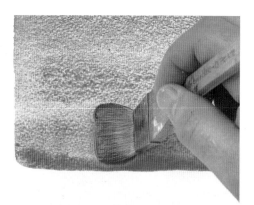

SEE ALSO

Stretching Paper, page 27
Flat Wash, pages 36–37
Graded Wash, pages 38–39

APPLYING THE WASH

1 A large brush is used to apply several bands of a rich Ultramarine to the paper. The color is brushed on wet-in-wet to achieve even coverage.

2 Working quickly wet-in-wet and using a cleaned brush, a band of red is brushed on, overlapping the still-wet blue so that the two colors bleed into each other. Further bands of red are applied, still working wet-in-wet.

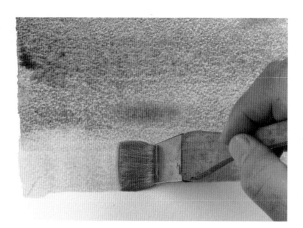

3 The same process is used to lay the third color of the variegated wash. The paint is then left to dry.

4 Three distinct bands of color form this variegated wash, each blending softly into the adjacent color. For a more subtle effect, the colors could be more closely related, for example, a yellow merging into an orange merging into a red.

MIXING PAINT

Have sufficient of each paint color mixed and ready before you begin—the essence of a successful wash is to work quickly so you won't want to have to stop halfway to mix up more paint.

WET-ON-DRY

LAYING NEW, WET WASHES OVER
EARLIER, DRY ONES IS THE
CLASSIC WAY OF BUILDING UP A
WATERCOLOR PAINTING.

Because it is difficult to achieve great depth of color with a preliminary wash, the darker and richer areas of painting are achieved by overlaying colors in successive layers—a technique known as "wet-on-dry." The danger with wet-on-dry is that you can allow too many layers to accumulate and muddy the colors, so if you are working mainly in flat washes, always try to make the first one really positive. It is, of course, equally permissible to paint some parts of a picture wet-on-dry and others wet-in-wet—indeed some of the most exciting effects are achieved by combining the two methods.

In acrylic, wet-on-dry is the most natural way to work since acrylic paints dry very quickly, but gouache—although also fast-drying—presents more of a problem. To work wet-on-dry in gouache, begin by using the paint like watercolor (with water but no white) and gradually build up to thicker layers. One thick layer over another will result in a dull, muddy effect.

SUGGESTED APPLICATIONS
• Work wet-on-dry where you want to build up richer tones.
• Use where you want to bring greater definition and sharpness to parts of a painting.

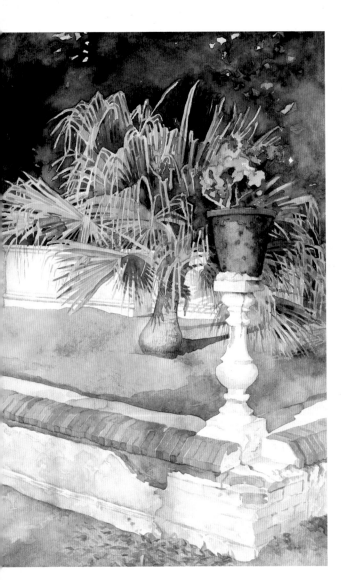

DRYING

One of the more irritating aspects of watercolor work is that of having to wait, sometimes for long periods, for paint to dry before the next color is added. When working wet-on-dry, it is perfectly permissible to use a hairdryer to hasten the process (see page 34). However, avoid using it on really wet paint because you may find you are blowing a carefully placed wash all over the paper.

LEADING THE EYE
Garden Things by Moira Clinch
In a sensitive response to the watercolor medium, Moira Clinch has cleverly combined wet-in-wet with wet-on-dry. To lead the eye to the top third of the painting, with the brilliant blue and red of the pot and geraniums, and the light, spiky foliage, she has created crisp edges, while the lower part of the picture has been painted selectively wet-in-wet.

PAINTING THE WASHES
1 A bright yellow wash is laid down over the outline of the bird. While still wet, the edges of the painted area are feathered with a damp brush, pulling the paint to create varying degrees of transparency. When completely dry, washes of translucent orange are laid over the yellow.

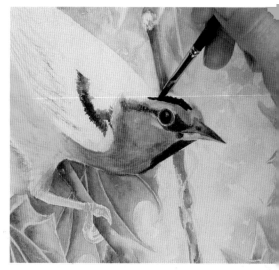

ADDING SHAPES

2 The spaces between the leaf veins are painted with a combination of green, translucent orange, and lemon yellow. The hard edges that define the leaf shape are retained, but the edges along the veins are lightly feathered.

3 The blue sky background is created by applying irregularly shaped dabs of cerulean blue: some edges of the blue dabs are pulled with a clean damp brush, leaving a few hard edges and some unpainted areas. Note how the graded washes and areas of unpainted white paper create depth.

ADDING FINE DETAILS AND TEXTURES

4 To maintain crisp edges, black and other deep-value colors should be painted onto a dry surface to prevent them from bleeding into adjacent colors. Small areas of color and fine details are worked with a short-bristled, flat brush. Here, black mixed from green and crimson was brushed on with short strokes to depict the fine texture of the bird's feathers.

5 Fine strands of grass, string, and horsehair make up the nesting material. A long, flexible rigger brush is ideal for applying wet paint in fine lines and squiggles. Any masking fluid that was applied in the nest area before the painting was begun is removed at this stage.

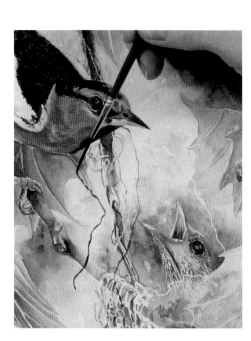

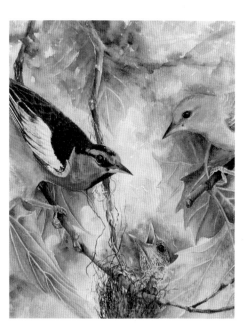

6 A rigger and a No.2 round brush are used to further define the strands of nesting material. The versatility of wet-on-dry technique allows the artist to obtain saturated colors next to thin washes. Sharp edges bring the subjects forward while softened edges retreat into the background.

SEE ALSO

Wet-in-wet, pages 44–45
Brushwork, pages 64–65

WET-IN-WET

THIS IS A TECHNIQUE THAT IS ONLY PARTIALLY CONTROLLABLE, BUT IT IS A VERY ENJOYABLE AND CHALLENGING ONE FOR PRECISELY THIS REASON, ALLOWING THE WATERCOLOR ARTIST TO TAKE ADVANTAGE OF THE "HAPPY ACCIDENTS" THAT RESULT.

Working wet-in-wet means exactly what its name implies—applying each new color without waiting for earlier ones to dry, so that they run together with no hard edges or sharp transitions. Any of the water-based media can be used, providing no opaque pigment is added, but in the case of acrylic, it is helpful to add retarding medium to the paint to prolong drying time.

The paper must first be well dampened and must not be allowed to dry completely at any time. This means, first, that you must stretch the paper (unless it is a really heavy one of at least 200lb/400gsm); and second, that you must work fast. An alternative method is to drop color into a wash that is still very wet so that the wetness of the paint itself allows the new color to spread.

Paradoxically, when you keep all the colors wet, they will not actually mix, although they will bleed into one another. Placing a loaded brush of wet paint on top of a wet wash of a different color is a little like dropping a pebble into water; the weight of the water in the new brushstroke causes the first color to pull away.

The danger with painting a whole picture wet-in-wet is that it may look altogether too formless and undefined. The technique is most effective when it is offset by edges and linear definition, so when you feel you have gone as far as you can, let the painting dry, then take a long, hard look at it and decide where you might need to sharpen it up.

SUGGESTED APPLICATIONS
• Use the soft, loose forms to suggest flowers, foliage, and tree shapes.
• Wet-in-wet also works well for billowing cumulonimbus cloudscapes.

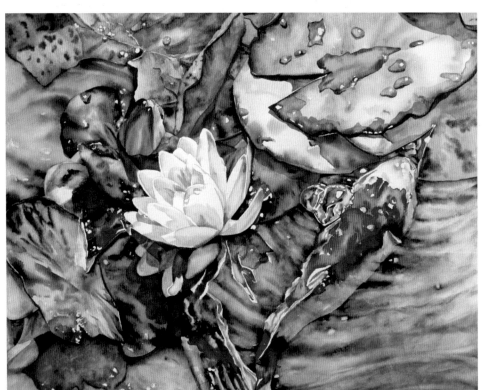

SELECTIVE WET-IN-WET
Julie by Sally Robertson
In all her paintings, Robertson works wet-in-wet within carefully defined areas, and this painting is no exception. In the water, a rainbow of freely applied colors capture the movement and suggestion of fish below the surface. The lily and the bubbles were painted wet-on-dry.

EXCESS PAINT

If the color runs too much, or bleeds into an area where you don't want it, you can gently lift out the excess color with a dry brush, cotton bud, or tissue (see Lifting Out, pages 56–57).

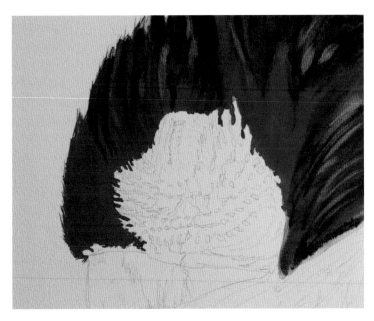

2 A wash of yellow-green is flowed in over the background. The artist works quickly to achieve an even effect. This process needs care as the more paint there is on the brush, the more will transfer to a wet surface, leading to some large, unwanted patches of color. When a narrower area is to be painted, dabbing the brush onto a paper towel first will remove some of the excess paint and make it possible to work more precisely.

APPLYING THE FIRST WASH

1 Having completed a detailed drawing showing the patterning of the plumage, and with the board tilted at approximately a 30° angle, the artist applies a wash to the head of the parrot, then adds shading and definition, working wet-in-wet so that the colors blend and blur. The brighter color is applied with a repeating side-to-side, top-to-bottom brushstroke. The remaining plumage is painted in the same way.

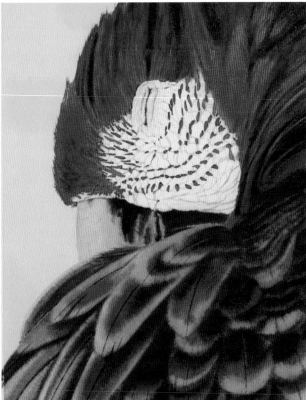

4 The artist continues working over the painting to complete the details. Note how the wet-in-wet technique gives a beautifully soft effect on the breast feathers.

3 The shadows and outlines of the feathers need to be soft and blurry, not hard-edged. Even if the underlying wash has already dried, it is possible to rewet the surface and work wet-in-wet, as here, to achieve the required effect.

SEE ALSO

Lifting Out, pages 56–57

BLENDING

TO ACHIEVE A SOFT, GRADUAL TRANSITION FROM ONE COLOR OR TONE TO ANOTHER, THE WATERCOLOR ARTIST CAN CHOOSE FROM A NUMBER OF DIFFERENT TECHNIQUES.

> SEE ALSO
>
> Wet-in-wet, pages 44–45
> Dry Brush, pages 68–69

BLENDING WITH SMALL STROKES

Plums in a Dish by Ronald Jesty
In this painting, the artist has dabbed on a number of different colors so that they blend subtly into each other, to convey the rich and complex coloring of the plums and their rounded shapes. In contrast, the shadows beneath have been allowed to form hard edges.

Blending colors or tones is a slightly trickier process with water-based paints than with oil paints or pastel, because watercolor paint dries more quickly. One option is to work wet-in-wet, keeping the whole area damp so that the colors flow into one another. This a lovely method for rendering amorphous shapes such as clouds, but is less suitable for precise effects, such as those you might need in portraits, because you cannot control the medium sufficiently—you might, for example, find that a shadow intended to define a nose spreads haphazardly out across the cheek.

To avoid the hard edges where a wash ends or meets another wash, brush or sponge the edge lightly with water before it is dry. To convey the roundness of a piece of fruit, for example, use the paint fairly dry, applying it in small strokes rather than broad washes. If unwanted hard edges do form, they can be softened by "painting" along them with a small sponge or cotton swab dipped in a little water.

The best method for blending acrylics is to keep them fluid by adding retarding medium.

This allows for very subtle effects, as the paint can be moved around on the paper.

Opaque gouache colors can be laid over one another to create soft effects, though the danger is that too much overlaying of wet color muddies the earlier layers. One way to avoid this is to use the dry-brush technique, applying the paint thickly with the minimum of water.

SUGGESTED APPLICATIONS
• Use to create soft effects in amorphous shapes such as clouds.
• Use to create a sense of three-dimensional form and definition, for example, in portraits or still lifes.

WETTING THE PAPER
1 First, an entire petal area is wetted with clear water.

2 While the paper is wet, yellow is painted on the interior of the petal and allowed to bleed out toward the edges. Gold is then added to indicate the shadowed center of the petal.

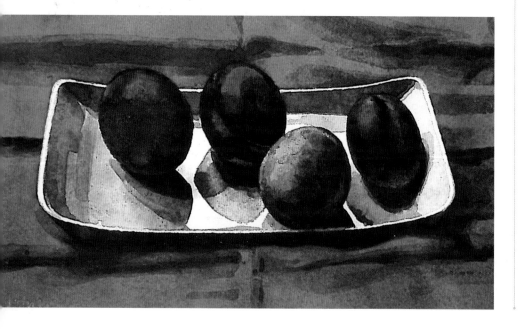

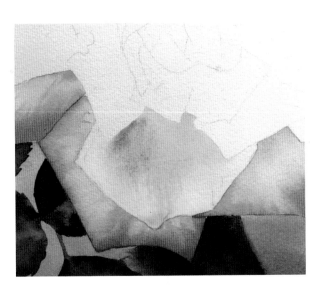

TILTING THE PAPER

3 The paper is tilted downward so that the colors can further blend into each other, while flowing to the outside.

4 While still wet, deep pink is added to the outside edges of the petals. The paper is turned around to let the pink bleed into the petal interior, pulling the color into the clear water that was initially laid onto the paper.

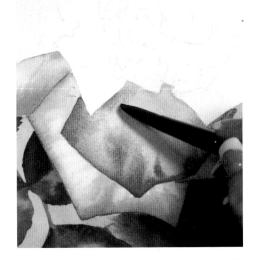

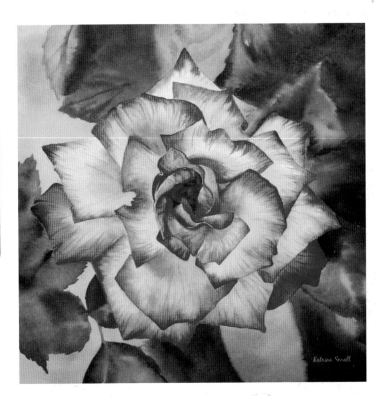

ADDING THE FINISHING TOUCHES

5 Once the paint is dry, the edges of the petal are re-wet and then once again saturated with deep pink. As the new layer of paint dries, petal lines are very lightly painted in using a fine brush.

6 The petal is nearly finished. Final touches include lifting out color with a cotton swab where highlights are needed.

7 The remaining petals are worked in the same way. The hard edges of the petals contrasting with the soft blending on their inner surfaces, along with the blurry background, really make the rose stand out.

Katrina Small

HARD EDGES

ONE OF THE DEFINITIVE QUALITIES OF WATERCOLOR IS ITS TENDENCY TO FORM A HARD EDGE, RATHER LIKE A TIDEMARK, WHEREVER IT MEETS A DRY SURFACE. THIS QUALITY IS ONE OF THE CHARMS OF THE MEDIUM.

A wet watercolor wash laid on dry paper forms a shallow pool of color that, if left undisturbed, will form hard edges as it dries. This can be alarming to the novice, but it is one of the characteristics of the medium that can be used to great advantage. By laying smaller, looser washes over previous dry ones, you can build up a fascinating network of fluid, broken lines and shapes that not only help to define form but give a sparkling quality to the work. This is an excellent method for building up irregular, natural forms such as clouds, rocks, or ripples on water.

You will not necessarily want to use the same technique in every part of the painting. A combination of hard and soft edges describes the subject more successfully and gives more variety. Soft edges can be created by working wet-in-wet; using a sponge, paintbrush, or cotton swab dipped in clean water to remove excess paint; or by dragging or pulling a wash over dry paper with either a brush or sponge, which will prevent the paint from pooling and drying to a hard edge.

SUGGESTED APPLICATIONS
• Use for foliage, clouds, ripples on water, or wherever a strongly textural effect is required.

SEE ALSO

Backruns and Blossoms,
pages 52–53

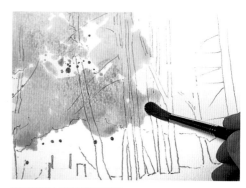

PAINTING THE FOLIAGE

1 The artist starts with a light pencil drawing to act as a guide for a painting of a forest. He then begins to drop in color for the foliage, applying wet washes to dry paper and leaving the paint to dry naturally and form hard, ragged edges.

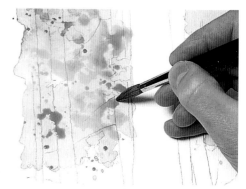

2 Drops of additional color are applied on top, and again left to dry to create a patchy texture reminiscent of foliage.

EXPLOITING HARD EDGES

The natural tendency of watercolor to form hard edges can be exploited for graphic effect, as shown in these two still-life paintings of the same subject. The first painting uses a more traditional approach, with softly blended colors and tones. In the second painting, the artist has chosen to create an almost collage-like impression with her use of hard edges, strong shapes, and dramatic tonal contrasts.

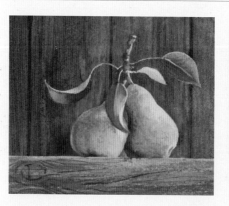

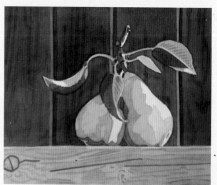

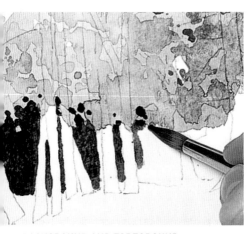

BACKGROUND AND FOREGROUND

3 When the foliage is dry, the artist carefully paints in the background, using the pencil outlines as a guide.

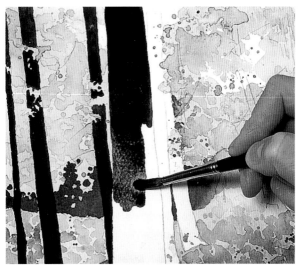

ADDING THE FINAL TOUCHES

5 When the other parts of the painting are dry, the artist fills in the trunks and branches with a solid, dark color that contrasts well with the filtered-light effect of the foliage.

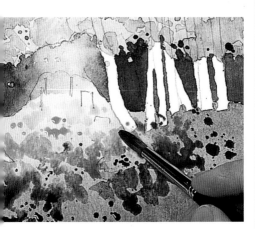

4 After painting in a base color for the foreground and leaving this to dry, the same technique used for the foliage is applied. Spots of different browns are dropped in and left to form hard edges suggestive of the leafy woodland floor.

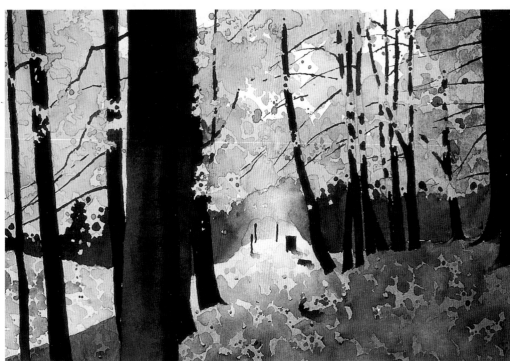

6 The finished picture demonstrates how effective this simple technique can be in conveying the texture of leaves. The solid trunks offer a contrast and accentuate the foliage effect.

GLAZING

BUILDING UP COLOR AND TONE BY OVERLAYING TRANSPARENT WATERCOLOR WASHES IS SOMETIMES REFERRED TO AS "GLAZING," AS IF IT WERE A SPECIAL TECHNIQUE—IN FACT, IT IS THE NORMAL WAY OF WORKING WITH THIS MEDIUM.

SEE ALSO
Wet-on-dry, pages 42–43

Glazing is a technique that was perfected by the early painters using oils. They would lay thin skins of transparent pigment one over the other to create colors of incredible richness and luminosity.

Watercolor is noted for its transparency and this makes it highly suited to glazing. Layers of transparent washes allow the white paper underneath to "shine" through, and it's this that gives watercolor its characteristic luminosity. The effects created by the technique are quite different than those of color applied opaquely, because light seems to reflect through each layer, creating the illusion that the painting almost is lit from within.

As well as traditional watercolor, acrylic paint is perfectly suited to the glazing technique. When glazing, each layer must be thoroughly dry before the next one is applied and acrylic has the advantage of drying fast.

Special media are sold for acrylic glazing—available in both gloss and matte—and these can be used either alone or in conjunction with water. A whole painting can be built up layer by layer in this way.

SUGGESTED APPLICATIONS
• Apply glazes wherever you want to build up color and tone without obscuring the brightness of the paper underneath.
• Use to "mix" color directly on the paper—think of your glazes as a tissue paper collage where each new layer alters the color of the underlying layer.

GLAZING OVER IMPASTO

Thin glazes can also be laid over an area of thick paint ("impasto") to great effect. The glaze will tend to slide off the raised areas and sink into the lower ones—a useful technique for suggesting textures, such as those of weathered stones or tree bark.

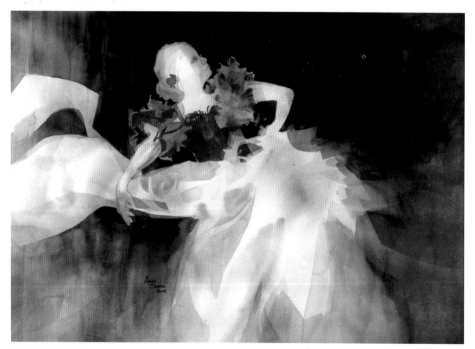

LAYERING COLOR
Dancer by Ann Smith
Smith's lovely image owes much of its impact to the combination of wet-in-wet and overlays of glazed color, which give depth to each area. It was begun more or less as an abstract, with splashes of transparent color, but once the figure of the dancer began to emerge the artist "drew in" her face and arms more carefully.

COLOR PREPARATION
Transparency is the key characteristic to bear in mind when glazing so it is advisable to do some color preparation on a separate piece of paper before starting a painting. Judge the transparency of your chosen colors by layering them over one another in a test strip.

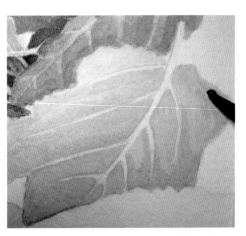

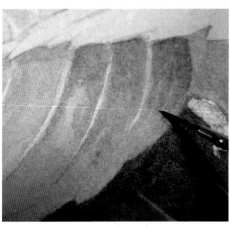

WORKING LIGHT TO DARK

1 Glazing relies on the application of successive layers of watercolor to develop color, tone, and intensity. It should be done slowly, and gradual changes made until the desired effect is achieved. A smooth, cold-pressed paper will hold many layers of paint satisfactorily but a soft brush and a light hand is required to avoid disturbing previous layers of paint. It is important to work from light to dark so that the highlights and lightest tones are first established.

2 Color is built up on the paper by applying thin washes of transparent color. Here, layers of blue and yellow are applied to a green leaf until the desired tonal values of green are reached.

STAINING PIGMENTS

3 Another property which may be considered when glazing is staining quality. Synthetically produced dye pigments such as Quinacridones will generally stain the paper while those made from metallic oxides and salts such as the Cadmiums will sit in a layer on the surface. Using diluted staining pigments initially may allow more layers to be added as they are less likely to be removed by subsequent applications.

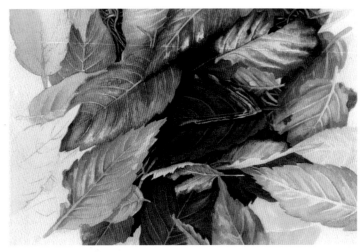

4 The shadowy areas between the leaves and on the darker colored leaves are painted by layering blue and violet over maroon, gold, and yellow to produce rich, dark areas of color.

ACHIEVING MUTED TONES

5 Applying light, bright layers initially allowed the white paper to glow through the paint producing vibrant colors, which add a jewel-like quality to the subject. Muted tones can be achieved by glazing complementary colors over one another, such as yellow over violet, or by layering more opaque colors for a flatter finish.

BACKRUNS AND BLOSSOMS

BACKRUNS FORM NATURALLY AND ARE A QUIRKY CHARACTERISTIC OF THE WATERCOLOR MEDIUM. BOTH A NUISANCE AND A DELIGHT TO PAINTERS, THEY CAN BE TREATED AS MISTAKES OR EXPLOITED TO THE ARTIST'S ADVANTAGE.

If you lay a wash and apply more color into it before it is completely dry, the chances are that the new paint will seep into the old, creating strangely shaped blotches with hard, jagged edges. These "backruns" are also sometimes called "cauliflowers" or "blossoms" because of their organic, flower-like appearance. They do not always occur, however; the more absorbent or rough-textured papers are less conducive to the formation of backruns than smoother, highly sized ones.

If you don't want a backrun and one does form, the only remedy is to wash off the entire area and start again. With practice it is possible to avoid them completely. However, many watercolor painters create backruns deliberately, both in large areas such as skies or water, or in small ones such as the petals of flowers, since the effects they create are unlike those achieved by conventional brushwork. For example, a realistic approximation of reflections in gently moving water can be achieved by lightly working wet color or clear water into a still-damp wash. The paint or water will flow outward, giving an area of soft color with the irregular, jagged outlines so typical of reflections.

SUGGESTED APPLICATIONS

• Use to suggest organic forms, such as blocks of foliage, flower shapes, or cumulus clouds.
• Backruns also work well for irregular, hard-edged shapes, such as reflections in water.

APPLYING INITIAL WASHES
1 The artist drops Rose Madder, Dioxazine Violet, Naples Yellow, and Winsor Blue onto wet paper and allows the colors to blend.

ABSTRACT SHAPES
Elementals No. 18 by David Castle
Based on a geometric framework, each shape is measured and drawn with a pencil and ruler, then painted wet-on-dry. Next, varying amounts of paint and water were dropped in to form "blooms" or backruns. While still wet, additional colors were dropped in to give more depth and interest.

WHEN TO ADD PAINT

It takes a little practice to be able to judge how wet or dry the first wash should be before adding more paint or water to create a backrun. As a general guide, if there is still a sheen on the wash it is too wet and the colors will merge together without forming a backrun, as they do when working wet-in-wet.

DROPPING IN WATER AND COLOR

2 While the color is still wet, the artist drops clear water from a clean brush into the paint. The water carries the pigment to the edge of the droplet as it continues to spread.

GRANULATION

Certain colors have a tendency to granulate—separate on the paper to create a spotty, grainy texture, rather like the mottling you might see in certain kinds of stone. Using these pigments when creating backruns can add further surface interest and texture.

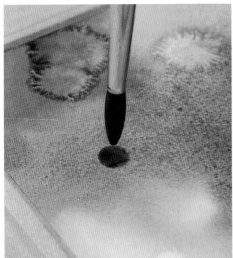

3 Continuing the method, the artist drops some Dioxazine Violet into the still-damp Rose Madder and the Winsor Blue, and then sits back and watches the paint spread.

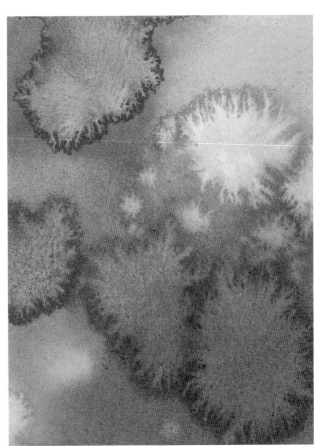

4 Once dry, the painting shows the blossoms and florets with the concentration of pigment around the edges. Smaller splashes have made smaller blossoms.

SEE ALSO

Wet-in-wet, pages 44–45
Hard Edges, pages 48–49
Granulation, pages 60–61

FEATHERING AND MOTTLING

BOTH FEATHERING AND MOTTLING EXPLOIT WATERCOLOR'S INHERENT TENDENCY TO BLEED IF THE SURROUNDING SURFACE IS DAMP— BUT WITH DIFFERENT RESULTS.

Working wet-in-wet is a classic watercolor technique but the feathering and mottling methods take this one step further. Instead of washing an entire area with water or paint and allowing the next wash to flow into it before the first wash is dry, these two techniques wet only certain areas, so the paint bleeds in a much more controlled way only where the artist wants it to.

In the case of feathering, bands of clean water are painted across a dry surface— either unpainted paper or a dry wash; then, while these are still wet, bands of a colored wash are laid at right angles across the water. The paint bleeds with a feather-like effect where it touches the water, but dries in hard-edged lines in the gaps in between. This can be a useful technique for rendering linear patterns, such as reflections in water.

The mottling technique is similar, except that the water is added afterward, flicked onto the paint while it is still wet. Because the water is applied in a more random way, the final result is less predictable. But, as with all watercolor techniques, unpredictability is part of the charm and fascination of the medium.

SUGGESTED APPLICATIONS

• Use to convey a stand of pine trees or tracery of branches in a forest canopy.
• Feathering can also work well for reflections in water.
• Mottling is an immensely useful technique for painting woodland trees and branches. It seems to present the labyrinth of tiny twigs exactly as they appear. It would be impossible to paint every little mark, but this rapidly creates instant tree texture.

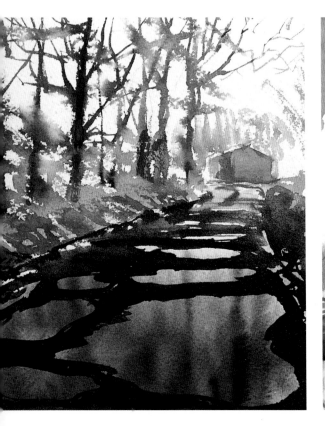

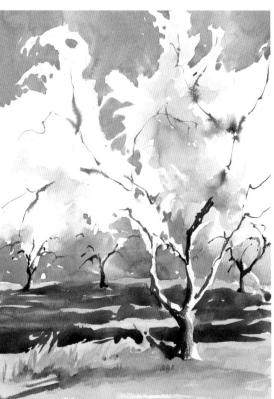

MOTTLED BRANCHES
Country Lane by Joe Dowden
In this painting (far left), the artist demonstrates a deft application of the mottling technique. Rather than attempting to paint every branch in a tight and controlled way, he merely suggests the delicate tracery. The result is loose and lively. The soft, feathery shapes are counterbalanced by the bold, hard-edged shadows in the water below.

SOFTENED COLOR
Spring Ballet by Jan Hart
Washes of delicate color have been loosely applied to the foliage of the tree in the foreground (left), leaving large areas white. A few quick lines have been sketched in for the framework of branches and allowed to bleed in parts to soften them. The whole effect is one of light and movement.

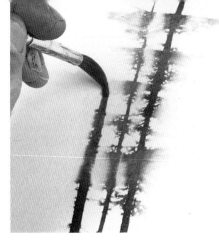

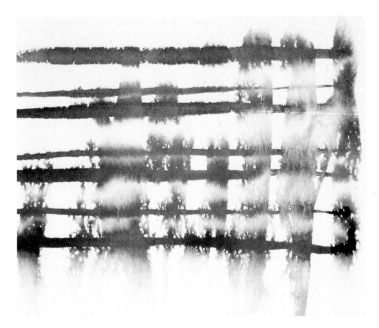

2 While still wet, parallel lines of color are applied at right angles to the strokes of water. As the lines of paint pass across the lines of water, they diffuse sideways, creating a feather-like effect.

FEATHERING

1 First, several strokes of water are dragged loosely across the paper. The strokes are spaced out so that there are gaps between them. Pressing too hard will make the water soak into the paper, so care is needed. The brush needs to be dragged gently but firmly along the surface so that the tooth of the paper "grabs" some of the moisture, while many of the tiny pits and dimples in the surface texture are left dry.

SEE ALSO

Wet-in-wet, pages 44–45
Backruns and Blossoms, pages 52–53
Spraying Water, pages 58–59
Spattering, pages 84–85

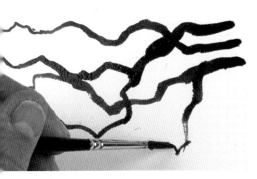

MOTTLING

1 The artist paints squiggly lines in a strong color.

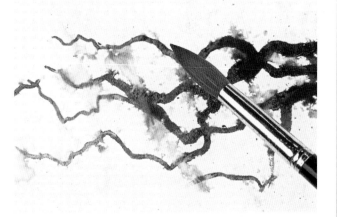

2 Before the lines of paint are dry, he spatters clean water over them by firmly tapping it over his hand and fingers, and letting droplets fly off onto the paper. Where the water hits the paint, the color diffuses outward.

CRISS-CROSS FEATHERING

You can vary the feathering technique by applying the strokes of water loosely at different angles, still leaving plenty of dry paper, to achieve a more random effect.

TIPS: MIXING COLOR

• When feathering, you need to have your colors mixed in sufficient quantity before you begin because the paint needs to be applied quickly before the water dries, or it will not "feather."

• It's important to use a wet, free-flowing mix and rich color for this technique. This will ensure that the original framework of lines remains strong, and does not lose its impact where it is diffused by water.

LIFTING OUT

LIFTING OUT IS NOT ONLY A METHOD OF CORRECTION THAT ALLOWS THE ARTIST TO REMOVE EXCESS COLOR FROM PARTS OF A PAINTING, BUT IS ALSO A USEFUL AND ADAPTABLE WATERCOLOR TECHNIQUE IN ITS OWN RIGHT.

SEE ALSO

Reserving Highlights, pages 74–75
Sponging, pages 82–83
Correcting Mistakes, pages 102–103
Perspective, pages 126–127

A number of different tools may be used to lift out paint. For instance, the effect of streaked wind clouds in a blue sky is quickly and easily created by laying a blue wash and wiping a dry sponge, paintbrush, or paper towel across it while it is still wet. The white tops of cumulus clouds can be suggested by dabbing the wet paint with a sponge or some blotting paper.

Another useful aid to lifting out is gum arabic, which binds watercolor pigments and is also used as a medium. Add it in small quantities to the color you intend to remove partially.

Paint can also be lifted out when dry by using a dampened sponge or other such tool, but the success of the method depends both on the color to be lifted and the type of paper used. Certain colors, such as Sap Green and Phthalocyanine Blue, act rather like dyes, staining the paper, while some papers absorb the paint, making it hard to move it around. Heavier-weight cold-pressed and rough papers are more robust and can take more punishment, and thus are excellent for lifting out in this way.

SUGGESTED APPLICATIONS
• Use to soften edges, diffuse and modify color, and create those highlights that cannot be reserved.
• Use to blur background areas so that they appear to recede, thus creating the illusion of three-dimensional depth (see Spatial Depth, pages 128–129).

INITIAL LIFTING OUT
1 A loose, uneven wash is laid down for the sky. While the paint is still wet, cloud shapes are lifted out by pressing firmly with paper towel.

CHOOSING TOOLS

When lifting out large areas of dry paint, a dampened sponge works well. However, for smaller areas or more intricate work, a more precise tool is needed. Choose your tool for lifting off with your subject in mind.

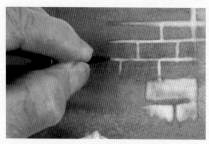

• A clean no.6 brush can be used to lift out lines and here, it is used to suggest the shape of bricks in a wall.

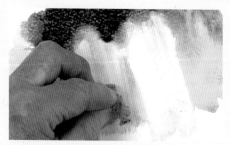

• Use a natural sponge and wipe downward with a strong movement to make rays of light.

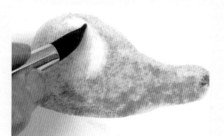

• A clean, wet brush is used to lift off paint and create soft highlights.

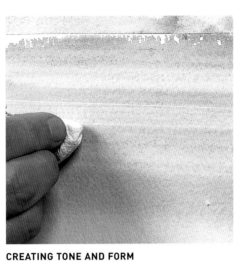

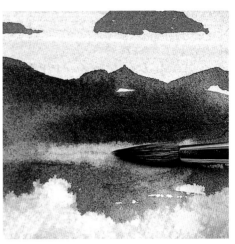

2 By varying the pressure applied, different amounts of color can be removed. The paper towel can also be rolled to a point to lift out fine detail, as shown here.

CREATING TONE AND FORM

3 A pale wash is applied for the sea. A piece of paper towel is then dragged across the damp wash to create varying bands of tone and color. The paint is left to dry.

4 The distant headlands are painted in a gray-blue wash and the hills in the foreground in a deep green. Paper towel is again used to blot up some of the color in the foreground to suggest forms in the landscape.

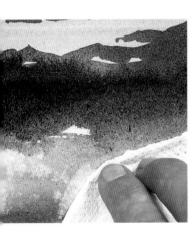

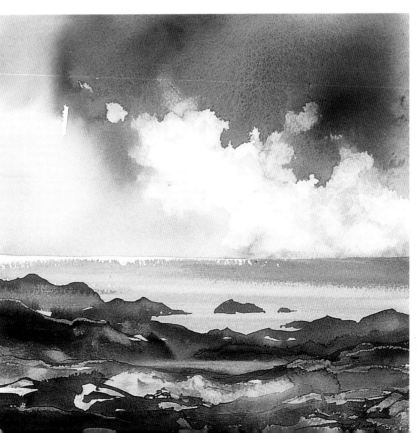

6 By restricting the palette to somber blues and greens, the artist has given the painting an overall unity. When seen as a whole, it does not lack drama however, due to the powerful contrasts in tone and texture that lifting out can produce.

5 While the paint is still damp, a clean, dry brush is used to lift out color in the middle distance to suggest a flat area between the hills.

SPRAYING WATER

THIS TECHNIQUE IS SIMILAR TO DROPPING IN CLEAR WATER TO CREATE BACKRUNS, BUT INVOLVES USING A SPRAY BOTTLE OR DIFFUSER TO ACHIEVE A MUCH MORE SUBTLE SPECKLED EFFECT.

Watercolor is a highly flexible medium, allowing the artist to create a wide range of effects. All depend on the way in which the paint interacts with water—as well as how much or how little water is involved. Spraying a wash with water is another way of manipulating the medium and taking advantage of its natural tendency to spread when wet. However, because the drops of water are small the effect is much more understated than with, say, backruns or other similar techniques—it is effectively a way of distressing the surface to produce a texture.

WHEN TO SPRAY

Timing is crucial with this technique—spray when the paint is still damp but has lost its surface sheen. If you spray while the area is still too wet, the water droplets will merge into the paint without leaving a mark.

LAYING WASHES
1 Working wet-in-wet, the artist adds washes of several different colors to the paper and lets the colors blend together.

SPRAYING THE DAMP PAINT
2 While the paint is still damp, water is sprayed onto it in short bursts from a bottle.

3 When the paint is dry, a random pattern of tiny watermarks is visible.

GRANULATION

ALTHOUGH NOT STRICTLY A TECHNIQUE IN ITS OWN RIGHT BUT PART OF THE BEHAVIOR OF CERTAIN COLORS, GRANULATION CAN NEVERTHELESS BE USED BY THE WATERCOLOR ARTIST TO GREAT EFFECT.

With some colors, pigment particles attract each other to produce a grainy effect called granulation. What may look like an alarming mistake to a novice—and one that must be corrected immediately—is appreciated by the more experienced painter as one of the delights unique to this medium, to be preserved and enjoyed. The texture produced by granulation is often very beautiful and can enhance a painting.

Granulating colors include several of the blues—Ultramarine, Cobalt, Manganese, and Cerulean—as well as Viridian, Raw Sienna, and Raw Umber. If the name on the label is followed by the word "hue," that color may not granulate as well.

As an experiment that will produce an interesting two-tone texture, a granulating color may be mixed with one that does not granulate well, for example, granulating Manganese Blue with non-granulating Alizarin Crimson.

SUGGESTED APPLICATIONS

• Exploit granulation to convey organic textures, such as those of masonry or stone.
• Use areas of granulation as a counterpoint and contrast with flat paint.

EXPLOITING DIFFERENT TECHNIQUES
Brittany Skyline by Roger Pickett
To build up the textures, Pickett has given himself a start by working on rough paper. The foreground was worked over a high-toned wash, and when dry, more paint was applied, mixed with granulating fluid, and the board was tilted to channel the granulation in various directions. Darker details were added first with a brush and then a sharpened twig, used to draw lines into the wet paint.

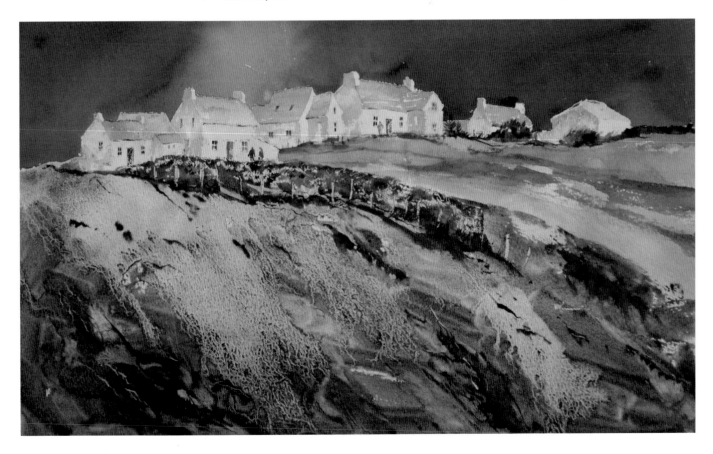

GRANULATION FLUID

Granulation fluid is a watercolor medium developed to make all colors granulate, if wished. It may be used straight or diluted with water, then mixed with the paint.

BRUSHING IN THE FIRST WASHES
1 The artist starts by brushing in a pool of Alizarin Crimson, followed by an overlapping pool of Manganese Blue (right).

GRANULATING COLORS

This selection of granulating paints shows how the pigments settle on the watercolor paper. Don't be alarmed by this uneven appearance; it is normal and can be used to great effect in your painting.

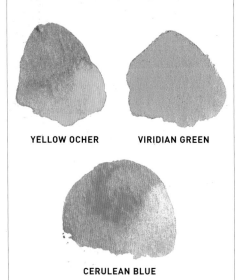

YELLOW OCHER **VIRIDIAN GREEN**

CERULEAN BLUE

APPLYING A GRANULATING MIX
2 He then flows in an Alizarin-Manganese mix in the middle.

CHOOSING PAPER

For the best effect and maximum granulation, use a rough paper.

3 When the paint is dry, the effect is clearly visible. The Alizarin to the left has not granulated but the mixed violet in the middle and the Manganese to the right have clearly granulated, producing that distinctive texture.

INCREASING GRANULATION

The amount of granulation you can expect to see varies according to the texture of the paper, the amount (and type) of water used, and the nature of the pigment itself. Although some pigments granulate on smooth, hot-pressed papers, the effect is increased if you use textured paper, as shown here. Mixing a particular color with distilled water can also increase its granulation.

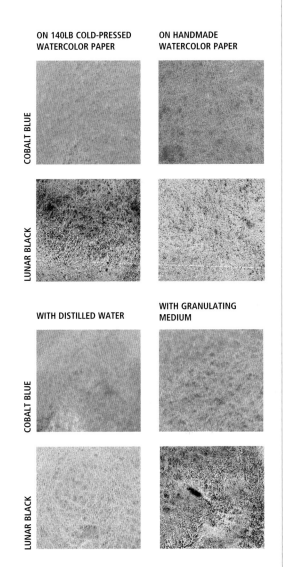

ON 140LB COLD-PRESSED WATERCOLOR PAPER

ON HANDMADE WATERCOLOR PAPER

COBALT BLUE

LUNAR BLACK

WITH DISTILLED WATER

WITH GRANULATING MEDIUM

COBALT BLUE

LUNAR BLACK

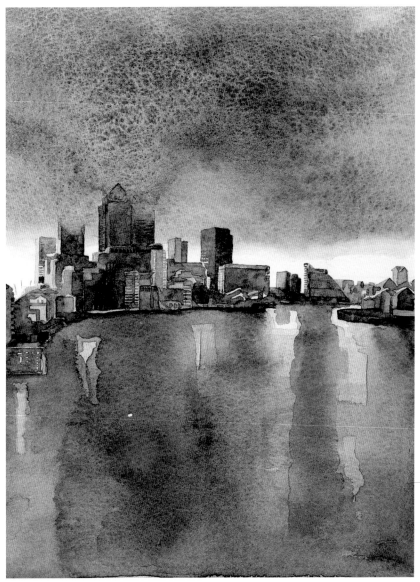

EXPLOITING GRANULATION
The Sky and the Water by Moira Clinch
In this wonderfully atmospheric painting, granulation has been deliberately induced in the sky area so that it has an almost solid presence. The water has been treated more smoothly, with carefully reserved highlights linking it to the sky and buildings above.

SEE ALSO

Backruns and Blossoms, pages 52–53
Feathering and Mottling, pages 54–55
Running In, pages 62–63
Spattering, pages 84–85

RUNNING IN

THIS IS A SIMILAR TECHNIQUE TO CREATING BACKRUNS, BUT THIS TIME THE BOARD IS TILTED TO ALLOW GRAVITY TO ACT ON THE PAINT.

FLOWING IN COLOR
Broad Sunlit River by Joe Francis Dowden
To convey the reflections of the trees in the water, the artist needed to flow color, rather than water, into the painted surface of the river. Working wet-in-wet and using Cadmium Lemon, Burnt Sienna, Payne's Gray, and other pigments, he allowed the lines of color to diffuse and spread to create the blurry reflections.

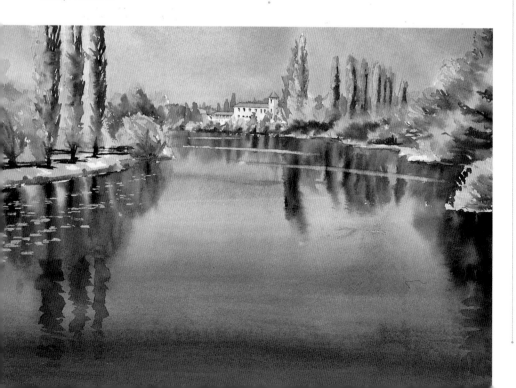

The difference between backruns and running in is that in the case of backruns the wet paint is allowed to spread in whatever direction it naturally wants to go, carrying a "tidemark" of pigment with it; with running in, the direction in which the water or wet paint runs is controlled by lifting the board so that the water or paint runs downward.

Running in has a limited number of applications compared with other watercolor techniques, but it's worth knowing nevertheless—watercolor is an incredibly flexible medium, offering the artist a wider range of effects than perhaps any other painting medium, so it's good to be aware of every option. If this technique is controlled carefully and the wetness of the wash judged correctly when the water is dropped in, the final effect can be subtle and pleasing.

The soft, vertical forms created by running in are suggestive of reflections in water, and could also be used to convey wet surfaces such as sidewalks. Carefully controlled, it could express the highlights on a shiny, cylindrical object.

SUGGESTED APPLICATIONS
• Use the running-in technique wherever you want soft, vertical forms, for example, to convey reflections in water or the highlights on straight-sided, cylindrical objects such as vases.

LAYING A WASH
1 A flat wash is laid down on the paper.

RUNNING IN WATER
2 While the wash is still wet, the board is held upright and a brush holding clean water is touched to the top. The water runs down, carrying the pigment with it.

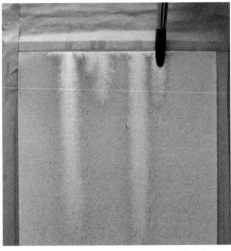

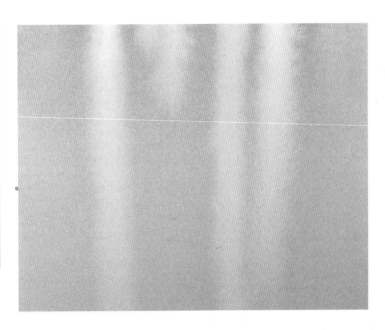

4 After the paint has dried, soft-edged passages of lighter color are left within the wash.

3 More drops of clear water are touched to the top of the still-wet paint.

DROPPING IN COLOR

Drop a color into a wet area and allow it to react as its nature determines. It may diffuse, feather, bleed, creep, drop, or shoot, depending on the introduced pigment and the density of the receiving wash. In these examples, Carbazole Violet (Dioxazine), a concentrated, dark organic pigment, receives inorganic and organic pigments very differently. Because of this unpredictability, experiment first on scrap paper before committing dropped-in color to your painting.

NICKEL AZO
If Nickel Azo is introduced into a lighter-weight wash, it shoots wildly. If the receiving wash is not wet enough, it drops to the paper.

COBALT VIOLET
This granulating pigment dives for the paper.

CADMIUM ORANGE
This heavy pigment dives in and spreads out into the lower layers of the wash, altering the color.

PERYLENE MAROON
This pigment appears to fuse with the wash it enters.

ULTRAMARINE BLUE
This pigment displays a ghostly, soft infiltration.

QUINACRIDONE GOLD
This displays a feathery edge in the Carbazole wash.

RUNNING IN COLOR

Instead of running in clear water, you could run in a wash of another color, wet-in-wet, tilting the board so that the color runs downward and diffuses into the underlying wash.

SEE ALSO

Backruns, pages 52–53
Feathering and Mottling, pages 54–55

BRUSHWORK

KNOWING WHICH BRUSH TO CHOOSE
FOR THE TASK IN HAND, AND HOW
TO HANDLE IT, CAN MAKE THE
WATERCOLORIST'S JOB THAT MUCH
EASIER—AND ENSURE GREATER
SUCCESS IN THE FINISHED WORK.

There's a common belief that brushwork is important only in oil painting. Watercolors are painted in gentle, flat washes, aren't they, with no obvious brushmarks? Well, yes and no. You can paint entirely in washes, as with wet-in-wet, where you certainly can't see any marks. But the marks a brush makes can be quite expressive, so it seems a pity not to make use of this resource. Some watercolorists build entire paintings by drawing with their brushes, using few, if any, flat washes, as in classical Chinese painting with its almost calligraphic brushstrokes.

Watercolor brushes come in all shapes and sizes and it is worth exploring the wide variety available, as well as learning what kinds of marks individual brushes can make. Wide, flat brushes are designed to make wide, flat marks, and are good for laying washes. Round brushes are perhaps more versatile, depending on how they are used. A fine to medium round brush can make broader marks if you apply more pressure, whereas if only the point is lightly touched to the paper, a fine line will be produced.

Always have more than one brush on hand, and when making marks be sensitive to what you are trying to convey—short, criss-crossing marks can suggest the texture of foliage; fine, zigzagging strokes are perfect for the reflections of trees in water.

SUGGESTED APPLICATIONS

• Let the shape of the brushmarks suggest their use. For example, drybrush done with a flat brush creates a texture reminiscent of the textured surfaces of wood and rocks. "Dancing" brushstrokes are good for foliage and vegetation.

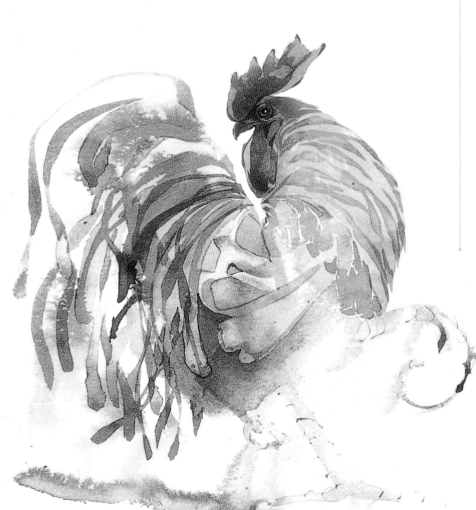

RESPONDING TO THE SUBJECT
Matador by Mary Ann Rogers
This painting demonstrates the artist's superb command of the watercolor medium. Her sensitivity to her subject is seen in the way in which she has varied her brushstrokes in response to the patterning and movement of the bird's plumage.

"DANCING" BRUSHSTROKES

1 To create dancing brushstrokes with a flat brush, the loaded brush is applied, edge-on, to the paper and swept either up or downward.

2 Though the brushstrokes are not as varied in width, a round brush makes very consistent, narrow, pointed "dancing" linework.

DRYBRUSH

1 To work the drybrush technique with a flat brush, a very lightly loaded brush is held nearly parallel to the surface and moved quickly across the paper. Some paint is released onto the raised areas, creating a scumbled effect.

2 A round brush works as well as a flat one for drybrush.

GRIP AND PRESSURE

How you hold your brush, and the pressure you exert, can alter your brushstrokes.

• Brush held almost upright; a light stroke made with tip

• Brush slanted, with pressure reduced at the end of the stroke

TWO-COLOR STROKES

This technique is possible only with a flat brush. Load one edge of a flat brush with one color, then load the other edge with a different color, and make dancing brushstrokes.

• Brush held near the top, with light pressure

• Brush twisted in mid-stroke

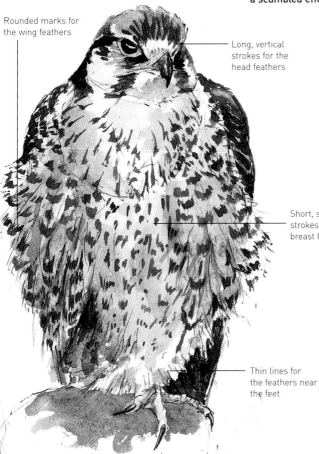

Rounded marks for the wing feathers

Long, vertical strokes for the head feathers

Short, straight strokes for the breast feathers

Thin lines for the feathers near the feet

CONVEYING SUBJECTS

Sketchbook Study by David Boys
Here the artist has developed a "language" of brushmarks to describe this bird's feathers. The marks follow the direction of the feathers, and vary in shape and in length from long to short—short, curling brushmarks convey the patterns on the long feathers, and dots and dashes the shorter breast feathers.

BRUSH DRAWING

DRAWING WITH A BRUSH IS AN EXCELLENT WAY TO LOOSEN YOUR TECHNIQUE, REQUIRING NO UNDERDRAWING IN PENCIL.

Opaque water-based paints are not suitable for brush drawing because they produce too solid a mark—the marks and lines you make must be fluid and must flow easily from brush to paper, so use ordinary watercolor, watercolor ink, or even acrylic paint, diluted with water to a wash.

With practice you will learn how much pressure to apply to your brush to make the line thicker, thinner, lighter, or darker. Light pressure with the tip of a medium-sized, pointed brush will give a precise, delicate line. A little more pressure will thicken the line, while increasing it still further will produce a shaped brushmark rather than a line. It is even possible to produce a line of great sensitivity that is thick in places and thin in others, a highly pleasing effect.

SUGGESTED APPLICATIONS

• Brush drawing is especially useful whenever you want your work to appear free and spontaneous.
• The technique is also good for conveying movement in a variety of subject matter.

SPONTANEOUS DRAWING
Down to the Start by Jake Sutton
Drawing spontaneously with the brush is an excellent way to convey movement, which forms the main theme of this sparkling picture. Movement is expressed in every area, from the scribbled clouds to the blobs and splashes of paint used for awnings and foreground figures.

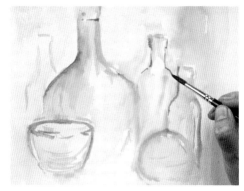

DRAWING IN THE OUTLINES
1 Using a fine brush and working on dry paper for a crisp effect, the artist draws in the main outlines of the bottles, making the lines in the foreground darker than those behind. The lines are then washed over with water to soften them —this will also allow the artist to erase and rework any errors. Loose washes of the same color are applied within the outlines, and to the surrounding area.

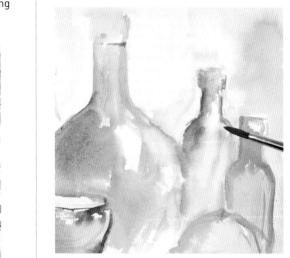

ADDING DEFINITION
2 When the paint is slightly dry, washes of darker colors are applied to define the shapes of the bottles, and to add shadows and depth to the surrounding area.

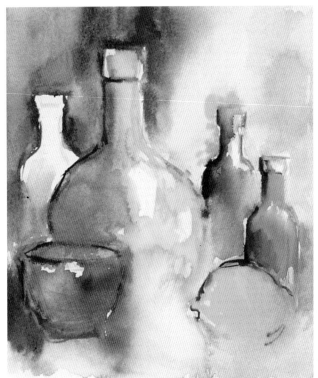

3 White or pale patches are left unpainted, for highlights. The artist continues building up the picture in this way.

4 The finished painting has sufficient definition for the objects in it to be clearly recognizable, but the looseness of the technique ensures that the whole retains its impressionistic approach.

TIPS: DRAWING LINES

• Vary the weight of your lines to suggest three-dimensional form. Thin lines suggest delicacy and lightness, while thicker lines convey greater solidity and weight, as can be seen in the bottles here.

• Wherever the underpainting is still wet, any marks or lines you make will bleed so if you want crispness make sure that the underpainting is dry first.

SEE ALSO

Brushwork, pages 64–65

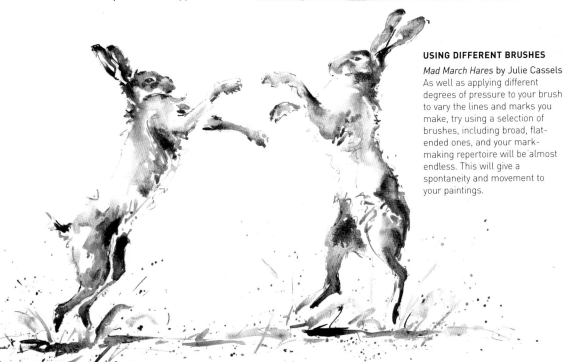

USING DIFFERENT BRUSHES

Mad March Hares by Julie Cassels
As well as applying different degrees of pressure to your brush to vary the lines and marks you make, try using a selection of brushes, including broad, flat-ended ones, and your mark-making repertoire will be almost endless. This will give a spontaneity and movement to your paintings.

CHINESE BRUSHES

In Chinese brush painting, brush marks are pared down to a minimum to capture the essence of a subject. Here, the flower petals are achieved by applying heavy pressure.

DRY BRUSH

THIS TECHNIQUE IS JUST WHAT ITS NAME IMPLIES—PAINTING WITH THE BARE MINIMUM OF PAINT ON THE BRUSH SO THAT THE COLOR ONLY PARTIALLY COVERS THE PAPER.

The dry-brush method is one of the most common ways of creating texture and broken color in watercolor. It needs practice: if there is too little paint, it will not cover the paper at all, but if there is too much, it will simply create a rather blotchy wash.

As a general principle, the technique should not be used all over a painting, since this can look monotonous. Texture-making methods work best in combination with others, such as flat or broken washes.

Opaque gouache and acrylic are also well suited to the dry-brush technique. In both cases the paint should be used with only just enough water to make it malleable—or even none at all. Cold-pressed or rough papers lend themselves best to this technique; as the dry paint is skimmed across the coarse surface, it adheres to the raised spots but does not sink into the indentations, automatically creating a textured effect.

SUGGESTED APPLICATIONS
- Use in landscapes for foliage and grass.
- Apply in seascapes to suggest the texture of the waves or highlights on the water.
- Use in portraits or animal painting to indicate the linear texture of hair or fur.

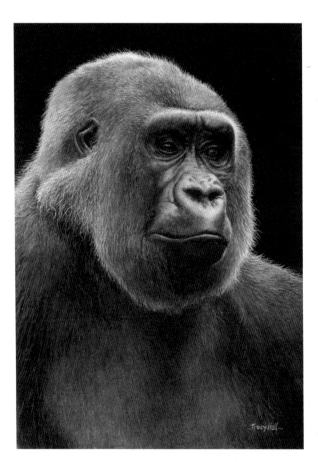

USING BODY COLOR
Pensive by Tracy Hall
The artist has used a variation of the dry-brush method to build up the texture of the animal's fur. She began with a tiny brush and pure watercolor, and toward the end added opaque white, which dries the paint by giving it more substance.

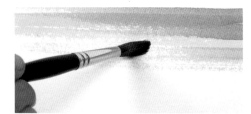

ESTABLISHING THE MAIN AREAS
1 Having pressed out excess moisture from the brush, the artist drags gray-blue watercolor across the paper for the sea. Since the paint is fairly dry, it does not spread evenly over the paper like a fluid wash, but produces a patchy finish suggestive of sparkling water.

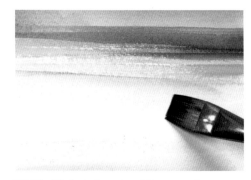

2 While this is drying, she adds washes for the sky and an uneven wash of light ocher for the beach.

WORKING THE FOREGROUND

3 Using a flat, broad brush and ocher, she begins to dry-brush the marram grass on the shore.

4 When the first layer of grass is dry, she builds up subsequent layers in the same way, dry-brushing progressively darker colors over the lighter tones. She also adds a small figure, partially hidden by the grass.

5 When the sea is completely dry, she dry-brushes streaks of Indigo mixed with Cerulean Blue over it. She also paints in the headland, overlaying a wash of gray-blue on top of the semi-dry sky so that the two blend a little to create a softer effect.

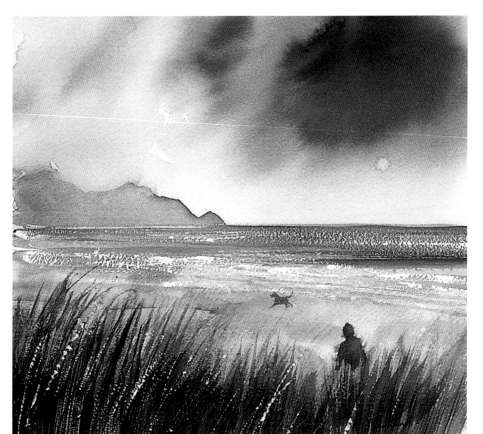

ADDING HIGHLIGHTS

6 The picture is completed with the addition of a little white gouache for extra highlights on the sea. Highlights are also scratched into the grass with a craft knife, and—as a final touch—the small figure of a dog running along the sand is placed in the middle ground.

BRISTLE BRUSHES

The best dry-brush effects are obtained with bristle, not soft sable or synthetic-hair, brushes (these are, in any case, quickly spoiled by such treatment).

SEE ALSO

Using Salt, pages 88–89
Creating Texture, pages 94–95

TONED GROUND

PRETINTING WATERCOLOR PAPER TO CREATE A TONED GROUND OFFERS SEVERAL ADVANTAGES TO THE WATERCOLOR ARTIST.

SEE ALSO

Stretching Paper, page 27
Flat Wash, pages 36–37
Wet-on-dry, pages 42–43

Although most watercolorists work on white paper, there are times when you might want to work on a lightly colored ground. The advantages are twofold. First, it helps you to achieve unity of color because the ground shows through the applied colors to some extent, particularly if you leave small patches uncovered. Second, it allows you to build up deep colors with fewer washes, thus avoiding the risk of muddying. This is especially well suited to opaque gouache work where muddying occurs very easily.

It is possible to buy heavy colored papers for watercolor work, but these may not always be easy to find, in which case you will need to color your own paper. You do this by laying an overall wash of thinned acrylic, or an overall watercolor wash. For any but the heaviest weights of paper, it is necessary to stretch the paper first.

The main problem with pretinting is deciding what color to use. Some artists like to paint a cool picture, such as a snow scene, on a warm, Yellow Ocher ground so that the blues, blue-whites, and grays are heightened by small amounts of yellow showing through. Others prefer cool grounds for cool paintings and warm ground for warm ones. Think carefully about the overall color key of your painting before pretinting; it can be helpful to try out one or two ground colors first.

SUGGESTED APPLICATIONS
• Apply a toned ground wherever you want to create a unified, coherent effect.
• A toned ground is also useful if you want to concentrate most of your marks in one part of the painting—the toned ground will "fill" the rest of the space so that the picture still works as a whole, without looking unfinished.

TINTING THE PAPER
1 First, the artist lightly sketches in the subject matter. He then tints the paper with a wash of Raw Umber acrylic paint. The paint is initially applied with a brush and then rubbed with tissue to create a slightly uneven, patchy finish.

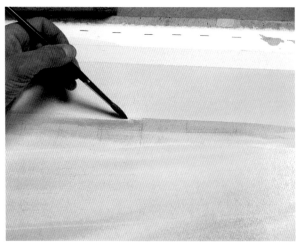

WORKING WET-IN-WET
2 When the initial wash is thoroughly dry, the artist rewets the paper and begins to deepen the color in parts. Rewetting the paper allows the paint to spread so that no hard edges form and the effect remains soft and blurry.

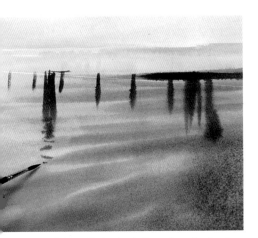

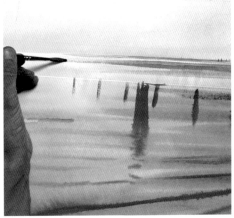

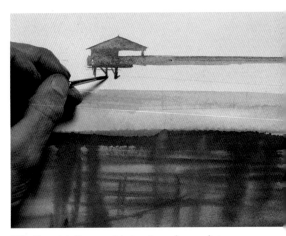

3 Maintaining a limited palette and continuing to work wet-in-wet, the artist builds up the tones and paints in the softer details, such as the reflections of the pier supports.

WORKING WET-ON-DRY

4 Once the atmosphere and color have been established, the painting is allowed to dry. Working wet-on-dry, crisper details can then be added.

5 Further details are added wet-on-dry, such as the building at the top right, the pier supports running across the top of the picture, the dark, wooden breakwaters, and the birds in the sky.

6 The toned ground and the disciplined palette bring together all the elements of the picture, giving unity and coherence. The tones become deeper toward the foreground increasing the sense of space and light.

TIPS: PAINTING GROUNDS

• Before you begin your painting, experiment with different-colored toned grounds on some spare paper. When the paint is dry, roughly brush on some of the colors you will be using in your final picture, to see what effect you get. Watercolor is translucent, so the toned ground will affect the colors applied on top.

• Remember that if you apply an overall toned ground, you will not be able to reserve highlights because there will be no white paper left.

LINE AND WASH

LINE AND WASH IS A TYPE OF VISUAL
SHORTHAND—COMBINING LINE
TO INDICATE FORM WITH COLOR
FROM THE BRUSH IS A RAPID AND
ECONOMICAL WAY TO CONVEY
A GREAT DEAL OF INFORMATION.

This technique has a long history and is still much used today, particularly for illustrative work. Before the eighteenth century, it was used mainly to put pale, flat tints over pen drawings, a practice that itself continued the tradition of the pen-and-ink wash drawings often made by artists as preliminary studies for paintings.

The traditional method is to begin with a pen drawing, leave it to dry, and then lay in fluid, light color with a brush. One of the difficulties of using this method is to integrate the drawing and the color in such a way that the washes do not look like a "coloring in" exercise, so it is often more satisfactory to develop both line and wash at the same time, beginning with some lines and color and then adding to and strengthening both as necessary.

Alternatively, you can work "back to front," as it were, laying down the washes first to establish the main tones and then drawing on top. In this case, you will need to begin with a light pencil sketch as a guideline.

The inks used may be waterproof or non-waterproof. Non-waterproof inks will run and add to the loose expressiveness of the medium. Loose-flowing lines and washes do not have to be completely precise.

SUGGESTED APPLICATIONS

• Line and wash is particularly well suited to small, delicate subjects, such as botanical plant drawings, or where you want to express precision of form, as with architectural subjects.
• The technique also works well for quick figure studies, where you want to convey a sense of movement.

ARCHITECTURAL SUBJECTS
Street in Kiev by Ray Evans
Line and wash is an excellent technique for architectural subjects, as can be seen here. The artist has used watercolor sparingly, reinforcing his fresh, clean washes with lively pen lines supplying the finer detail. Responding to different elements within the scene, he has varied his line accordingly—straight lines for the timber cladding, spidery lines for the branches, and circles for the stones and pebbles in the walls and road surface—so that the line adds interest to the picture as well as providing information.

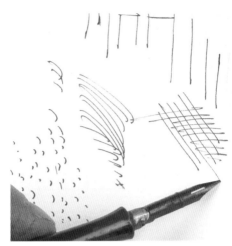

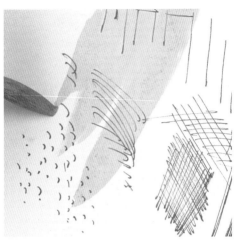

INITIAL LINEWORK

1 A few short strokes, lines, and markings are made with an Indian ink pen, by first dipping it in the ink pot and then drawing directly on the paper.

LAYING WASHES

2 When the ink lines are dry, a loose wash is brushed over them. Waterproof ink, which does not run, has been used here.

3 The artist continues to build up the color over the ink drawing. Even though the color is quite intense it is transparent, allowing the linework to show through—this is the essence of line and wash.

TIPS: DRAWING LINES

• Tone can be built up by drawing numerous fine lines close together, in a technique known as "hatching." If the lines cross, it is referred to as "cross-hatching." The tone created by hatched lines can be supplemented with dark washes, perhaps for windows or doorways on a building.

• You need not limit yourself to a dip pen for drawing the lines. Many different instruments can be used, including ballpoint pens, or even an old broken twig dipped in ink to create scratchy lines with their own spontaneity.

LEAVING UNPAINTED AREAS

4 Some of the linework is left unpainted so that it remains sharp and focused. As with all art, the trick is knowing when to stop and not to overwork a piece—it can be a real advantage to stop short of completing a very detailed image.

TIPS: MAKING MARKS

• Before making marks on what will be the finished piece, "warm up" by experimenting with the pen on another sheet of paper.

• Take care that large droplets of ink do not roll off the pen and make large blots on the image.

SEE ALSO

Brush Drawing, pages 66–67

RESERVING HIGHLIGHTS

ALTHOUGH YOU CAN CREATE WHITE HIGHLIGHTS BY APPLYING OPAQUE WHITE PAINT, THE PUREST HIGHLIGHTS IN WATERCOLOR WORK ARE MADE BY "RESERVING"—THAT IS, LEAVING THE PAPER BARE.

RESERVING LARGE AREAS
Spanish Farm by Joe Francis Dowden
Space and brightness are vital in this stark, uncompromising Spanish highland. To retain the quality of sunlight falling on the white walls of the farm buildings, the artist reserved that part of the picture. Once he had established the colors and tones of the surrounding hills, he applied color to the buildings.

The light reflecting off white paper is an integral part of watercolor painting, giving good watercolors their lovely, translucent quality. For this reason, the most effective way of creating pure, sparkling highlights is to reserve areas that are to be white by painting around them. This means that when you begin a painting, you must have a clear idea of where the highlights are to be, so some advance planning is necessary.

When you lay a wash around an area to be reserved, it will dry with a hard edge. This can be very effective but it may not be what you want, for example, on a rounded object such as a piece of fruit. In such cases, you can achieve a gentler transition by softening the edge with a brush, small sponge, or cotton swab dipped in water.

Small highlights, such as the points of light in eyes or the tiny sparkles seen on sunlit, rippling water, which are virtually impossible to reserve because of their size, can be achieved either by masking or by applying white gouache as a final stage. Highlights can also be created by removing paint, by lifting out or scraping back.

SUGGESTED APPLICATIONS
• Use highlights to create tonal contrast and give the illusion of three-dimensional form.
• Reserve crisp highlights on shiny objects and softer highlights on more matte surfaces.

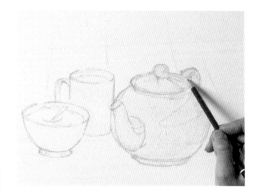

MAKING AN INITIAL SKETCH
1 The artist makes a preliminary drawing, lightly sketching in the shapes of the highlights so that they will be easy to reserve.

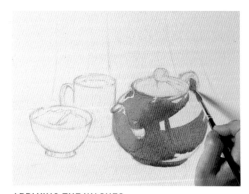

APPLYING THE WASHES
2 The highlight is to be an important feature of the painting, so the teapot is painted first. Because the pot has a reflective surface, the edges of the highlights are crisp, an effect the artist wants to exploit fully.

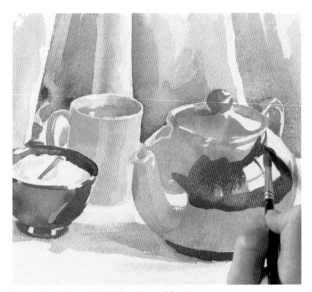

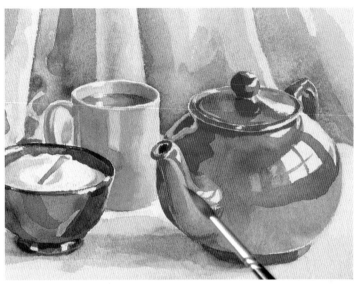

3 The background and the other objects are painted with all the highlights reserved as white paper or a pale color. The artist now begins to build the darker tones.

4 The softer highlight on the spout of the teapot is made by reserving the lighter color, that is, painting darker washes around the original light pinkish-brown.

SEE ALSO

Lifting Out, pages 56–57
Scraping Back, pages 76–77
Masking, pages 78–79
Body Color, pages 96–97

SOFT HIGHLIGHTS

To create a soft, colored highlight, apply slightly diluted Chinese white or white gouache on top of the color. The white will sink slightly into the color below to produce a gentle, soft-edged highlight, perfect for matte surfaces.

COLORED HIGHLIGHTS

Not all highlights are pure white; in paintings where all the tones are dark, too many whites could be over-emphatic. In this instance, you will need to wait until some color has already been applied, and then either reserve areas of an initial pale wash or build up really dark tones around a later, mid-toned one. If you want to work wet-in-wet, you will have to wait until the initial wash has dried completely before rewetting the paper.

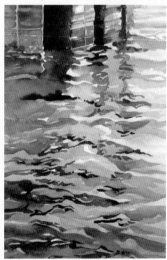

1 Soft tones are built up, wet-in-wet, on an underwash of pale blue.

2 Crisper shapes are added wet-on-dry for definition and form.

SCRAPING BACK

SOMETIMES CALLED SGRAFFITO, THIS TECHNIQUE SIMPLY INVOLVES REMOVING DRY PAINT SO THAT THE WHITE PAPER IS REVEALED.

The scraping back method is most often used to create the kind of small, fine highlights that cannot be reserved, such as the light catching blades of grass in the foreground of a landscape, or the small points of light you might see on the surface of rippled water. It is a more satisfactory technique than opaque white applied with a brush, because this can look clumsy and, if laid over a dark color, does not cover it very well.

Scraping is done with a sharp knife, such as a craft knife, or with a razor blade. For the finest lines, use the point of the knife, but avoid digging it into the paper. A more diffused highlight over a wider area can be made by scraping gently with the side of the

knife or with a razor blade, which will remove some of the paint but not all of it. The method should only be used in the final stages of a painting because it scuffs the paper and makes it impossible to apply more paint on top; in addition the paint must be completely dry.

The same technique can be used for gouache or acrylic, but it is essential that the surface is one that can withstand this treatment.

SUGGESTED APPLICATIONS
• Use for tiny highlights that cannot be achieved either by masking or reserving; for example, delicate surface textures, blades of grass, or sparkles on water.

LAYING A WASH

1 Layers of watercolor are first built up in the usual way. This kind of light underpainting will allow for scraping back later.

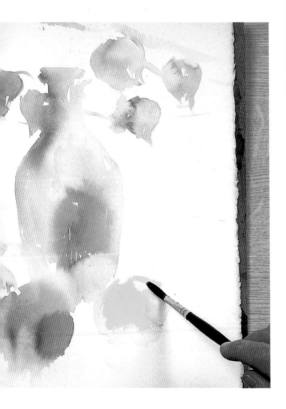

SCRAPING BACK DAMP PAINT

2 Using a round-bladed craft knife, the artist scrapes away the plant stems. This is done while the paint is just damp so that it is easier to remove. Working in this way requires careful judgment. If the paint is too wet, the color will simply flow back into the space it previously filled; the paper surface will also be wetter and so more easily torn. If the paint is left to dry completely, however, it can be more difficult to scrape away.

IMPROVISING TOOLS

3 Other tools can be used for scraping back. Here, a credit card provides a useful edge for scraping away bands of just-damp color.

4 A fingernail provides another ready tool for scraping back.

ADDITIONAL HIGHLIGHTS

5 If more highlights are required, the surface may be gently rubbed with sandpaper. This must only be done when the paint is completely dry—sandpaper will rip the surface of damp paper.

6 To create shafts of light, the sandpaper can be folded to a knife-edge (below).

DRAWING WITH A BLADE

You can use the blade of a scalpel or craft knife like a pen or pencil to "draw" linear highlights or texture, as on the inner surface of this mushroom—but take care to judge the wetness of the surface correctly before you start.

PAPER QUALITY

This method will not be successful unless you have a good-quality, reasonably heavy paper—it should be no lighter than 300gsm. On a flimsier paper, you could easily make holes or spoil the surface.

CHOOSING SCRAPING TOOLS

Almost anything sharp enough to scratch away the surface of the paint can be used for scraping back, but consider first the kind of shape you want to make and choose your tool accordingly. For example, sandpaper gives an overall sparkle or, folded and used on edge, it creates more concentrated linear highlights. Blades also produce linear highlights, while a credit card "pulls back" color for a more diffused area of brightness.

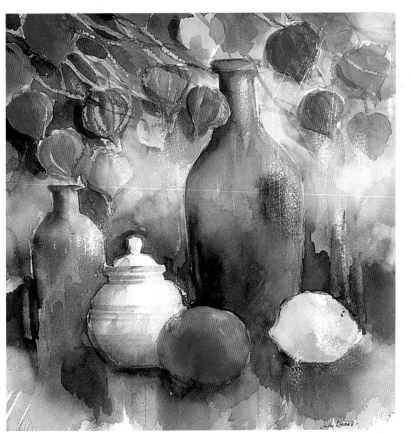

7 Translucent watercolor washes and scraped-back areas give the finished still life a luminous quality.

SEE ALSO
Reserving Highlights, 74–75
Masking, 78–79

MASKING

THE TWO MAIN PURPOSES OF MASKING ARE TO CREATE HIGHLIGHTS BY RESERVING CERTAIN AREAS OF A PAINTING, AND TO PROTECT ONE PART OF A PICTURE WHILE YOU WORK ON ANOTHER.

SEE ALSO

Wax Resist, pages 80–81
Reserving Highlights, pages
 74–75
Scraping Back, pages 76–77

If over-used, masking can detract from the spontaneity that we associate with watercolor, but it is a method that can be used creatively, giving exciting effects that cannot be obtained by using the more classic watercolor techniques. Liquid masking fluid or masking tape may be used.

The liquid is applied with a brush and comes in two forms. One has a slight yellow tint, allowing you to see the brushstrokes as you apply them. The disadvantage is that the yellow patches are visible as you paint and tend to give a false idea of the color values. There is also a colorless type, which does not distort color perception but can be hard to see. Fluid-filled pens are also available, allowing you to "draw" with the fluid.

Once the fluid is completely dry, washes are painted over it. When the paint is dry, the mask is removed by gently rubbing with a finger or an eraser. The beauty of liquid mask is that it is a form of painting in negative—the brushstrokes you use can be as varied in shape as you like, and you can create lovely effects by using thick and thin lines, splodges, and little dots.

Sometimes a painting needs to be approached methodically and dealt with in separate parts, and this is where the second main function of masking comes in. Liquid mask or masking tape (ideal for straight lines) can be used as a temporary stop for certain areas of the painting. Covering the whole area of the building with liquid mask or putting strips of masking tape along the edges will allow you to paint freely without the constant worry of paint spilling over to spoil the sharp, clean lines. Once the background is finished, the mask can be removed, and the rest of the painting carried out as a separate stage. It may be mechanical, but it is a liberating method for anyone who wishes to have complete control over paint.

SUGGESTED APPLICATIONS

• Reserve small, intricate highlights with liquid mask, for example a pattern of leaves and twigs catching the sunlight in a woodland scene.
• Use to protect one area of a picture while painting freely on another.

APPLYING INITIAL COLOR

1 Using a light pencil outline as a guide, the artist begins painting in the petals of the flowers with washes of blue and purple watercolor. She also washes Raw Umber and Burnt Sienna over the stems. Patches of deeper blue are applied for the sky. The paint is left to dry completely.

MASKING OUT

2 She then masks the flowers and stems with liquid mask and leaves it to dry.

PAINTING OVER THE MASK

3 The artist paints a green wash all over the flowers, using directional strokes for the grasses. The paint is left to dry, then a few more stems in the foreground are masked out with fluid.

4 When the second coat of mask is dry, she paints darker green over the grasses and on the trees in the background. All the paint is now left to dry fully before the masking is removed.

5 Final details, such as the orange hearts of the flowers, are added with a fine brush.

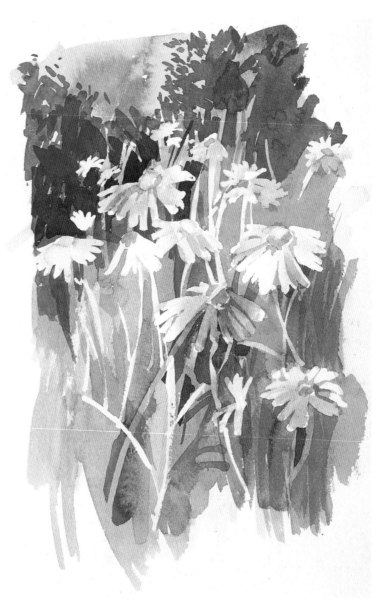

TIPS: BEST PRACTICE

• If the paper is too rough or too smooth, masking will either be impossible to remove or will spoil the paper—the best surface is a medium one (known as "NOT" or cold-pressed).

• Rubbing the paintbrush in wet soap before dipping it in the fluid makes it easier to clean later. The brush should also be cleaned immediately after use.

6 Masking has allowed the artist to work in a spontaneous way, and has produced an effect impossible with any other technique. When the mask is removed the results can be a little unpredictable—but any "happy accidents" become key elements of the style.

WAX RESIST

THIS SIMPLE TECHNIQUE, BASED ON THE ANTIPATHY BETWEEN OIL AND WATER, CAN YIELD MAGICAL RESULTS.

Wax resist is a valuable addition to the watercolorist's repertoire and involves deliberately repelling paint from certain areas of the paper while allowing it to settle on others. If you draw over paper with wax or an oily medium and then overlay this with watercolor, the paint will slide off the waxed or greasy areas. You can use either an ordinary household candle or inexpensive wax crayons. The British sculptor, Henry Moore (1898–1986), also a draftsman of great imagination, used crayons and watercolor for his series of drawings of sleeping figures in the London Underground during World War II.

The wax underdrawing can be as simple or as complex as you like. You can suggest a hint of pattern on wallpaper in a portrait by means of a few lines, dots, or blobs made with a candle, or create an intricate drawing using crayons with sharp points.

Wax beneath watercolor gives a delightfully unpredictable speckled effect which varies according to the pressure you apply and the type of paper you use. It is one of the best methods for imitating natural textures, such as those of rocks, cliffs, or tree trunks.

SUGGESTED APPLICATIONS
• Use to create natural patterns and textures, such as the bark of trees, dappled sunlight, or light through foliage.

APPLYING WAX AND OIL PASTEL
1 Having first lightly penciled in the outlines of the figures, the artist roughly scribbles over the sunlit background and trees using a white wax candle and green and yellow oil pastels.

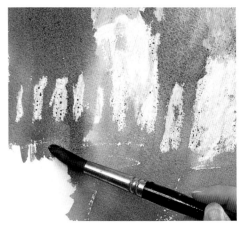

PAINTING OVER THE RESIST
2 Dark shades of watercolor are then flooded over the whole area. The waxy parts reject the watercolor, but where there are tiny gaps in the waxy surface the color adheres, creating broken shapes and a speckled effect that is characteristic of the wax-resist technique.

FOAMING SEAS
Headland by Charles Knight RWS, ROI
Wax-resist techniques are used to create the frothy waves in this picture which create a feeling of movement and add drama to the composition.

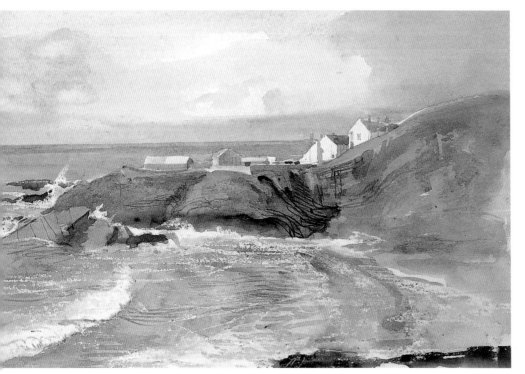

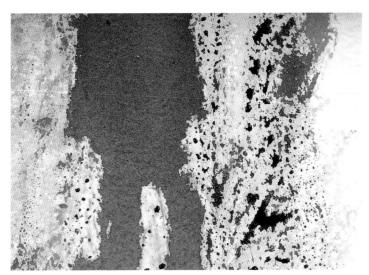

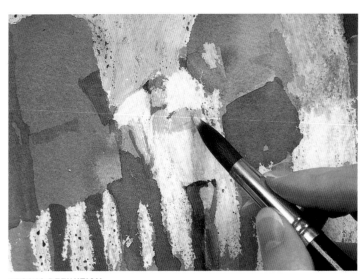

3 It is difficult to achieve even coverage of the surface using a waxy medium, as seen here in close-up. However, the relative unpredictability of this technique is part of its charm, and adds valuable surface texture to the finished painting.

ADDING DEFINITION
4 When the initial washes are dry, additional tones are added to define the forms without overworking them.

5 The finished piece shows just how effective the wax-resist technique can be. The sunlit background and the shadowy forms in the foreground are suggested with just enough tone and detail in the lightest, most impressionistic way. The trick here, as always, is knowing when to stop, to avoid overworking and ruining the painting. Notice, too, the clever contrast between the bright, acid tones of the background and the cooler, deeper tones of the figures.

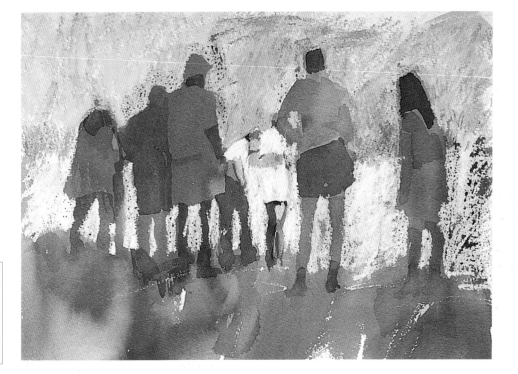

SEE ALSO

Masking, pages 78–79
Creating Texture, pages 94–95

SPONGING

DABBING PAINT ONTO PAPER WITH A SPONGE GIVES AN ATTRACTIVE, MOTTLED EFFECT, AND IS AN EXCELLENT WAY TO DESCRIBE TEXTURE.

A sponge is an important part of the artist's toolkit. It can be used both to blot up excess color, and also to apply color when a textured effect is required. It can even be used to apply overall washes. Small artists' sponges are available, but you can improvise and cut a piece off a larger sponge.

Use a different sponge for different colors (or wash your sponge out thoroughly between applications). Where you want a drier application, it's easy to reduce the amount of paint you are applying simply by squeezing the sponge slightly to expel the excess. By applying denser paint in shadowed areas, you can suggest form as well as texture. If you've used too much paint—perhaps obscuring the highlights—remove some by dipping the sponge in clean water, squeezing out the surplus, and dabbing back into the paint. You can do this even when the paint is dry.

There is no reason why whole paintings should not be worked using this method, but sponging does have its limitations. The marks made by a sponge are not precise enough for intricate work or fine detail, so in the later stages of a painting brushes are usually brought into play to create fine lines and details.

SUGGESTED APPLICATIONS

• Sponging is a useful way of creating a large mass of texture, for example, to simulate a profusion of ragged plants in a garden, undergrowth in the wild, or perhaps the masonry in an old building or the rough appearance of rocky crags.

INITIAL SPONGING

1 The artist begins by sponging on yellow, orange, and green for the sunlit areas of the foliage. To preserve the crispness of the marks and to prevent them spreading and softening, he sponges onto dry paper. He continues to add color until the desired shape for the canopy of each tree is achieved. The paint is left to dry so that there is no muddying of subsequent colors.

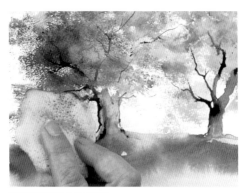

VARYING THE TONES

2 The trunks and branches are painted in, using a brush. A loose band of color is added along the bottom to indicate the ground. Darker, cooler tones are added with a sponge to indicate the shadowed foliage, and left to dry slightly.

CREATING TEXTURE

Summer Walk Unknown artist
The irregular texture of a natural sponge has been employed to make broad soft washes instead of using a brush and to create a broken, speckled texture for the foliage. A tracing paper stencil was used for the straight lines of the tree trunk.

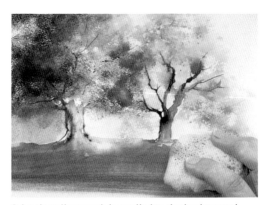

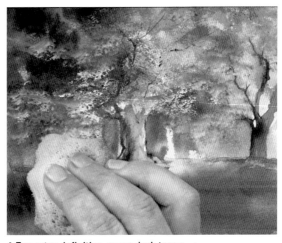

TIPS: CHOOSING A SPONGE

• Always use natural sponge for painting as it is more absorbent and pliable and—with its irregularly spaced holes—produces a more pleasing, organic pattern than harsh, synthetic sponge.

• Small natural sponges vary from coarse to very fine, and this affects the texture they produce. Experiment with different kinds to see which you like.

3 A pale yellow wash is applied to the background, working from right to left and light to dark and allowing the wash to pick up some of the sponged color in the foliage. This will have a softening effect on the sponging, so that the technique does not dominate the picture. The sponge is then used to apply a band of French Ultramarine across the foreground.

4 For extra definition, more dark tones are dabbed on with the sponge. Where the sponge is too unwieldy, a brush may be used to apply these darks.

ADDING HIGHLIGHTS

5 Finally white body color is sponged on for the lightest foliage on the left.

WET OR DRY?

The crispest effects are achieved by sponging onto a dry surface. For a softer sponged effect, try dabbing the color onto a slightly damp surface. Or work both wet and dry in different parts of the painting to create varying texture and definition.

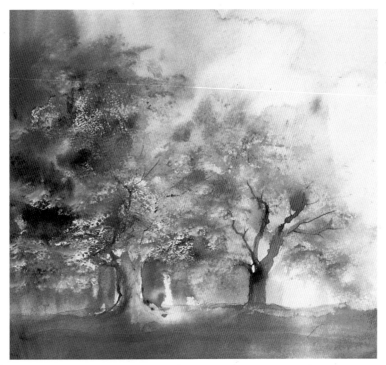

6 The limited palette of yellow, orange, brown, and blue gives the finished piece overall cohesion. Note, too, the careful balance between shadows on the left and highlights on the right, which avoids a confused mass of tones.

SEE ALSO

Spattering, pages 84–85
Using Salt, pages 88–89
Stippling, pages 90–91
Scumbling, pages 92–93
Creating Texture, pages 94–95

SPATTERING

SPRAYING OR FLICKING PAINT ONTO THE PAPER, ONCE REGARDED AS UNORTHODOX AND "TRICKSY," IS NOW ACCEPTED BY MOST ARTISTS AS AN EXCELLENT MEANS OF ENLIVENING AN AREA OF FLAT COLOR OR SUGGESTING TEXTURE.

Any medium can be used, but the paint must not be too thick or it will cling to the brush. To make a fine spatter, load a toothbrush with fairly thick paint, hold it horizontally above the paper, bristle side down, and run your index finger over the bristles. For a coarser effect, use a bristle brush, loaded with paint of the same consistency, and tap it sharply with the handle of another brush. The bristle brush method can also be used for watery paint, but will give much larger drops. Some artists like to use a paintbrush, flicking paint off it by tapping the metal part of the handle against the finger, to release a spray of paint.

The main problem with the method is judging the tone and depth of color of the spattered paint against that of the color beneath. If you apply dark paint—and thick watercolor will of necessity be quite dark—over a very pale tint, it may be too obtrusive. The best effects are created when the tonal values are close together.

SUGGESTED APPLICATIONS
• Apply to evoke natural textures, such as foliage, shingle, or sand.

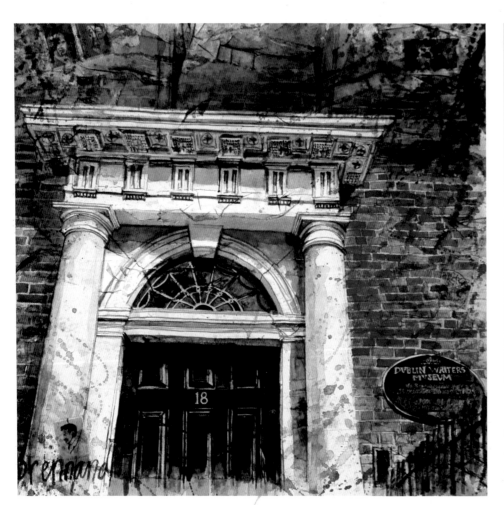

USE A MOUTH DIFFUSER

If you need to spatter one pale color over another—for example, to express the texture of a pebbled or sandy beach, for which the technique is ideal—the best implement to use is a mouth diffuser of the kind sold for spraying fixative.

PRACTICE FIRST

Spattering is a somewhat unpredictable method and it takes some practice before you can be sure of the effect it will create, so it is wise to try it out on some spare paper first.

SUBTLE SUGGESTIONS
The Dublin Writers' Museum by Catherine Brennand
The artist has suggested the marble columns of this building through judicious applications of spattered paint, which are much more effective than any exact representation would be.

2 Tissue paper protects the foreground and sky from successive layers of spattering. More pigment is added at each stage to bring shadow and depth to the image.

BUILDING UP TEXTURE

1 Sap green is gently spattered over a loose drawing of tree trunks, sections of which have been masked out to suggest dappled light.

3 The same green is brushed loosely over the foreground, with areas of blue and violet flooded in to suggest a carpet of bluebells. Salt is sprinkled in to add further texture.

SEE ALSO

Sponging, pages 82–83
Using Salt, pages 88–89
Stippling, pages 90–91
Creating Texture, pages 94–95

4 After all the spattered paint has dried, the tree trunks are painted with Burnt Umber and Sap Green.

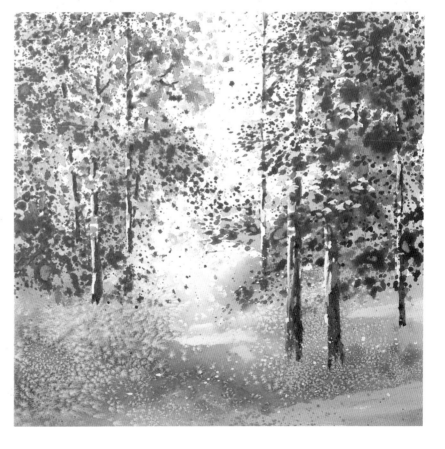

BLOTS AND DROPS

FLICKING BLOTS OF PAINT ONTO DRY PAPER OR DROPPING SPOTS OF PAINT INTO A WET WASH ARE RELATIVELY RANDOM WAYS OF ADDING COLOR, TEXTURE, AND INTEREST—AND CAN PRODUCE SOME PLEASING AND SURPRISING RESULTS.

WORKING ON WET PAPER
Time to Crush by Jeanne Lamar
In her painting, the artist has dropped paint onto wet paper in places, producing subtle color mixes and soft edges. Certain areas were then sharpened up, but with care taken to preserve the spontaneous effect.

Blot painting is a technique most often associated with monochrome ink drawing, but now that watercolors are available in liquid (ink) form this technique has become more popular with watercolor artists. The other reason for its inclusion is that it is an excellent way of loosening up technique and providing new visual ideas. Like backruns, blots are never entirely predictable, and the shapes they make will sometimes suggest a painting or a particular treatment of a subject quite unlike the one that was planned. Allowing the painting to evolve in this way can have a liberating effect and may suggest a new way of working in the future.

The shapes the blots make depend on the height from which they are dropped, the consistency of the paint or ink, and the angle of the paper. Tilting the board will make the blot run downhill; flicking the paint or ink will create small spatters; wetting the paper will produce a diffused, soft-edged blot.

Dropping a blot onto the paper and then blowing it will send "tendrils" of paint shooting out in various directions.

An associated technique exploits watercolor's tendency to spread when applied wet-in-wet. The method involves dropping small amounts of wet paint from a brush into a wet wash. The drops spread and feather out on their edges, rather like backruns, but because they are small and are applied in a more controlled way, the effect is different.

SUGGESTED APPLICATIONS
• Blots can be used to suggest the textures of a tree, flowers, or pebbles.
• Blown "tendrils" of color may suggest stems and branches.
• Drops, applied to wet paint, are a good way of adding color to textured foliage, or creating a marbled effect.

CHOOSING PIGMENTS

Different pigments have different qualities and thus behave in different ways. Some are opaque, some more translucent, some granulate, some dry flat. Experiment by dropping different colors into wet washes and observe how they interact, then choose the combinations that you like best and that produce the effects you want.

DROPPING COLOR WET-ON-DRY

1 The artist flicks a loaded brush onto paper to produce these random paint blots.

DROPPING COLOR WET-IN-WET

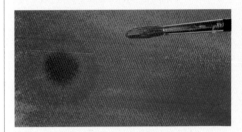

• A dense wash of a deep pink is brushed onto the paper. While the wash is still wet, Ultramarine is dropped in. The brush can be touched to the surface, or droplets can be allowed to fall off the brush from above. Larger droplets are made by using more paint, smaller ones by using less.

• As a variation, a wash of indigo was laid down and opaque colors were dropped onto it. Cadmium Lemon and Cobalt Turquoise Light are both lighter than indigo but because of their opacity they make an impression on the darker wash and push the indigo color out to form darker ringlets.

BUILDING UP THE IMAGE

2 The blots suggest honesty seeds to the artist, so she builds up the picture by drawing in the paper-thin petals and stems of the plant, using a fine brush.

3 Washes of color are added where necessary, and additional spots of color are dabbed on with a finger.

4 The artist completes the work by adding in just enough definition to allow the image to be read figuratively, while taking care to retain the original spontaneity.

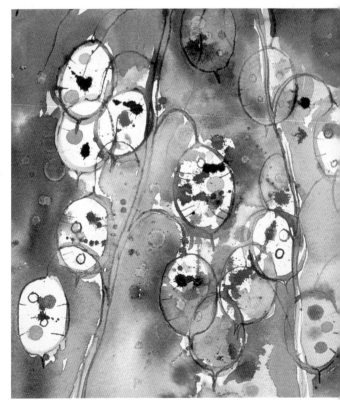

SEE ALSO

Backruns and Blossoms, pages 52–53
Spattering, pages 84–85

USING SALT

THERE ARE NUMEROUS WAYS TO
BREAK UP AN AREA OF WATERCOLOR
AND ADD TEXTURE. ONE OF THE MOST
INTERESTING AND UNEXPECTED IS TO
SPRINKLE A WET WASH WITH SALT.

SEE ALSO
.
Dry Brush, pages 68–69
Stippling, pages 90–91
Scumbling, pages 92–93

It is one of the paradoxes of painting that a
large area of flat color seldom appears as
colorful, or as realistic, as one that is textured
or broken up in some way. The Impressionists,
working mainly in oils, discovered that they
could best describe the shimmering effects of
light on foliage or grass by placing small dabs
of various greens, blues, and yellows side by
side instead of using just one green for each
area. This technique can be adapted very
successfully to watercolor, but there are
many other ways to break up color.

Dropping table or sea salt into the wet paint
can produce some interesting textures. Being
water-retentive, the grains of salt soak up the
wetness of the paint from the immediate area,
speeding up the drying process there. As the
paint dries, little star shapes appear as the
water floods out of the crystals and pushes
the color away to create feathered edges.

SUGGESTED APPLICATIONS
• The effects you achieve can be translated into
different textures depending on the context in
which they are used—snow, lichen, rocks,
leaves, flowers, and so on.

DIFFERENT-SIZED GRAINS
. .
Salt grains of different sizes produce
shapes and textures of different kinds.
Experiment to see what you can create.

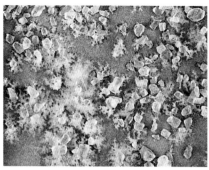

• Using larger salt grains produces more
distinct star-like shapes with feathered
edges.

• Smaller-grained salt produces
a finer texture.

BACKGROUND INTEREST
Fleur de Fête by Katrina Small
In her painting, the artist has
used salt spatter for the
background alone. This
contrasts nicely with the sharp
delineation and careful blends
used for the feet and sandals.

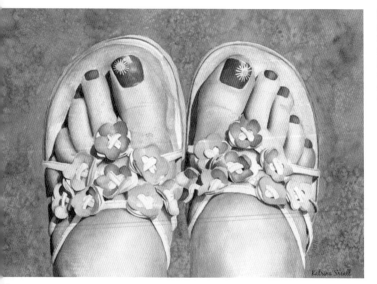

TIPS: CHOOSING A FINISH
. .
• The wetness of the wash will
determine the final result, so judge the
wetness carefully to achieve the effect
you want.

• Breaking up color with salt is most
effective in areas with an even finish, as
this provides the greatest contrast.

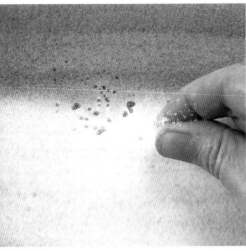

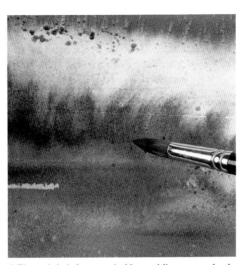

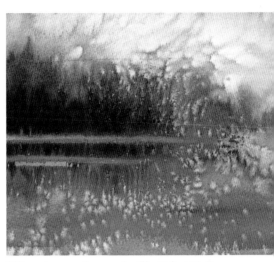

CREATING PATTERN WITH SALT

1 Initial washes establish the areas of sky, mountains, and lake. While the washes are still wet, salt is sprinkled into selected areas—in this case, the sky, to create a cloud-like effect.

2 The salt is left to work. Meanwhile more color is added wet-in-wet to achieve the required density in different parts of the picture, and the colors are allowed to bleed into each other.

3 The colors are deepened, still wet-in-wet, to strengthen the impression of the mountains and lake. Salt is sprinkled onto the lake to create a speckled pattern, like that of sparkling water.

VARYING THE WETNESS

One of the tricks in creating salt textures lies in judging the wetness of the paint, as this will affect the pattern you achieve, as shown in the examples below.

• Here salt is added to very wet paint, giving a softer and more diffuse effect.

• In this example, the salt is added after the paint has dried a little—still damp, but not running.

• Here the paint has almost dried; the effect is smaller and tighter.

STIPPLING

THIS METHOD OF APPLYING PAINT IN A SERIES OF SEPARATE, SMALL MARKS, USING THE TIP OF A BRUSH, PRODUCES A DISTINCT TEXTURE THAT IS QUITE DIFFERENT FROM OTHER TECHNIQUES. KNOWING HOW TO APPLY IT CAN ADD TO YOUR ABILITY TO CONVEY A VAST NUMBER OF POSSIBILITIES IN WATERCOLOR.

STIPPLING SELECTED AREAS

Simple Pleasures by Denny Bond
The stippling in this picture has mainly been used for the foreground. Before applying color, liquid masking was applied with a toothbrush to produce a ground texture, and then a further layer of stippled color was added to achieve depth. The barn was painted in two successive dry washes.

Stippling was, and is, a technique favored by painters of miniatures, and is seldom used for large paintings for obvious reasons. However, for anyone who enjoys small-scale work and the challenge of a slow and deliberate approach, it is an attractive method and can produce lovely results, quite unlike those of any other watercolor technique. It can be used to create texture, or as a method of blending colors and giving an area of color greater depth.

If you are using the technique as a way of color blending—similar to the Pointilliste method of the painter Seurat—success depends on the separateness of each dot or mark: The colors and tones should blend together in the viewer's eye rather than physically on the paper. As with all watercolor work, the stippled marks should be built up from light to dark, with highlights left white or only lightly covered so that the white ground shows through, while the dark areas are built up gradually with increasingly dense brushmarks. Highlights can also, of course, be added with body color.

If your aim is to create an area of texture in a painting, the effect you achieve will depend on the brush you use, and on the wetness of the paint.

SUGGESTED APPLICATIONS
• Stippling can produce the perfect texture for many things—the rows of vines in a vineyard, the rough texture of ground, or the mottled face of a cliff, for example.

SEE ALSO

Using Salt, pages 88–89
Scumbling, pages 92–93
Creating Texture, 94–95

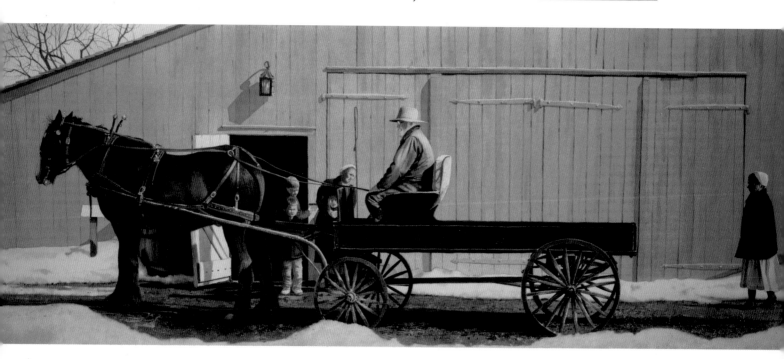

STIPPLING THE FIRST COLOR

1 The artist loads an old sable brush with Cadmium Red and dots down color onto the surface.

VARYING THE STIPPLE

2 Next, to create a contrasting stipple, he loads a large, flat hake brush liberally with a green mix. He shakes the brush to separate the fibers into clumps, then dabs it down repeatedly in a broad line to give roughly parallel lines of texture, rather like plowed furrows in a field.

3 The marks from stippling create various possibilities—clumps of ferns or tire tracks could be implied by these marks.

TIPS: VARYING CONSISTENCY

• The paint should have a creamy consistency when you are stippling—if it is too wet, the dots will merge or dissolve.

• The drier the paint, the more distinct a stippled pattern you will make.

• Once you feel reasonably confident with the technique, try varying the consistencies of the paint to produce distinct patterns.

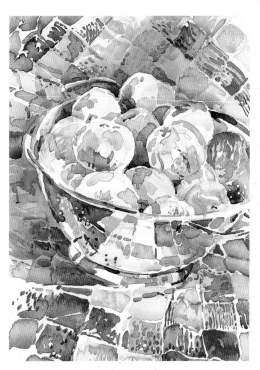

MAKING RANDOM MARKS

Use the point of the brush to make random brushstrokes, allowing some of the marks to merge. Vary the marks depending on the kind of pattern or texture you want to create.

SCUMBLING

USUALLY DONE WITH A SHORT-HAIRED BRUSH (THE OLDER THE BETTER), SCUMBLING INVOLVES SCRUBBING DRY PAINT UNEVENLY OVER ANOTHER LAYER OF DRY COLOR SO THAT THE FIRST LAYER SHOWS THROUGH IN PARTS.

SEE ALSO

Sponging, pages 82–83
Stippling, pages 90–91

This is one of the best-known of all techniques for creating texture and broken color effects. Scumbling can give amazing richness to colors, creating a lovely glowing effect rather akin to that of a semi-transparent fabric with another, solidly colored one beneath. There is no standard set of rules for the technique because it is fundamentally an improvisational one.

Scumbling is most frequently used in oil painting, but is in many ways even better suited to acrylic and gouache because they dry so much faster—the oil painter has to wait some time for the first layer to dry. The particular value of the method for gouache is that it allows colors to be overlaid without becoming muddy and dead-looking—always a danger with this medium.

Because of the relatively thin consistency of watercolor, the technique is less well suited to this medium than to gouache and acrylic. Whatever medium you are using, the trick is to apply dry paint as thickly as possible—if it is too wet, it will simply spread out across the paper. If you are scumbling with watercolor, it is more effective if you are using tubes, as you can then apply the paint undiluted, straight from the tube.

Use a rough paper, too, rather than a smooth, hot-pressed one. In the same way as the dry-brush technique, the dry, scrubbed-on paint will not be fluid enough to sink into the hollows but will adhere to the raised tooth, which will accentuate the scumbled texture.

SUGGESTED APPLICATIONS

• Use wherever you want to evoke a natural texture—for rocks, masonry, fur, and so on.

SCUMBLED WATERCOLOR
Lucky Cockerel by Tracy Hall
For her painting, the artist has cleverly adapted the scumbling method to watercolor to build up the textures of the stonework and barn door. She has used the paint with the minimum of water and glazed over the scumbled areas when dry.

TIPS: TEXTURING

• A bristle brush is ideal for scumbling, but other possibilities include stenciling brushes, sponges, crumpled tissue paper, or even your fingers. If you do use a softer brush, make sure it is an old one that can take some rough treatment—a good brush will soon be ruined.

• Practice your technique on some spare paper. Load the brush well with dry paint, then, with a twisting, dabbing motion of the brush head, "grind" the paint into the paper. Repeat the process for a delightfully varied texture.

• Like other texture-creating techniques, scumbling works best in contrast with smoother, less textured area, so keep it localized to small areas of your painting—an all-over scumbled texture will lose impact.

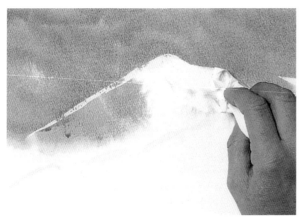

APPLYING INITIAL COLORS

1 The edge of the mountain is covered with masking fluid and left to dry. The paper is dampened, and a wash of Antwerp Blue with a touch of Payne's Gray is laid. The color is lifted out where it floods over the mountain top.

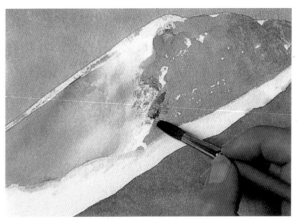

SCUMBLING DRY COLOR

2 The shadows on the mountain are painted with a darker, grayer mix of the two colors used previously. When the paint is dry, dry sepia is scumbled on the exposed rock edges and used to pepper snow in the center.

3 A diluted but dry mixture of Antwerp Blue and Payne's Gray is used to scumble the trampled snow in the foreground. Tone is built up by further scumbling.

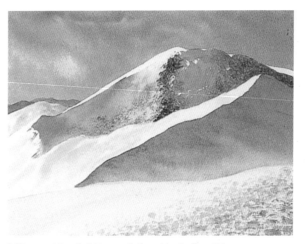

4 The masking fluid is carefully rubbed off and the white areas are dampened. A pale wash of Antwerp Blue is applied for the shadows in the undulating snow. The crispness of the edge of the snow-covered mountain provides a pleasing contrast to the scumbled marks in the foreground.

PLANNING THE LAYERS

Experiment with scumbling to see the effects you can get. Try applying light colors over dark, dark over light, or a vivid color over a contrasting one.

CREATING TEXTURE

THERE ARE TWO MAIN KINDS OF TEXTURE IN PAINTING: SURFACE TEXTURE, IN WHICH THE PAINT ITSELF IS BUILT UP OR MANIPULATED IN SOME WAY TO CREATE WHAT IS KNOWN AS SURFACE INTEREST; AND IMITATIVE TEXTURE, IN WHICH A CERTAIN TECHNIQUE IS EMPLOYED TO PROVIDE THE PICTORIAL EQUIVALENT OF A TEXTURE SEEN IN NATURE.

Surface texture is sometimes seen as an end in itself, but in many cases it is a welcome by-product of the attempt to turn the three-dimensional world into a convincing two-dimensional image. Since watercolors are applied in thin layers, they cannot be built up to form surface texture, but this can be provided instead by the grain of the paper. There are a great many watercolor papers on the market, some of which—particularly the handmade varieties—are so rough that they appear almost to be embossed. Rough papers can give exciting effects, because the paint will settle unevenly (and not always predictably), breaking up each area of color and leaving flecks of white showing through.

Acrylic paints are ideal for creating surface interest because they can be used both thickly and thinly in the same painting,

providing a lively contrast. You can vary the brushmarks, using fine, delicate strokes in some places and large, sweeping ones in others.

Several of the best-known techniques for making paint resemble rocks, tree bark, fabrics and so on are described in other entries, but there are some other tricks of the trade. One of these—unconventional but effective—is to mix watercolor paint with soap. The soap thickens the paint without destroying its translucency. Soapy paint stays where you put it instead of flowing outward, and allows you to use inventive brushwork to describe both textures and forms.

Intriguingly unpredictable effects can be obtained by a variation of the resist technique. If you lay down some turpentine or paint thinner on the paper and then paint over it, the paint and the oil will separate to give a marbled appearance.

SUGGESTED APPLICATIONS

• Study the texture you wish to evoke, then choose an applicator that will reproduce that texture.

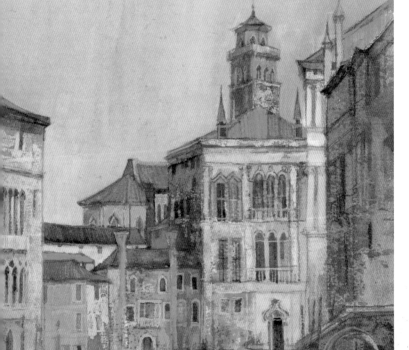

APPLYING PAINT WITH PAPER
Venice by Moira Huntly
To suggest the beautiful crumbling plaster walls of the buildings, the artist brushed watercolor onto a thick piece of paper, then pressed it firmly onto the working surface. The effect of this technique will vary depending on the texture of the paper and the thickness of the paint.

SEE ALSO
............
Dry Brush, 68–69
Wax Resist, 80–81
Sponging, 82–83
Spattering, 84–85
Scumbling, 92–93

INITIAL DRAWING AND PAINTING
1 First, the artist draws the basket in lightly, and then applies washes to the background, foreground, and to the basket itself. The paint is left to dry completely.

BUILDING TEXTURE

2 Shadowed areas are painted in, and, while the paint is still wet, the textured side of a piece of paper towel is pressed into it to lift off some of the paint and leave an imprint of the paper behind. The paint is then left to dry.

3 Spots of darker color are then dabbed onto the basket using bubble wrap, bubble-side out, to suggest the mottled, textured weave of the basket.

4 When this is dry, a strip of corrugated cardboard is used to apply paint for the woven border along the top edge of the basket.

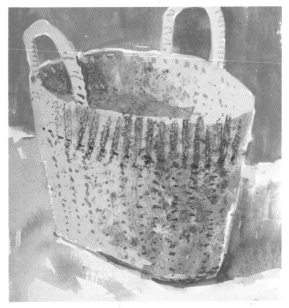

5 An imaginative application of paint, using the kind of scrap materials that most people have in their homes, has resulted in the almost tactile surface texture of this basket.

ALUMINUM FOIL AND PLASTIC WRAP

Striking effects to create a range of features—twisting ridges and edges, a texture of sharp lines, and dark-and-light patches—can be achieved with aluminum foil. Try this experiment. Have a crumpled sheet of aluminum foil at the ready. Apply three broad bands of color wet-on-dry, allowing them to blend. Press the sheet of aluminum foil onto the paint. Press it gently all over so the crumpled surface is in contact with the still-damp watercolor. When the paint has dried, remove the foil, and see its texture imprinted onto the page. Try the same technique with plastic wrap.

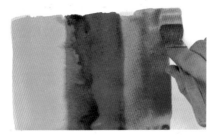

Applying the washes

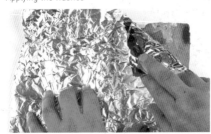

Pressing on the foil

The final effect

BODY COLOR

THIS SLIGHTLY CONFUSING TERM SIMPLY MEANS OPAQUE WATER-BASED PAINT. IT CAN BE USED TO GREAT EFFECT WITH THE MORE CONVENTIONAL TRANSLUCENT WATERCOLOR.

SEE ALSO

Wet-in-wet, pages 44–45
Toned Ground, pages 70–71
Reserving Highlights, 74–75

In the past the term "body color" was generally used to describe Chinese White mixed with transparent watercolor and applied to parts of a painting, or the same white used straight from the tube for highlights. Today, however, it is often employed as an alternative term for opaque gouache paint.

Some watercolor painters avoid the use of body color completely, priding themselves on achieving all the highlights in a painting by reserving areas of white paper. There are good reasons for this, because the lovely translucency of watercolor can be destroyed by the addition of body color, but opaque watercolor is an attractive medium when used sensitively.

A watercolor that has gone wrong—perhaps become overworked or too bright in one area— can often be saved by overlaying a semi-opaque wash, and untidy highlights can be cleaned up and strengthened in the same way.

SUGGESTED APPLICATIONS

• Transparent watercolor mixed with either Chinese White or gouache Zinc (not Flake) White is particularly well suited to creating subtle weather effects in landscapes, such as mist-shrouded hills. The mixture gives a milky, translucent effect slightly different from that of gouache itself, which has a more chalky, pastel-like quality.

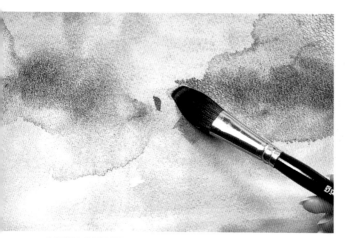

LAYING A TONED GROUND
1 First, a toned ground is laid down over the entire surface, using acrylic paint in a pale beige-cream. When this is dry, the building, trees, and foreground are painted in with Ultramarine, Prussian Blue, Alizarin Crimson, and Sap Green watercolor. Washes of these colors are painted wet-in-wet, using a large brush and loose brushstrokes. There is little form or definition at this stage of the painting.

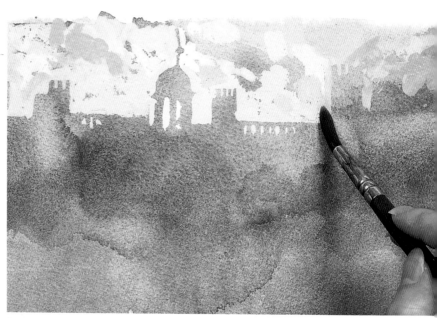

BUILDING THE SKY AND FOREGROUND
2 When the washes are dry, body color is used to build up the sky. The artist uses gouache in white, Lemon Yellow, Indian Yellow, and a neutral gray.

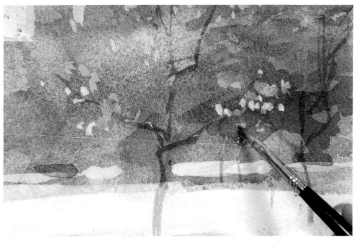

3 White, Saffron Green, and Indian Yellow gouache are applied to the grassy area in the foreground, deliberately echoing the colors of the sky. Patches of especially solid body color here create the effect of dappled sunlight.

ADDING FINAL DETAILS
4 Further details, such as trunks and branches, are added to the trees, using Olive Green and Prussian Blue watercolor. The artist then dabs on touches of pale yellow gouache to highlight some of the leaves on the trees in the foreground.

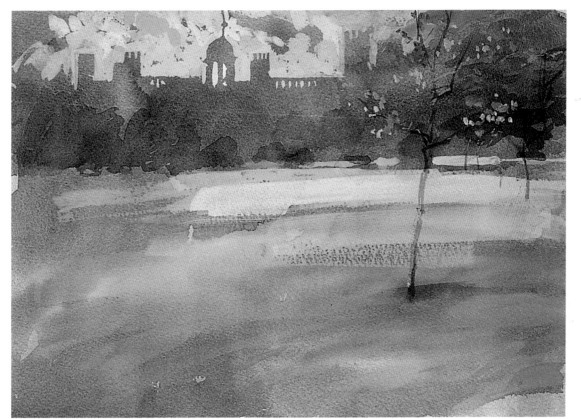

5 The mixture of misty, blue-mauve watercolor and sharp, solid gouache creates a highly atmospheric scene, reminiscent of the colors on a sunny early morning.

BEING SELECTIVE

• Use body color selectively—restricting it to parts of the painting so that it contrasts with the more translucent washes will have the greatest impact.

MIXED MEDIA

ALTHOUGH MANY ARTISTS KNOW THAT THEY CAN CREATE THEIR BEST EFFECTS WITH PURE WATERCOLOR, MORE AND MORE ARE BREAKING AWAY FROM CONVENTION, FINDING THAT THEY CAN CREATE LIVELIER AND MORE EXPRESSIVE PAINTINGS BY COMBINING THE ATTRIBUTES OF SEVERAL DIFFERENT MEDIA.

To some extent, mixing media is a matter of trial and error, and there is now such a diversity of artists' materials that there is no way of prescribing techniques for each one or for each possible combination. However, it can be said that some mixtures are easier to manage than others. Acrylic and watercolor, for example, can be made to blend into one another almost imperceptibly because they have similar characteristics, but two or more physically dissimilar media, such as line and wash, will automatically set up a contrast. There is nothing wrong with this—it may even be the point of the exercise—but it can make it difficult to preserve an overall unity. The only way to explore the natures of the different materials and find out the most effective means of using them is to try out various combinations.

SUGGESTED APPLICATIONS
• Develop a sensitivity to your subject matter and choose media accordingly, to evoke a corresponding impression, mood, and texture.

Water-based media
Acrylic used thinly, diluted with water but without the addition of white or any medium, behaves in more or less the same way as watercolor. There are two important differences between them, however. One is that acrylic has greater depth of color so that a first wash can, if desired, be extremely vivid, and the other is that, once dry, the paint cannot be removed. This can be an advantage, as further washes, either in watercolor or acrylic, can be laid over an initial one without disturbing the pigment. The paint need not be applied in thin washes throughout: the combination of shimmering, translucent watercolor and thickly painted areas of acrylic can be very effective, particularly in landscapes with strong foreground interest, where you want to pick out small details like individual flowers or grass heads (very hard to do in watercolor).

Gouache and watercolor are often used together, and many artists scarcely differentiate between them. However, unless both are used thinly, it can be a more difficult combination to manage, since gouache paint, once mixed with white to make it opaque, has a matte surface, which can make it look dead and dull beside a watercolor wash.

Ink and watercolor are another successful combination, as demonstrated in the example on the facing page.

CAPTURING DETAIL
The Pink Umbrella by Paul Dawson
Every surface in this picture is treated with the same loving attention to detail to create its meticulously rendered realistic effects. These include dry brush over preliminary wash to texture the floorboards, table, and walls; the leaves were added with thick gouache on top. For the chair, a wash was laid, then the cane weave was defined with ink and finished with fine glazes of acrylic.

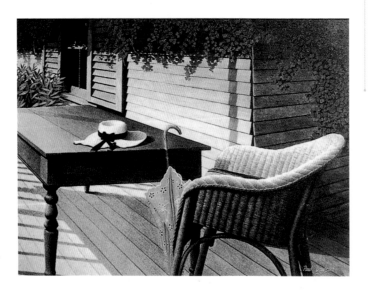

TIPS: "RESCUING" WORK

• It is often possible to save an unsuccessful watercolor by turning to acrylic in the later stages.

• Try using a failed watercolor as a basis for experimentation; many successful mixed-media paintings are less the result of advance planning than of exploratory reworking.

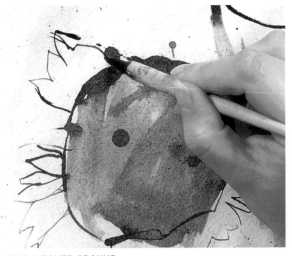

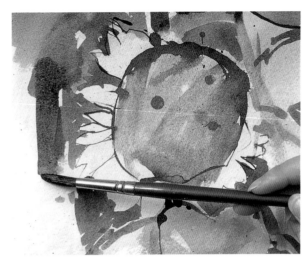

BUILDING UP WITH DIFFERENT MEDIA

2 She continues to build up the tones, using a mixture of ink and gum arabic.

LAYING A TONED GROUND

1 To create a toned ground that will unite the whole image, cyan acrylic ink is first dripped onto damp paper and spread and rubbed in with paper towel. Using an ink dropper, the artist then draws in some rough outlines with colored ink. While the ink is still wet, she blocks in areas of darker tone with a paintbrush and ink mixed with gum arabic.

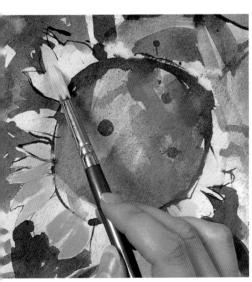

3 She paints the sunflower petals in yellow gouache, an opaque color.

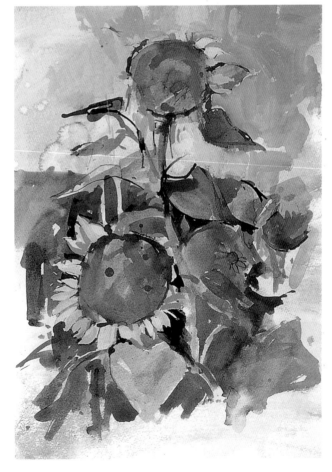

4 The finished picture shows how well the two media complement each other. The patchy, translucent, blue-green ink washes provide the perfect contrast to the strong, flat, yellow gouache of the flower petals.

Watercolor and pastel

Soft pastels can be used very successfully with watercolor and provide an excellent means of adding texture and surface interest to a painting.

Overlaying a watercolor wash with light strokes of pastel, particularly on a fairly rough paper, can create sparkling broken colors.

Oil pastels have a slightly different, but equally interesting effect. A light layer of oil pastel laid down under a watercolor wash will repel the water to a greater or lesser degree (some oil pastels are oilier than others) so that it sinks only into the troughs of the paper, resulting in a slightly mottled, granular area of color.

Gouache and pastel

These two media have been used together since the eighteenth century when pastel was at the height of its popularity as an artist's medium. Some mixed-media techniques are based on the dissimilarity of the elements used, which creates its own kind of tension and dynamism; however, gouache and pastel are natural partners, having a similar matte, chalky quality.

Watercolor crayons

These are, in effect, mixed media in themselves. When dry, they are a drawing medium, but as soon as water is applied to them, they liquefy to become paint that can be spread with a brush. Highly varied effects can be created by using them in a linear manner in some parts of a painting and as paints in others. They can also be combined with traditional watercolors, felt-tipped pens, or pen and ink.

SEE ALSO

Line and Wash, pages 72–73
Wax Resist, pages 80–81

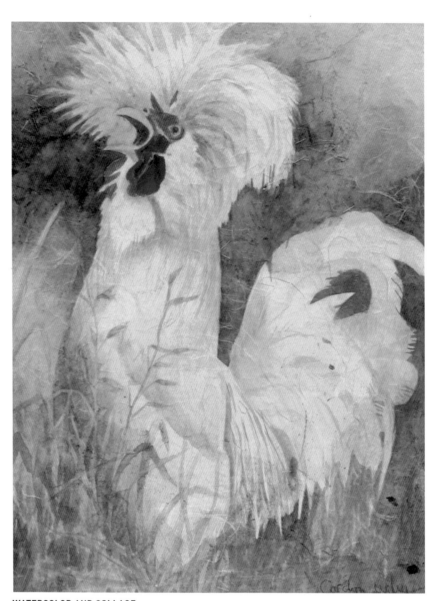

WATERCOLOR AND COLLAGE
Polish Rooster by Carolyn Wilson
This painting began with a watercolor underpainting on thick paper, which was then collaged with various textured oriental rice papers, using acrylic matte medium as the glue. The collaged pieces were torn, not cut. When the paper was dry, a further layer of color was added.

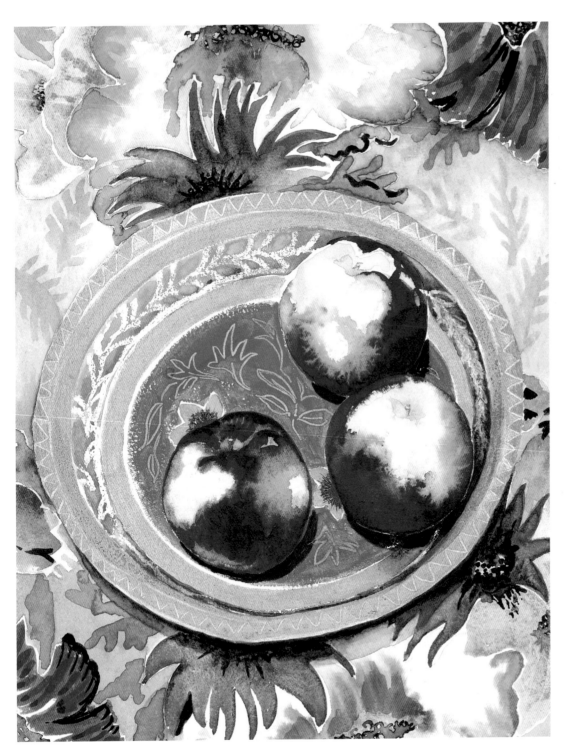

TOUCHES OF GOLD
Apples in a Papier Maché Bowl
by Clare Brooks
At first sight, this painting appears
to be simply a watercolor, but the
artist has been highly innovative and
inventive, using gold powder added to
aqua paste for the patterns around the
edges of the bowl, and employing the
sgraffito technique for the markings
inside the bowl. By mixing the colors
for the apples with gum arabic, she
was able to slow the drying time and
thus make the paint more workable.

OTHER MEDIA

The only limit to mixed-
media work is your
imagination and skill, so
experiment with as many
different combinations as
you like. Try watercolor
with charcoal and pencil,
or with conté crayon or
colored wax crayon.

CORRECTING MISTAKES

IT IS A COMMON BELIEF THAT WATERCOLORS CANNOT BE CORRECTED BUT, IN FACT, THERE ARE SEVERAL WAYS OF MAKING CHANGES, CORRECTING, OR MODIFYING PARTS OF A PAINTING.

Before painting complete pictures, you'll need to know how to correct mistakes. Every watercolorist may sometimes find that a wash has gone over an edge that was meant to be clean, or decide halfway through a picture that a color isn't quite right. It is comforting to know that there are remedies.

The methods depend on how far you have progressed with your painting. Paint can be removed by lifting out with a sponge and clean water, but you can lift paint out more radically by actually washing it off. If you notice at an early stage that something is badly awry—perhaps the proportions are wrong or an initial color doesn't look right—put the entire painting under cold running water and gently sponge off the paint.

In the later stages of a picture, you may want to change a small area without disturbing the surrounding colors. In this case, dab off the paint with a dampened sponge, and let the paper dry before repainting. For tiny areas, you can use a dampened cotton swab or wet brush, which is also ideal if you want to add highlights or soften over-hard edges.

Sometimes you may find that a white area has been spoiled by small flecks and spatters of paint. You can touch these out with opaque white, but a better method is to remove them by scraping with the flat edge of a cutting or craft knife; don't use the point which could dig into the paper and spoil the surface.

CORRECTING THE SPREAD OF COLOR
If one color floods into another to create an unwanted effect, the excess can be mopped up with a small sponge or piece of blotting paper.

UNEXPECTED EFFECTS

Don't be in too much of a hurry to correct a "mistake." One of the charms of watercolor is its ability to produce unexpected effects. Allow yourself to be led by the medium to a certain extent, and see if you can work with those "happy accidents," making them look like an intentional part of the finished piece.

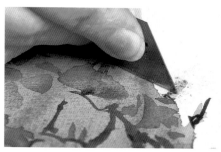

SCRAPING AWAY BLEMISHES
Small specks and spatters are easily removed by scraping with a knife or razor blade. This must be done with care, however, or the blade might tear holes in the paper.

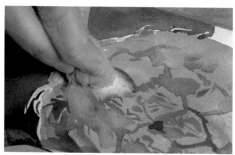

SPONGING OFF EXCESS COLOR
If there is too much color in one area, some can be lifted out with a damp sponge.

CLEANING UP EDGES
Ragged edges can either be tidied up with a knife, as in the top example, or with opaque white gouache paint, as here.

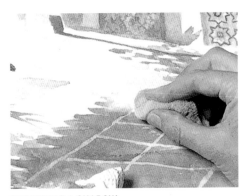

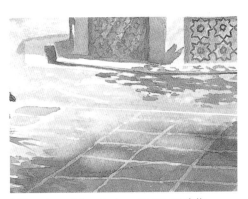

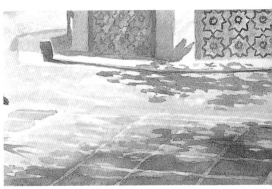

SOFTENING A SHADOW

1 A shadow in the foreground is too hard-edged. The artist washes away part of it with a sponge dipped in clean water.

2 The edges of the shadow are successfully softened but the divisions between the light and dark areas are now insufficiently defined. The aim is to give a crisp, dappled effect, similar to the shadow below the fountain.

3 A little more of the mauve-blue watercolor is applied at the back of the shadow and left to dry. Then a mixture of red watercolor and white gouache, carefully matched to the pinks of the courtyard paving, is painted over the blue shadow.

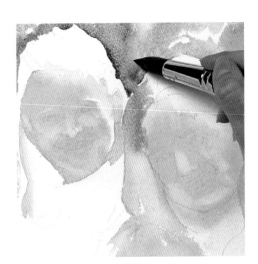

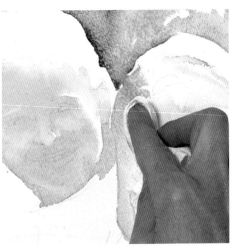

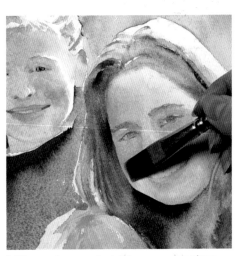

CORRECTING A PAINT RUN

1 The artist is painting a background to a family portrait when the wash that he is applying bleeds onto one of the foreground figures.

2 If you experience accidental spills, use a tissue quickly to mop up any of the accidental color.

3 It is easy to correct mistakes as you go along. Here some hair color was spilt onto the cheek and was lifted off with a damp flat brush.

SEE ALSO

Lifting Out, pages 56–57
Reserving Highlights, pages 74–75
Scraping Back, pages 76–77

PICTURE-MAKING

Whatever the medium used, there are certain principles an artist needs to know, such as understanding tonal values and the optical illusions of perspective and three-dimensional form. Developing a personal language, maintaining the practice of sketching, and knowing how to make a good composition are universal, too. But certain factors are more relevant just to watercolor. For example, the translucency of the medium means that you can't simply paint over a mistake, as you can in, say, oils, so planning your work ahead is essential. Similarly, a wash of one color laid over another will alter the color of both, so a knowledge of the way in which colors interact is also especially important for the watercolorist. This section explains all the basic principles that allow the artist to translate three-dimensional reality onto the two-dimensional plane.

THE PRIMARY PALETTE

THE PRIMARY COLORS ARE THE THREE FUNDAMENTAL COLORS WHICH ARE MIXED TO CREATE ALL OTHER COLORS IN THE PAINTER'S PALETTE. THERE ARE TWO SETS OF PRIMARIES: ADDITIVE AND SUBTRACTIVE.

Perhaps you remember learning at school about the three "primary" colors—red, yellow, and blue—from which all other colors can be mixed. But just which particular red, which yellow, and which blue does this refer to? To complicate matters further, there is more than one kind of primary color. There are the light or "additive" color primaries, that you see through light, as in a television or on a computer screen; and pigment or "subtractive" color primaries, that you see as paint pigments or inks. Artists need to consider both types when painting. Colors are mixed according to the subtractive pigment primaries, and then our eyes evaluate the colors we use through the additive light primaries.

LIGHT OR ADDITIVE COLOR PRIMARIES
When we mix colors of light, the more we mix the brighter the color gets. Colors add to each other. By mixing just three colors of light—red, green, and blue—we can make any color we want. These are the primary colors used to make the millions of different colors we see on television and computer screens.

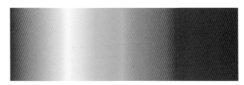

PIGMENT OR SUBTRACTIVE COLOR PRIMARIES
Paints and pigments absorb different colors of light, subtracting from what you see. The more pigment is added, the more light is absorbed and the darker the combined color becomes. It is nearly the opposite of mixing light. The primary colors for paint or pigments are cyan, magenta, and yellow (these, along with black, are the four colors used in color printing and to create the printed colors you see on this page). Mixing the three pigment primaries produces black or gray, as well as all other pigment colors.

THE COLOR WHEEL
This color wheel attempts to accommodate both systems. It uses Quinacridone Magenta, Aureolin Yellow, and Cobalt Blue as primary colors. Admittedly the Cobalt Blue is not a true cyan, but neither is Cerulean, Phthalo, Manganese, or Ultramarine. Cobalt Blue mixes well with other pigments, which some would say partially makes up for its limitations.

PRIMARIES MIX TO GRAY
The three pigment primaries mixed together make gray.

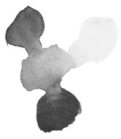

1 Yellow
Aureolin Yellow

2 Yellow-orange
New Gamboge

12 Yellow-green
Green Gold

3 Red-orange
Cadmium Orange

11 Green-blue
Ultramarine Turquoise

10 Turquoise
Cerulean Blue

4 Red
Cadmium Red

5 Magenta
Quinacridone Magenta

9 Cyan
Cobalt Blue

6 Red-violet
Quinacridone Violet

8 Middle blue
French Ultramarine

7 Blue-violet
Carbazole Violet (dioxazine)

PRIMARIES MIX TO SECONDARIES
Two pigment primaries mix together to make a secondary color. Primaries with secondaries provide a full range of colors.

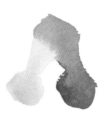

Magenta + yellow = orange Yellow + cyan = green Magenta + cyan = blue-violet

Choosing primary palettes

Because the pigment primaries mix to create all other colors, an artist can use just three pigments for a painting. These three studies of the same subject use only primary colors of different kinds of watercolor pigment. Why not try it out yourself: choose three primaries that have the characteristics you want—and go!

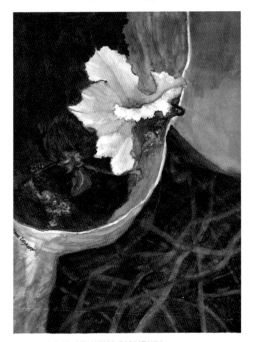

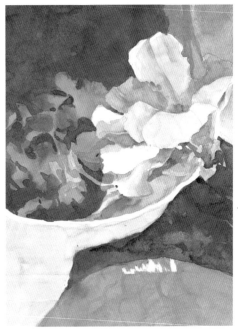

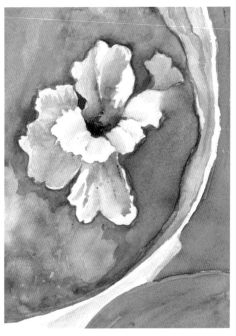

PERMANENT, STAINING PIGMENTS

John Deyloff selected three permanent, staining primaries for his study: Phthalo Blue, Holbein's Opera, and Quinacridone Gold. Note the very dark darks that he was able to mix from these three pigments—as well as some lighter grays. Transparent washes are more difficult to obtain with these strong pigments.

TRANSPARENT, NON-STAINING PIGMENTS

Jan Hart played with three of her favorite pigments, which demonstrate a bit of granulation (in the Cobalt Blue), transparency, and nice variation in colors. Note that achieving very dark darks is not as easy with this palette of primaries. The colors chosen were: Cobalt Blue, Rose Madder Genuine, and Aureolin Yellow.

SEDIMENTARY OR OPAQUE PIGMENTS

Karen Norris chose three sedimentary or opaque pigments for her study. Her selection enabled her to create some interesting textures and pigment mixtures, as well as some sense of transparency. Quinacridone Burnt Scarlet is not a sedimentary pigment, but the artist chose to include it with the two that are—Ultramarine Blue and New Gamboge.

Phthalo Blue

Opera (Holbein)

Quinacridone Gold

Cobalt Blue

Rose Madder Genuine

Aureolin Yellow

Quinacridone Burnt Scarlet

Ultramarine Blue

New Gamboge

COMPLEMENTARY AND ANALOGOUS PALETTES

IT IS SAID THAT NO COLOR IS MORE BEAUTIFUL, MORE EXCITING, OR MORE VIBRANT THAN WHEN IT IS PLACED NEXT TO ITS COMPLEMENT—ITS PARTNER—ACROSS THE COLOR WHEEL.

On the color wheel, the complement of a primary color (magenta, cyan, or yellow) is the combination of the other two primaries. So mixing a color and its complement is the same as mixing all three primaries together. The complementary palette is a simple, easy-to-use color scheme with potential for the strongest color contrasts.

The analogous palette offers the artist adjacent, closely related pigments that combine in perfect harmony. Each pigment contains a part of its neighbor, which makes them all related. Many people who grew up in the "dyed to match" culture of the 1950s, when orange and red were thought to clash, only learned years later to appreciate the rich harmony of the analogous hues. Choose a minimum of three adjacent colors to explore the interesting ways in which this palette can be used to promote the desired feeling and mood.

The studies of a pink rose (opposite) demonstrate the effects that the analogous palette can produce. The close relationship between the colors results in great coherence in the finished painting. Some artists enjoy combining high-chroma (pure and vivid) pigments with low-chroma, more "muddy" ones within an analogous scheme.

THE COMPLEMENTARY COLOR WHEEL

Yellow's complement, blue-violet, is a mix of magenta and cyan. Blue-violet plus yellow = dark gray or black.

Yellow

Magenta

Cyan

Blue-violet

TIPS: CHOOSING COMPLEMENTARY SCHEMES

• For a complementary scheme, think "contrast."

• In a complementary scheme, the most striking color choice is a warm and a cool. "Warm" colors are reds, oranges, and similar pigments; "cool" colors are blues and greens.

• Consider using a warm, pure color (red or orange) as an accent placed opposite unsaturated cool colors to emphasize the warms—or vice versa.

• For best results choose a dominant complementary that will appear directly and in mixes. Use the other complementary for accents.

• Avoid overuse of unsaturated warm colors such as brown or dull yellow. Overuse tends to create a deadening effect.

USING A COMPLEMENTARY PALETTE

Beyond the Coyote Fence by Allen Brown
Allen Brown selected Cadmium Orange and Ultramarine Blue as complementary colors for his painting. His color choices appear to be consistent with the pigment color wheel. Although he used pure Cadmium Orange very sparingly and pure Ultramarine Blue even more sparingly, his deft use of both for mixing colorful neutrals is quite apparent. He made a conscious choice to use more Ultramarine Blue than Cadmium Orange to give the cool bias his winter landscape needed.

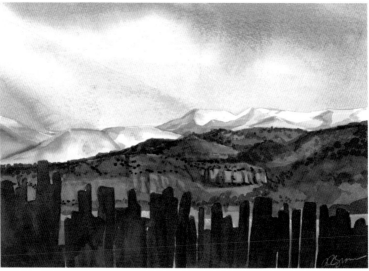

Cadmium orange

Ultramarine blue

ANALOGOUS COLOR WHEELS

The first pigment wheel (right) shows close analogous color relationships, and the second pigment wheel (far right) shows one step or looser relationships. Try both and see the different possibilities.

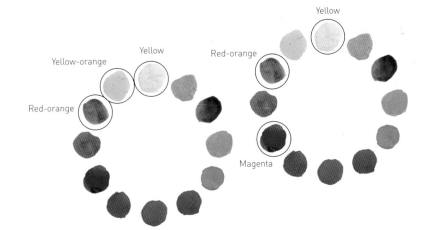

TIPS: CHOOSING ANALOGOUS SCHEMES

• For an analogous color scheme think "coordination"; the analogous scheme is inherently harmonious.

• When using an analogous scheme, the choice of appropriate subject matter is all-important—it too needs to have harmony of color. In the case of greens, the analogous color scheme is fully visible in nature: Remember this in your next summer landscape.

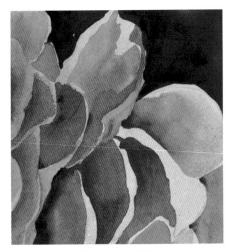

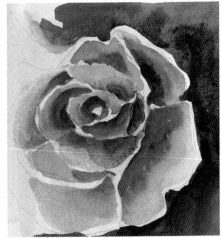

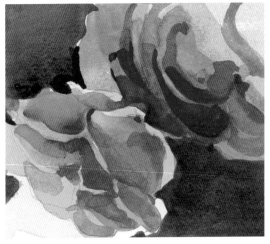

PURE, HIGH-CHROMA PIGMENTS

The use of three or four adjacent high-chroma pigments on the visual color wheel certainly grabs attention with its sizzle. It can overwhelm the eye if the high-chroma pigments are used purely and at full strength. Even mixes of these intense pigments create a vibrant painting. Here the Quinacridone Magenta provides some relief in the background. Rose Madder Genuine was used as an underwash.

LOW-CHROMA, SEMI-NEUTRAL

Each of these pigments is located away from the high chroma rim of the pigment map. Together they comprise "neutralized" violet, red, and red-orange, along with some wonderful granulations. A distinctive mood of mystery, or cloaked danger, is evoked by these semineutrals. Note the rich creeping and granulating in the mixes. An underwash of pale English Red Earth helped to set the somber mood.

HIGH- AND LOW-CHROMA

You can combine two high-chroma pigments and one low-chroma, or two low and one high, as shown. A simple, elegant color scheme can consist of three carefully selected analogous paints—two of low chroma and a single high-intensity pigment. Here the dusky Purpurite Genuine and smooth Venetian Red were selected as the red-violet and red-orange, respectively. The central magenta position was claimed by the vibrant Opera—a "hot pink" that is really cool in temperature.

Vermilion | Opera (Holbein) | Quinacridone Magenta | Rose Madder Genuine | Venetian Red | Purpurite Genuine | Napthamide Maroon | English Red Earth | Venetian Red | Opera (Holbein) | Purpurite Genuine

CHOOSING A PALETTE

WHEN STARTING A WATERCOLOR, IT CAN BE TEMPTING SIMPLY TO "PAINT WHAT YOU SEE"—THAT IS, TO USE THE WHOLE RANGE OF COLORS THAT YOU PERCEIVE IN THE SUBJECT IN FRONT OF YOU. BUT FOR A MORE EFFECTIVE RESULT, IT IS BETTER TO WORK WITH A UNIQUE COLOR PALETTE.

When choosing a color palette to work with, be aware that the more colors you use in a painting, the more difficult it is to achieve color harmony. Restraint and a more considered use of color will result in a more harmonious finished piece that will be more pleasing to the eye, as well as conveying mood and a sense of artistic authority.

An artist's "palette"—the color scheme used in a painting—is a specific choice of colors based on their relationship to each other on the color wheel. Many artists resist color schemes—until they try one. Using a color scheme is an effective way to extend your understanding of colors and color relationships.

It's well worth investing some time experimenting with various palettes. As your understanding grows, you'll be better placed to choose the palette that is most sympathetic to your subject matter, and that will produce the effect you want. Your command of color scheming will contribute significantly to the "mood" of your painting and the blending of all the elements into a coherent whole. You may be surprised to discover the range of colors and tones you can achieve with just a limited number of pigments. The studies shown here all feature the same subject yet, because the same palette isn't used in each case, the final results look and feel different. As well as these options, there are others to explore.

TIPS: CHOOSING COLORS

- For best results in an analogous scheme, avoid combining warm and cool colors.
- Use the monochromatic Velásquez, and complementary palettes (see pages 112–113) to learn about value/tone relationships and/or as value studies for another painting.
- To maintain control and restraint in your use of colors, try putting tape over the paints in your palette that you intend not to use.

MONOCHROMATIC PALETTE

Using a single color in variations of lightness and saturation makes for easy viewing and can establish an overall mood. It also forces the artist to think in terms of tonal values (see pages 116–117). Here Manganese Violet, representing the red-violet in the color wheel, was selected as much for its texture as for its color. Note how the granulation provides additional interest. However, in a monochromatic scheme it can be difficult to distinguish the most important element of the painting since all parts are rendered in different tonal values of a single color.

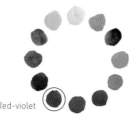

Red-violet

Manganese Violet

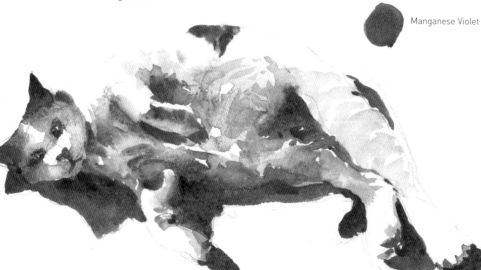

ANALOGOUS PALETTE

This color scheme (see page 109) offers the strongest potential for creating unity and a particular mood. It is as easy to use as the monochromatic scheme, but it looks richer. Using paint colors that are immediately adjacent to one another creates a singular boldness—there is no color contrast. A painting done in an analogous scheme can encompass all cool colors for a somber or nighttime scene, or all warm colors for a lighter portrayal.

It is possible to select immediately adjacent hues for a "tight" study, or hues that are separated by one color step for a "loose" study. It also is possible to select analogous pigments that are located in more neutral positions on the color wheel, such as greens or red-violets, for more neutral mood possibilities. Above all, this color scheme encourages you to step out of your comfort zone.

PRIMARY PALETTE

Because this scheme uses the three primary colors (which produce all other colors), it may offer the widest range of color possibilities. At the same time, the choice of just three pigments as the base helps produce unity and harmony in the painting. The primaries can be pigments that represent the magenta, yellow, and cyan of the pigment color wheel, or the red-orange, blue-violet, and green of the light color wheel (see "The Primary Palette," pages 106–107).

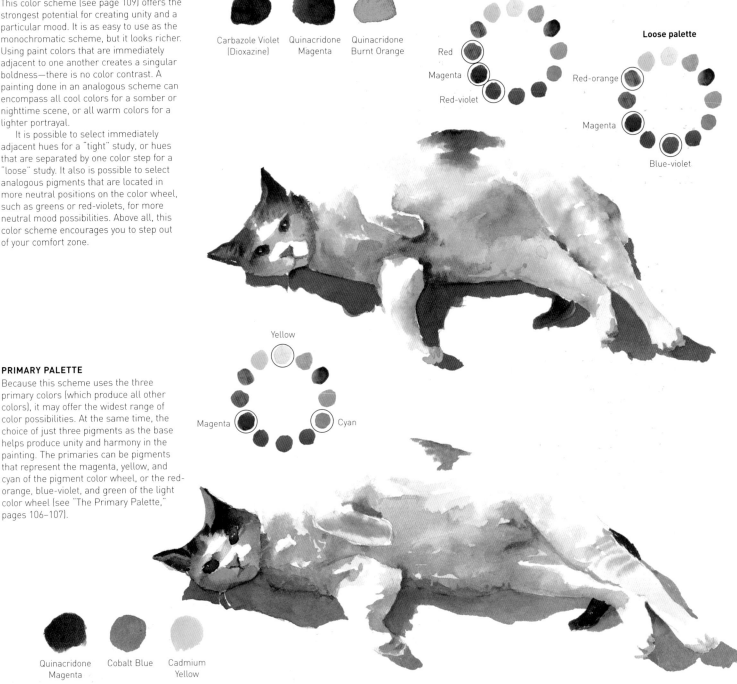

Carbazole Violet (Dioxazine)

Quinacridone Magenta

Quinacridone Burnt Orange

Tight palette

Red
Magenta
Red-violet

Loose palette

Red-orange
Magenta
Blue-violet

Yellow
Magenta
Cyan

Quinacridone Magenta

Cobalt Blue

Cadmium Yellow

THE VELÁSQUEZ PALETTE

Named for Spanish artist Diego Velásquez, this is a
subtle version of the primary pigment palette, using a
limited selection of three to four pigments that were
available to the old oil-painting masters. The Yellow
Ocher, Burnt Sienna, and Ultramarine Blue combine
to create soft neutrals and glowing lights, as shown
in the study. Modernize the palette by substituting
Quinacridone Gold for Yellow Ocher and Quinacridone
Burnt Orange for Burnt Sienna. Ultramarine Blue
remains a longtime favorite of many artists and a
staple of their palettes. You can achieve a wonderful
glow with these pigments. The pale green is achieved
by mixing Yellow Ocher and Ultramarine. Although
Ultramarine and Burnt Sienna cannot create lavender,
the neutral achieved is most useful.

Yellow Ocher Ultramarine Burnt Sienna
 Blue

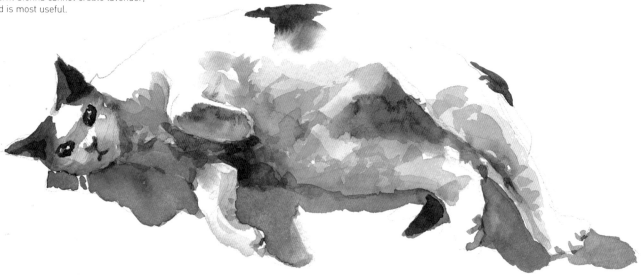

PAINT A COLOR WHEEL

You can build your own color wheel and take it with
you when you paint. It is a good idea to keep any color
wheels that you create very simple. There should be a
lot of room for individual interpretation and substitution
of pigments when something new and exciting comes
out. When a new pigment comes out, add it to your
existing color wheel to fill in the gaps or do a new color
wheel—just to find out what your current thinking is.

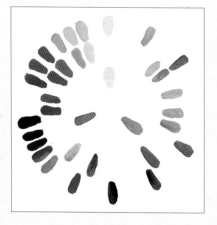 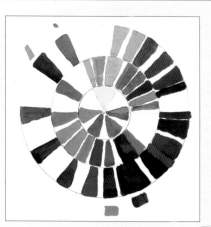

COMPLEMENTARY PALETTE

Using pure color opposites (see "The Color Wheel," page 106) enables you to present a stronger contrast than in any other color scheme, thus drawing maximum attention. For the best results, place cool colors against warm ones, or vice versa. The predominance in the amount of one color over the other creates the intended mood. A night painting, for example, may start as a complementary color scheme. Note the strong contrasts in this cat study.

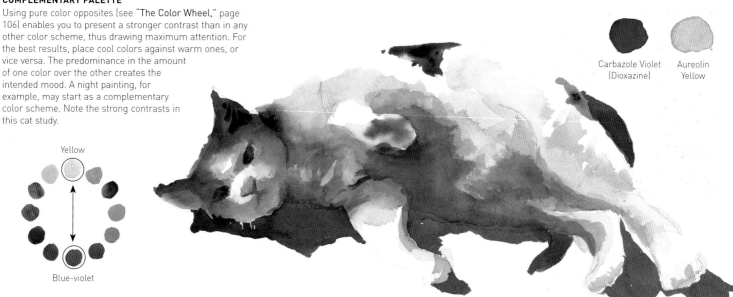

Carbazole Violet (Dioxazine) Aureolin Yellow

Yellow

Blue-violet

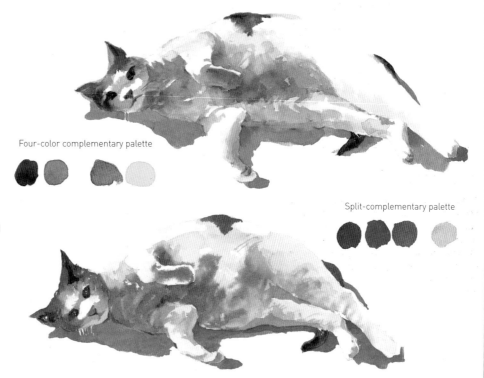

TIPS: GETTING THE MOST OUT OF A PALETTE

• Increase the richness of the complementary palette by using four colors in two complementary pairs, for example a blue-violet and a cyan complementing a yellow and a red-orange (see left).

• Try the "split-complementary" scheme that places a single warm color—say, a yellow—against three oppositional colors, such as a warm blue, a blue-violet, and a violet (see below left).

• Use a six-color scheme, consisting of three sets of complements: a magenta and a green; a yellow and a blue-violet; a blue and an orange. These three sets will allow you to mix a range of neutrals, from brown to gray, and each can be "pushed" toward the pure color for accents.

• Try a tertiary palette, using "tertiary" colors that are defined as those mixed from one primary and one secondary, for example, red and green, or blue and orange. The tertiary palette is useful for achieving complementary neutrals, with accents. A predominantly warm or cool bias works best with this scheme.

Four-color complementary palette

Split-complementary palette

COLOR MIXING AND OVERLAYING

WHEN MIXING COLORS, REMEMBER THAT THEY ALWAYS LOOK DARKER WET, IN THE PALETTE, THAN THEY WILL DO ON THE PAPER.

TIPS

• Keep the water in your jar clean: dirty water may taint your colors. Refresh it often or use two jars—one of clean water for diluting paints, one for rinsing brushes.

• As you progress with the color mixing, don't rely on the look of the color on the palette—test it out on a spare piece of watercolor paper.

• Avoid mixing four or more colors together, or all you'll achieve is a characterless mud.

As explained on pages 106–107, the pigment primaries—red, yellow, and blue—cannot be mixed from other colors. The secondaries, made from two primaries, and the tertiaries, made from the three primaries or one primary and a secondary, are also all available ready-made. However, you can achieve more variety through mixing—and it's fun. When you experiment with color mixing, you will discover how dramatically the proportions of the pigments used affect the mixture and how much stronger some pigments are than others. The amount of water you add will affect the intensity of color too.

If you don't achieve the color you want when mixing wet, you can always adjust it by overlaying, in other words, "mixing" colors on the paper rather than in the palette. This is comforting because it takes away the fear that nothing can be changed once it's down on paper. Don't rely too much on overpainting though; it's still best to achieve the right color first time.

When mixing colors, don't always go for the obvious mix of pigments—or even the obvious tube or pan color. You can get richer and subtler effects by combining more unlikely pigments.

RICH DARKS
There are many ways of achieving a dark mix other than using black directly from the pan or tube. One way is to mix Ultramarine Blue and Light Red. This combination makes a beautiful gray, with a large range of subtle hues that can be mixed in any strength up to a virtual black. Ultramarine Blue and Indian Red produce a more intense dark. Here Ultramarine Blue and Light Red are mixed on the palette to create a dark gray.

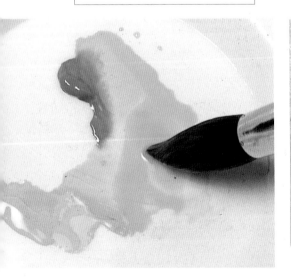

THE RIGHT GREEN
Manufacturers' greens are often very strong, and often too crude for the greens you see in nature. Rather than using a green straight from the tube or pan, start with a yellow such as Cadmium Lemon or New Gamboge. Add a smaller amount of a green, such as Phthalo Green or Hooker's Green, until the paint is the desired color. Here Cobalt Teal was added to Permanent Yellow to get a bright green. Finally, add Burnt Umber or Burnt Sienna to the color to tone it down and make it look more natural.

Overlaying colors

Because watercolors are transparent, you can't make a color lighter by putting another one on top; you can only make it darker. And because of this transparency, you can't achieve a really dark color with a first wash, as the white paper always shows through to some extent. It is done by laying one color over another. You can also change colors by overlaying one on top of another; however, aim for no more than four layers of color, as too many will spoil the fresh sparkle that is one of the most attractive features of watercolor.

Raw Umber

French Ultramarine

OVERLAYING TO DARKEN COLOR

Some pigments are more transparent than others; to achieve the desired density, it may be necessary to overlay further layers of the same color. The first layer should be completely dry and it is necessary to work quickly so that each new layer does not stir up the one beneath.

French Ultramarine

Cadmium Yellow

Payne's Gray

Yellow Ocher

OVERLAYING TO LIGHTEN COLOR

A light color applied over a dark one does not disappear. Although you can change the nature of an underlying color in this way, you can't significantly change its tonal value (see pages 116–117) unless you paint over it with a more opaque pigment.

French Ultramarine

Alizarin Crimson

Cadmium Yellow

French Ultramarine

OVERLAYING TO CHANGE COLOR

Although you can alter a color by laying another on top, you can't obliterate the first one—the new color will be a mixture of the two.

WET VERSUS DRY

One of the trickiest aspects of watercolor painting is judging what the color will look like when it's dry, so it's a good idea to do a test on a spare scrap of watercolor paper first. There can be considerable difference between a dry color (top) and a wet one (bottom).

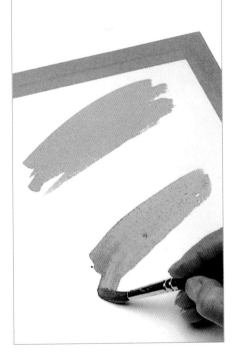

TIPS: MIXING COLORS

• Although you can add white to a watercolor mix to lighten it, you will alter its character totally, making it creamy and opaque. It is usually better to get paler tones by adding water rather than white paint.

• When painting a small area, use a small brush to add water to the color on your mixing palette; a large brush would absorb too much color and none would be left on the palette. Apply the color to the paper with the same small brush.

• When painting a large area, mix the water with the paint to form a reservoir on the palette, ensuring that sufficient paint is produced at the start to complete the wash without having to go back and mix more color.

ANALYZING TONE

TONE, OR COLOR VALUE, INDICATES
THE DARKNESS OR LIGHTNESS OF A
SUBJECT. EVERY COLOR, AND
WATERCOLOR PAINT COLOR,
HAS ITS OWN VALUE.

All living beings use sight in practical ways; it is part of their "survival kit." Humans, for example, may use their sight to judge the distance between them and an oncoming car. However, humans' aesthetic use of sight is less well developed. An artist needs to cultivate this use of sight to look for relationships in the visual world—in colors, in shapes, and in tones.

Tones—or "tonal values"—refer to the relative lights and darks that we perceive in everything we see. Even in the absence of line and color, we still know what we are looking at simply from the way in which these tones interrelate. The relative pattern of lights and darks in a drawing or painting helps to convey form and give an illusion of spatial depth, as well as contributing to its success as a composition. So it's not enough to know about color; you need to have a good awareness of tone too.

TRANSLATING TONE TO COLOR

Think of a black-and-white photograph. It contains no color or lines, yet we can still "read" the image perfectly well simply from the pattern of lights and darks and all the stages in-between. Doing studies like this one are a really good exercise and will heighten your awareness of tone.

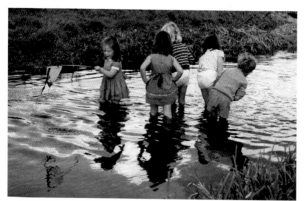

BLACK-AND-WHITE PHOTOGRAPH

1 The children in this photograph, together with their reflections, make strong vertical shapes. Crossing the picture, there are the horizontal shapes of the bank and the ripples in the water. The absence of color makes it easier to see this pattern.

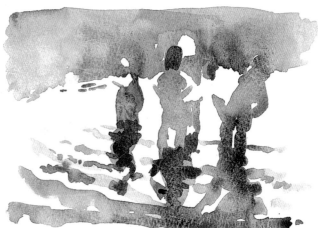

TONAL SKETCH

2 In a linear drawing, edges are defined by lines—a pattern of lines is produced on the paper. In a tonal painting, edges are defined by areas of tone. The tonal pattern may overlap what would have been the line pattern; note how the children and their reflections make one continuous shape.

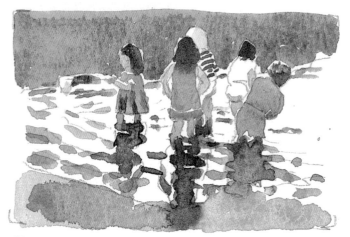

COLOR SKETCH

3 In a colored version of the same scene, the tones of the colors match those in the black-and-white tonal sketch.

IDENTIFYING TONAL CONTRASTS

When you are sketching outside, look for tonal contrasts. Which direction is the light coming from? On a sunny day this is easy to ascertain because shadows will be pronounced. Even though your logical mind may find it hard to believe, on a very bright day an intensely blue sky may actually be tonally darker than the buildings it illuminates. Conversely, on a dull day the land may be darker than the sea and sky.

SCOTTISH SEA SCENE

1 In this photograph of a Scottish scene on a damp, gray day the tonal contrast is between the sea, which reflects the sky, and the land.

2 In the resulting monochrome sketch (in which a yacht has been substituted for the boat), the land is much darker than the sky and water.

MEDITERRANEAN TONAL SKETCH

1 In this monochrome sketch, a white building is set against a searingly blue sky. In relation to the sky, the building appears much lighter and this is reflected in the grays used. Even without the addition of color, the drawing conveys a powerful illusion of bright sunlight.

2 In this colored version, the sky has been painted a deep blue to emphasize the contrast in tone between sky and building and to convey the warm, sunny light that is so reminiscent of the Mediterranean.

MAKE A TONAL PANEL

To help you understand tone, make some tonal panels. First make a panel with black and white paint. Then make others with neutral mixes, in various intensities.

BENCHMARK STRIP

1 Mark out a strip of 10 squares on a sheet of paper, making the size of the squares about ¾in (2cm). Now fill in the squares with paint, grading them from white to black (Chinese White and Ivory Black are good for this—usually, of course, it's not necessary to use black or white paint in watercolor. Start with white in the first square and add a minimal amount of black to increase the darkness of each subsequent square until reaching pure black. This tonal panel will act as a "benchmark strip" for the tones in your painting.

COLOR STRIP

2 Make a color strip to compare with the benchmark strip. Start with a yellow. See how close in tone it is to the white compared to the blue, which is tonally much darker.

NEUTRAL STRIP

3 Make a third strip of squares. Mix a neutral gray from three primary colors, such as Cobalt Blue, Scarlet Lake, and Aureolin Yellow. Use this mixture to make a panel that matches the benchmark strip in tonal value. Start with pure water in the first square to match the white paint, then use less water and more paint in the following squares. You will not achieve black, but you will be able to make a good dark tone. Now try the same procedure with others mixes of primary colors.

USING A TONAL PANEL

To practice recognizing tonal values, make a simple graded tonal panel of five 1½in (3.75cm) squares. Leave the first square blank to match your paper. Grade the tones in even steps toward a dark that is not quite black. Move this panel around your painting. Notice how the edge of the different squares in your strip will almost "disappear" when matched with a part of your picture that is of the same tonal value.

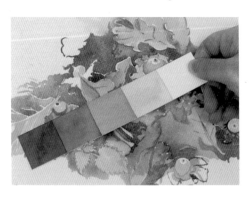

CONTRASTING TONAL VALUES

1 In this bright, sunny painting, the tonal contrasts are very marked. The building—which is backlit by the sun and silhouetted— is a dark tone. The surrounding sky is much lighter.

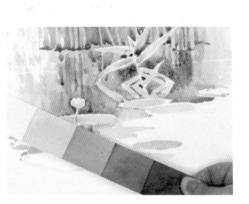

SOFT TONAL VALUES

2 Playing down the tonal values between the reeds and the water—and emphasizing the contrast between the water lily and the water—focuses attention on the flower.

CLOSE TONAL VALUES

3 The leaves and fungi on this shady woodland floor are all very close in tone. There is just enough contrast to define the shapes.

USING A TONAL VIEWER

Color can confuse your perception of values. An intense color can appear lighter in value than it really is. A red, transparent Plexiglas square can help here. You may be able to order a piece cut to 3 x 3in (7.5 x 7.5cm) through your local glass store. Or you can attach a small piece of red plastic to a blank slide mount. When you look through the red plastic, all the colors will be visible as values of light red to dark red.

LIGHT AGAINST DARK

Charisma by Jeanne Lamar

In this painting, the pale flowers stand out against the dark background, but even here there is considerable variety of tone, suggesting leaves and stems without being too specific.

LIGHT AND SHADOW

PAINTING IS ALL ABOUT LIGHT OR THE ABSENCE OF LIGHT. THROUGH LIGHT AND SHADOW WE UNDERSTAND FORM, TEXTURE, AND COLOR.

Manipulation of the overall lighting in a painting affects mood and feeling, so it is no wonder this aspect is one of the most essential in painting. One of the best-known movements demonstrating this is French Impressionism. The Impressionists were known for capturing the transient effects of atmosphere and light, painting outdoors in the French countryside with its clear air and warm light. There they expressed what they saw—the incredible colors of light, shade, and shadow. Creating shadow and light in watercolor is notoriously difficult but can be made easier by understanding the theory behind it. Conversely, the beautiful translucency of the medium and its affinity with the glazing technique allows the artist to overlay areas of shadow that positively glow.

Color in shadow

When asked the color of shadows, most people reply, "gray." But shadows are never just gray. Conventional wisdom also suggests that the color of shade (the part of the object turned away from the sun) is a darker shade of the object's local color. However, colors from the surroundings are also reflected into the shadow, and the time of day plays a part too. Sunlight in early morning and late afternoon is warmer (more yellow or orange) than direct light at noon, and so affects ambient colors and hence the colors reflected into the shadow.

TIPS: A CAST SHADOW...

• ...is darkest, sharpest, and coolest at its origin. It is always attached to the object that is casting it unless that object is in the air.

• ...is always transparent, allowing the underlying subject to show through.

• ...of a near or hard-edged object has hard edges. Shadows of distant or fuzzy objects have soft edges.

• ...changes as it passes over different surfaces. It may change in color, direction, and shape. For example, when the cast shadow of a roof overhang passes over a recessed area, such as a doorway or window frame, the shadow changes, usually dipping downward.

• ...of a tree extending horizontally across the ground is linear and generally appears longer than it is wide. If you paint it very wide, it won't appear to lie flat on the ground. Shadows closest to the viewer are widest, warmest, and darkest. Those farther away become progressively thinner and cooler.

• ...of foliage often produces "sun pictures" on the ground. The sun filters through the numerous openings of foliage to create irregular patterns of light. This is what we call "dappled light."

• ...may have colors of adjacent objects and even light reflected from another surface within it.

CAST SHADOW
When a light source falls on an object, the cast shadow is the dark area that is caused by the object blocking the light source. The base color of the cast shadow is the complement of the light source; here (above and right), the shadows are blue-violet with the complementary yellow-orange light source.

SHADE AND REFLECTED LIGHT
When a light ray bounces, its light waves become longer and the color of the light becomes warmer. The shaded area receiving bounced light grows warm. This concept helps to explain why in bright sunlight we see orange in the shaded side of a building (left).

THE COLOR OF SHADOWS

Under warm incandescent light, a tomato was placed on three different-colored surfaces —pure white, dark green, and yellow-gold. The direct yellow-orange light produces a blue cast shadow, which appears to our eyes as a combination of the shadow color, surface color, and any reflected color. The shadow's variable edge is due to other sources of light in the room.

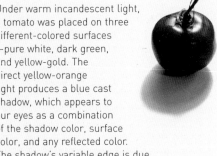

TOMATO ON WHITE

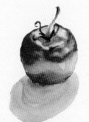

On a pure white surface the cast shadow is blue. Within the cast shadow, closest to the base of the tomato, is some red reflected from the tomato creating an area of violet (red + blue). Note the band of reflected light from the white surface back onto the middle of the tomato.

TOMATO ON DARK GREEN

The color of the cast shadow is still blue but it appears darker on the dark green surface color. As the surface color is reflected back onto the tomato, the combination is a dark neutral (red + green).

TOMATO ON YELLOW-GOLD

The cast shadow is the same blue—but now its visible color is a mix of the blue and the yellow-gold surface—a pale greenish gold. Because the shadow is light enough, some of the reflected tomato red can be seen in the shadow. Yellow color from the surface reflects back onto the tomato to create orange (red + yellow).

PAINTING CAST SHADOWS

These photographs and accompanying studies demonstrate choices in painting cast shadows.

POSTS AND MUD WALL

1 The sun shining from the upper left makes parallel beam shadows across the mud surface of the building in this photograph. When they reach the perpendicular light-colored wall, the shadows change direction and color. Note that the darkest, sharpest, and coolest part of the shadow is at its origin—the base of the protruding beam.

SUNNY WALL

1 In the original photograph, the sun casts solid, hard-edged shadows of the rain spout and beam end (not shown) onto the sunny wall. Note the reflected light glow on the shaded left wall. A tree also casts its shadow onto the sunny wall in softened linear shapes and dappled sun pictures. The shadows change in color as they fall over the white curtains.

2 An overall underwash of yellow anticipates the sunshine. The window is left as it is. Beginning with the shaded left wall, a bright mix of Rose Madder Genuine and yellow is brushed into the reflected light corner and pulled across to the left edge. While still wet, a darker mix of Rose Madder Genuine and Napthamide Maroon is blended in, leaving the upper corner alone. On the sunny wall, Rose Madder Genuine over the Aureolin Yellow is the perfect base for a darker and drier shadow mix applied with a round brush. Now the area is re-washed and more soft shadows added. Pure Cobalt Blue is applied to the window, using similar soft strokes for the cast shadow. Finally the harder-edged cast shadow from the left wall is added, using Cobalt Blue-Violet and taking care to paint the negative space around the sunlit grasses in the foreground.

2 The texture of the dried mud wall is achieved with granulating pigments, added directly into a still-wet base of Rose Madder Genuine. The undersides of the projecting beams are rendered warm and lighter, to suggest reflected light. The shadows are transparent Cobalt Blue, thinned and warmed up with Rose Madder Genuine as they move away from the beams.

WORKING WITH LIGHT SOURCES

WHATEVER THE SUBJECT YOU ARE PAINTING, THE PLACEMENT AND DIRECTION OF THE LIGHT SOURCE OR SOURCES WILL BE CRITICAL TO ITS SUCCESS. BE AWARE THAT SHADOWS CHANGE SHAPE AND DIRECTION THROUGH THE DAY—TAKE PHOTOS FOR REFERENCE AS YOU WORK.

As well as contributing to the overall mood of a painting, shadows serve various other important functions. For example, they act as an anchor, "tying" an object to whatever surface it is standing on. If you're painting a pitcher on a table, for instance, and you leave out the shadow below it, the pitcher will look as if it's floating in space. They also help to create an illusion of three-dimensional space within the flat, two-dimensional surface of a painting, as well as introducing a sense of drama.

A shadow falls on the opposite side from which the light is coming—the object that casts it is blocking that light. You can vary the direction (and strength) of the shadow according to the effect you want to create, either by moving the object itself in relation to the light source or by altering the direction from which the light is coming. This is easiest if you are using artificial light—it could be as simple as moving the table lamp that is lighting your still life. If you are painting a portrait, you could ask the sitter to move so that the light, and therefore the shadow, falls differently on them.

To complicate matters a little, light often comes from more than one source, creating softer, secondary shadows in addition to the stronger main shadow. When observing your subject, be alert for such subtleties.

CREATING PATTERNS WITH LIGHT AND SHADOW

Frailty by Denny Bond
In this highly realistic painting, the artist has focused on the patches of light and the silhouette of the foliage cast on the wall to the right. Highlights on the foliage bring the plant forward in space, and the shadowed wall glows with reflected color.

TIPS: CASTING SHADOWS

• The shape of a shadow is related to the shape of the object that casts it.

• Shadows are darkest close to the object.

• The darkness and definition of a shadow depends on how close it is to the light source. A strong, directional light will cast stronger, more clearly defined shadows than more diffused light.

HOW CAST SHADOWS WORK

In the original photograph, a strong, directional light is coming from the right of the vase, casting a strong shadow to the left. The lighting is simple and comes from a single source, so there are no secondary shadows. In the painting, the same color is used for the cast shadow and the dark side of the vase. The yellowish cloth is painted around the shadow, overlapping it in the foreground just below the vase. Note how the shadow serves to "anchor" the vase to the table—it is an essential part of the picture; without it the vase would float and there would be little sense of the space around it.

The color of a shadow is affected by that of the surface on which it falls

The shape of the shadow is related to the shape of the object

Light from the side casts strong, clear shadows

Shadows are darkest close to the object

FLOWERPOTS ON A WINDOW LEDGE

Here, the strong directional light coming through the window casts diagonal shadows behind the flowerpots. In order to "attach" the pots to the surface so that they don't appear to float, the artist has painted additional patches of shadow just behind the pots, right next to the base of each one. The strong shadows and highlights on petals, leaves, and pots create a powerful sense of light flooding the whole scene.

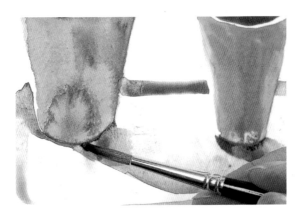

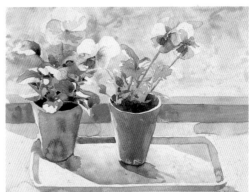

THREE-DIMENSIONAL MODELING

WHATEVER YOU ARE PAINTING, IN WHATEVER MEDIUM—WHETHER IT'S A TEACUP, A TREE, OR A HUMAN FACE—THE WAY TO CREATE AN ILLUSION OF THREE-DIMENSIONAL SOLIDITY IS THROUGH THE USE OF LIGHT AND SHADE.

The form of any object is defined by the light that falls on it. The lightest and brightest parts are where the light strikes directly; the shaded or shadowed ones occur wherever the object blocking turns away from the light.

The intensity of the light and the texture of the object will determine the degree of contrast between light and dark areas, so you will first need to work out how dark the shadows are in relation to the highlights. This helps you decide how strong or weak each mixture should be.

When depicting the form of an object you should adapt your technique to suit its shape. Unless you are working wet-in-wet, watercolor washes naturally dry with hard edges. This is helpful when you're painting a building or table, where the divisions between the shaded and light-struck areas are clear. It is less so when you want to depict a rounded form with soft transitions between light and shade. Solve the problem by laying two or more washes side by side and blending them gently into one another.

OBJECTS WITH DEFINED EDGES

1 On square-edged objects like this, the divisions between light and shade are clear, and the shadowed side can be surprisingly dark.

BUILDING TONES

2 In the corresponding painting, a pale wash of pale yellow—the predominant color—is first laid over nearly all of the object and background. Darker tones of the same color are then applied to the surfaces away from the light—the inside of the box, the side closest to the viewer, and the top edge of the back. The color is applied wet-on-dry, to give crisp, defining edges. This instantly creates the illusion of three-dimensional solidity.

3 To make the box look even more convincing and to give surface interest, the grain of the wood is painted in with the tip of a small brush. However, the marks are still kept very light on the surfaces where the light strikes, so as not to destroy the convincing 3D effect.

CURVED OBJECTS

1 On curved surfaces like this flowerpot, the light areas flow into the darker ones with no obvious boundaries. In addition, in the case of surfaces that don't reflect much light such as terracotta, the contrast between light and shade, and the transition between them, may be quite subtle.

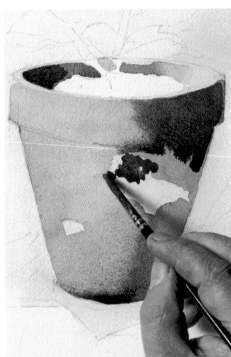

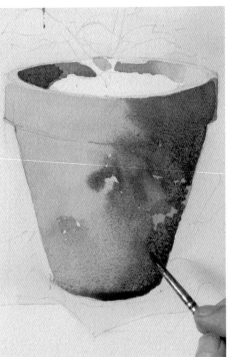

TIPS: LIGHT AND SHADOW

• Assessing lights and darks can be difficult because our eyes register color first, rather than tone. A useful trick is to half-close your eyes, and to practice translating the objects you see into black and white photographs in your mind.

• When blending a dark area into a light one on a rounded object, take care not to overwork the paint. Too many blended overlays of color can begin to look tired and muddy, so try to judge the strength of the darkest part correctly.

BLENDING WASHES

2 To paint the pot, the artist began by laying a light pink-brown wash and working darker color into it while still wet. He created the mottled area with blobs of dark green dropped into very light yellow. Because the first washes were not allowed to dry, the dark colors blended softly into them.

3 The colors were strengthened all over the pot, and worked lightly into each other with a small paintbrush (above and right). The pot looks convincingly solid and rounded with the color well blended but not overworked. The only hard edges visible are those on the rim of the pot and the tiny light strip on the left side.

PERSPECTIVE

THE PERCEIVED WORLD IS THREE-DIMENSIONAL, BUT THE PAINTER MUST TRANSLATE SPACE AND FORM IN A WAY THAT MAKES SENSE ON THE FLAT SURFACE OF A PIECE OF PAPER. ONE OF THE OPTICAL TRICKS THAT ARTISTS HAVE AT THEIR DISPOSAL IS LINEAR PERSPECTIVE.

Visual perception is the name for the way in which our brains interpret the messages from our eyes. One of the peculiarities of visual perception is that objects appear to get smaller the farther away they are. Similarly, parallel lines, such as train tracks or furrows in a plowed field, appear to converge in the distance, although of course in reality they maintain the same parallel relationship. This optical illusion is known as perspective (linear rather than aerial; see pages 128–129).

Discovered by Italian Renaissance artists, linear perspective became an obsession for some. Paulo Uccello, in particular, spent many hours experimenting with perspective and foreshortening (whereby the parts of an object appear to become compressed and smaller the farther away they are from the viewer). The results can be seen in his famous painting *The Battle of San Romano*, painted in the 1450s and now hanging in the National Gallery in London. The fallen lances on the ground all point toward a common vanishing point (the point at which parallel lines appear to converge) and the foreshortening of a fallen figure on the ground is thought to have been the first time that this technique was used.

Understanding and mastering perspective will allow you to create a sense of distance and scale in your images, to show objects overlapping, getting smaller, or converging in an orderly and understandable way.

CONVERGING LAVENDER ROWS

1 This photo of a lavender field in the south of France clearly shows the effect of perspective, with the rows of lavender converging toward a vanishing point in the distance, leading the eye into the picture and toward the village in the background.

TIPS: PERSPECTIVE

• When working with perspective, remember that angles converge toward a common vanishing point, and that this vanishing point relates to the onlooker's viewpoint. In this painting of a lavender field, for example, we know without thinking that the onlooker is standing just left of the center of the picture space, because the lavender rows here are hardly slanted at all but point straight ahead. Conversely, the rows on either side become progressively more angled the farther they are from the onlooker.

• When assessing the perspective of an angular object such as a wall or building, hold a viewfinder or L-shaped frame up to it so you can accurately measure the angles against the right angles of the frame.

DOING A PERSPECTIVE DRAWING

2 The preliminary drawing shows the converging lines of the lavender rows. Some of the original details have been subtly altered for a more effective composition, and a few light initial washes have been laid.

BUILDING UP COLOR AND DETAIL

3 Working from the back to the front, the artist begins adding color and detail to the buildings in the village and the surrounding trees. The foreground lines are still visible.

4 The rows of lavender are loosely painted in with a violet, crimson, and indigo mix, working wet-in-wet and sprinkling the wet paint with salt to create texture. Shadows are added to give a sense of form.

5 In the finished picture, colors and details have been strengthened. The rows of lavender clearly demonstrate the principles of perspective and show how useful this visual tool can be in creating the illusion of three-dimensional space on a flat, two-dimensional surface.

SPATIAL DEPTH

ONE OF THE CHALLENGES FACING THE
ARTIST IS TO GIVE THE ILLUSION OF
SPATIAL DEPTH, SOMETIMES KNOWN
AS AERIAL PERSPECTIVE—IN OTHER
WORDS, TO CONVEY THE SENSE THAT
THERE IS A FOREGROUND, MIDDLE
GROUND, AND DISTANCE.

Using linear perspective (explained on pages 126–127) is one way of suggesting recession, but many subjects have few or no parallel lines, and this is where aerial perspective comes in. It's especially important for large, sweeping subjects such as landscapes.

Aerial perspective affects our visual perception in several ways. To begin with, the tiny particles of dust and moisture in the air affect the way we see colors, so that they become paler and paler toward the horizon, with the tonal contrasts minimal or imperceptible. Colors also become cooler, with a higher proportion of blue in them. A classic example is a landscape with hills, where the hills in the foreground are dark but become progressively paler in tone the farther away they are. This effect can even be seen in photographs, recorded by the "mechanical eye" of the camera lens.

In the same way as objects seem to become paler and "cooler" the farther away they are, they also become less defined, more hazy and less detailed. So, to create a sense of space, keep detail for foreground objects.

Tonal contrast is another way to increase the feeling of space. If all the colors in a picture are of a similar tone, the effect will be to flatten it. Sometimes, contrary to the principle that tones become paler with distance, darker tones in the background and paler ones in front can be effective. But this will depend on the subject matter and other factors need to be taken into account too, like the amount of definition and detail included with the paler foreground tones.

VENICE VIEW
In the painting shown being developed on the right and facing page, a deliberate decision was made not to paint in the sky and only to add a small amount of paint to the water, in order to maintain a sense of space. Cooler blues and browns—Cerulean Blue and Raw Sienna—are used for the lofty domes, and warmer ones— French Ultramarine and Burnt Sienna—for the bulk of the buildings and the foreground. This helps to achieve the huge spatial distances in the painting. Pure bright colors here and there, as on the striped parking poles, add vitality to the picture.

LAYING FOUNDATIONS
1 First, a broad pattern of light and dark is created, starting with a yellow wash overlaid with various strengths of violet. While the first yellow wash is still damp, quick, sure strokes of violet, applied with a small brush, are added to suggest the windows—this is all the detail they require as they are in the background. The tones behind the poles in the foreground are deepened to make them stand out, while the stripes on the poles in the middle distance differentiate them from their surroundings.

2 Tone and detail start to be added to give contrast and definition. The foreground posts are painted with a thin mix of Cadmium Orange and Alizarin Crimson. A thin application of Alizarin Crimson and Cadmium Red is washed over the buildings, and French Ultramarine is then added to suggest shadows. The effect is still soft but already a sense of depth is beginning to emerge.

3 Definition is increased further to separate out the objects on the different spatial planes. Light patches are left in the wash on the buildings in the background to suggest structure without going into detail. The distant poles are darkened, while the striped poles are brought forward by applying a dark wash around them. The background is almost complete. The addition of darks has given substance to the bulk of the buildings, which has made the domes and turrets recede.

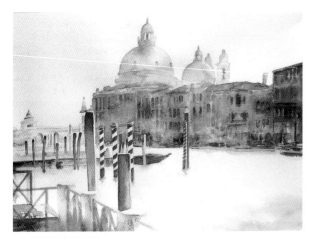

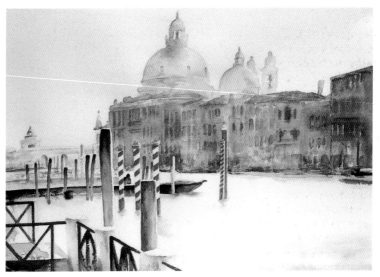

DRAWING THE EYE

4 Strengthening the colors in parts of the foreground focuses the eye there—touches of pure bright Cadmium Red on the parking poles, Burnt Sienna on the near posts, and Viridian Green on the boat.

5 The detail added to the gondola helps to emphasize the post, while detail stroked onto the foreground fence gives it solidity and brings it forward in space. Additional darks on the far buildings emphasize the water's edge. The foreground posts have also been darkened, adding to the three-dimensional aspect of the painting. The final picture has a great sense of height and distance, achieved by leaving large expanses of sky and water unpainted, and cleverly using cool and warm colors.

MAKING COLOR STUDIES

ARTISTS ARE ALWAYS ADVISED TO CARRY A SMALL SKETCHBOOK IN WHICH TO DRAW SUBJECTS THAT CATCH THEIR EYE, AND THAT THEY CAN LATER WORK UP INTO MORE FINISHED PIECES. MAKING COLOR STUDIES IN YOUR SKETCHBOOK TAKES THE PROCESS ONE STEP FURTHER.

Color studies fall midway between sketching and painting. When you have the time and concentration to develop a sketch image more fully, color is often the element that you will want to focus upon in greater detail. For this kind of work, paint is the essential medium, rather than colored pencils, crayons, or pens. The potential for mixing and overlaying colors gives you the necessary degree of subtlety and range of interpretation.

Watercolor is the traditional and most suitable medium for doing color studies. It is a better choice than gouache because the colors are translucent and do not readily devalue when they blend and mix, and they can be mixed and overlaid directly on the paper surface, building up strength and tone layer upon layer, whereas opaque gouache generally has to be mixed in a palette to achieve accurate color effects.

However, you may sometimes need what is known as body color—a degree of opacity—to create particular nuances such as strong highlights or textural detail. Many watercolor boxes include a small tube of opaque white for highlighting, which should always be done at the final stage of a watercolor study.

STUDY TIPS

- An alternative to doing studies in watercolor is to use watercolor pencils. These are easy to carry and the only extra items you will need are some water and a brush to sweep the water across the penciled marks to transform them into washes.

- Don't be afraid to make written notes on your color studies. This can provide you with important information that you may need later on.

NOTING THE ESSENTIALS
This deceptively simple color sketch contains a lot of information that will be of use to the artist later. As well as noting color and tonal values, the study preserves a strong sense of space and a clear delineation of the relative spatial planes, from the foreground to the distant background.

Speed versus content

A quick color study is a spontaneous response to a subject, and you would not want to lose that spontaneity. However, if a study is to provide useful reference later, a little consideration should go into it. Remember that, because watercolors are translucent, you cannot retrieve a light tone from a dark once you have laid the color, or overpaint with a paler hue. Spend a little time studying the subject before you start work to establish a general sequence of colors, but do not abandon spontaneity—"dash in" particular color effects as you see them. If you are unsure where to start, identify one hue and work right across your sketchbook page, putting down that hue wherever it occurs in your subject. Work through the next most obvious color, and so on, until you have woven the general pattern of colors. Then start to develop the image by adjusting the balance of individual hues in relation to one another and overlaying smaller color areas to achieve more subtlety and depth.

The color studies on these pages combine that lovely, loose brushwork that so typifies the watercolor medium with useful information on color and form—indeed, they could stand as finished pieces in their own right.

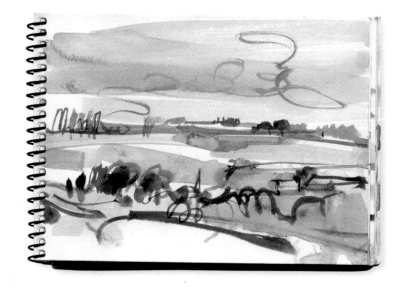

RECORDING LIGHT AND SHADE

Using just a few colors and some simple brushstrokes, the artist has recorded the key elements of this scene. The white highlights on the tree trunk and the shadows snaking across the ground instantly give a sense of the bright sunshine and deep shade that define the subject.

MAKING COLOR NOTES

Simple outlines and subtle variations of color in the mass of foliage are recorded here. Color studies can be useful in simplifying visual information, helping the artist to maintain focus later when working up a study into a painting.

RECORDING AN INITIAL RESPONSE

Despite the speed with which this richly colored study was made, it still "reads" as a sunset with foliage and long grass in the foreground. As a record of the artist's initial response to the subject, it is an invaluable aide-memoire, helping her remember what struck her most about the scene and thus what to emphasize in any painting she develops from it.

FINDING YOUR STYLE

THE WAY THAT YOU PAINT AND DRAW, THE MARKS YOU MAKE, THE COLORS YOU USE, AND THE SUBJECTS YOU CHOOSE, MAKE UP YOUR PERSONAL ARTISTIC "LANGUAGE." LIKE A CHILD LEARNING TO SPEAK, YOU NEED TIME AND PRACTICE TO DEVELOP YOUR VOCABULARY.

Often, through lack of confidence, beginners will paint the way that they think they should rather than follow their own creative instincts. Even the greatest artists have to begin somewhere and it takes years of practice for them to develop their own personal style. As they become more sure, their work can move from the figurative to the more abstracted. Think of Picasso, for example; his early drawings, produced at a precociously early age, were highly academic and gave little hint at the highly personalized and distinctive style of work that was to come later.

There are several ways to develop your own artistic "language." The first, obviously, is practice: draw and paint often, to hone your skills and sharpen your eye. If you feel that you never have enough time to paint, take comfort from the thought that little and often can be a more effective strategy than spending whole days on a painting, with long gaps of time in-between. A successful painting requires that you develop a relationship with it, and ideally this requires daily contact—if only just to look at it and assess what to do next (not all creative work occurs on the paper; a lot of it is processed in the mind's eye).

Have a watercolor pad to use for color sketches, and as a place to explore and experiment. See the pages as a place to play with the medium, to make marks freely without worrying about making "mistakes." Really, there are no mistakes, just opportunities for learning. Working quickly and freely can help you to loosen up too, and prevent your style becoming too "tight."

Nourish your artist's imagination. Study the work of other artists for ideas and inspiration that might trigger ideas of your own. These examples of the same artist's work, that range from experiments with mark-making and color sketches to more finished pieces, show just how enjoyable it can be to explore the possibilities offered by watercolor.

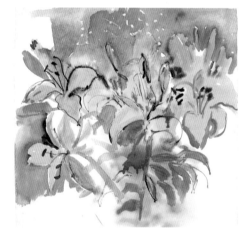

EXPLORING A SINGLE SUBJECT
In this lively series of paintings by Brian Innes, the artist has explored the same subject several times, using different colors and different backgrounds to create different effects. Painting the same subject more than once can be a useful way to build a relationship with it, and develop your own painting language in response to it.

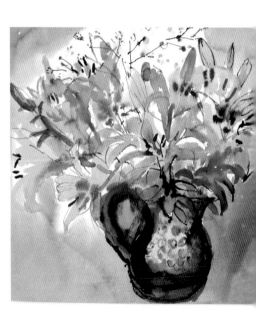

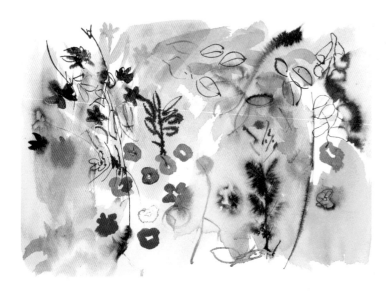

EXPERIMENTING WITH WATERCOLOR

Watercolor offers more techniques to the artist than perhaps any other painting medium. Your watercolor pad, or some spare paper, is the ideal place to explore the kinds of effects you can achieve. In this color sketch (left) the artist explores his responses to the subject with a range of different marks, techniques, and media.

STOP AND REFLECT

To help you assess your painting to see whether it is working and what adjustments to make, hold it up to a mirror and look at it in reverse. This useful trick stops you seeing what you "know" and gives you a more objective view—even if it is a back-to-front one.

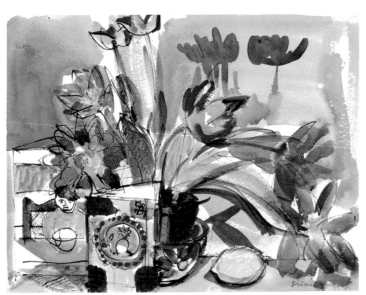

GAINING CONFIDENCE

Color sketches like this one (above) are the backbone of the artist's repertoire. Not only do they record valuable information, but they also help the artist to "loosen up" and gain in confidence. In the study of a vase of flowers by a window (right), the artist has not been constrained by idea of what a watercolor "should" be but has freely mixed the medium with wax resist and black line.

WORKING FROM PHOTOGRAPHS

PHOTOGRAPHS ARE A WONDERFUL REFERENCE FOR PAINTING, AND THERE ARE FEW ARTISTS NOWADAYS WHO DON'T USE A CAMERA. HOWEVER, IT IS IMPORTANT TO REMEMBER THAT THE CAMERA DOESN'T ALWAYS SEE AS WE DO.

When sketching directly from the subject, you may decide to leave out some features and possibly change things around a bit to improve the composition. You should try to do the same with photographs. It is more difficult in this case, however, since a photograph presents only one viewpoint; if you are out in the landscape, you can move around to explore more possibilities. Always bear in mind that painting is about interpretation, not slavish copying. You don't have to follow the same format as the photo; instead, try framing it in different ways using L-shaped pieces of cardboard or paper. You might find that taking the middle section of a landscape-format photograph provides a more unusual vertical composition.

Remember also that there are ways to add to a photograph, such as by putting in more sky or foreground than is actually shown. Wide landscapes or seascapes often benefit from a low horizon, with the sky occupying more than half the picture space, while a large area of foreground has the effect of pushing a focal point back in space to create a stronger feeling of depth and of the image receding. Test this by sticking your photo down on paper and sketching in more sky or foreground with a quick-to-use medium such as pastel.

LIGHTENING THE COLORS
Club del Mar by Linda Kooluris Dobbs
This painting is obviously not a true record of the scene; instead, the artist has drawn on experience and her immediate impressions to heighten the colors while retaining the composition. Notice especially the group of leaves above the broken branch, which are black in the photograph.

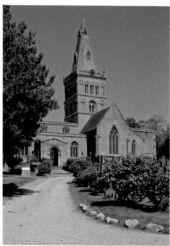

EXPLORING POSSIBILITIES
The photograph at the top is rather cluttered, with the expanse of foreground reducing the importance of the building. "Zooming into" a smaller area in the version above offers a stronger, more effective composition with strong possibilities.

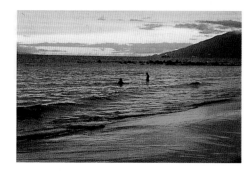

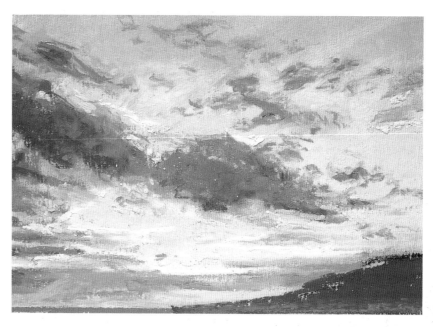

CHANGING THE EMPHASIS

The artist took this photograph (above) mainly to capture the effect of the light on the waves. However, when she looked at it again, she decided that it was unbalanced, so in her painting (right) she extended the sky from her memory in order to achieve a more expansive image.

FOCUSING ON THE SUBJECT

Yellow Daisies by Katrina Small
In the finished painting (below), the artist has been faithful to the colors, shapes, and shadows of the flowers in the photograph (bottom). However, she has chosen to give the painted version a much more blurry, and colorful, background, which throws the daisies into greater relief.

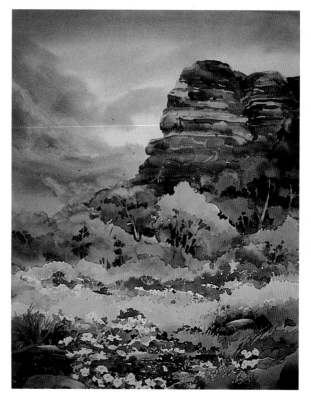

EDITING THE IMAGE

Blue Skies by Sue Kemp
Here, the artist was interested as much in the light effects as in the rocks, and she has departed radically from the more uniform colors of the photograph. She has also given more emphasis to the rocks by increasing their height, and has improved the composition by including clouds that balance this dominant feature and also give a sense of movement.

COMPOSITION

COMPOSITION IS THE ARRANGEMENT OF ELEMENTS WITHIN A SPACE, AND GOOD COMPOSITION IS ESSENTIAL TO ANY PAINTING.

Creating a successful painting is about more than the subject matter you choose and the colors and techniques you use—it needs to be well composed too. A pleasing composition will appear harmonious and balanced, with all the elements working together to create an eye-catching scene.

To put it simply, "composition" refers to the way in which all the parts of your painting work together: where the subject matter is placed within the space, how the space is divided up, and how these two aspects work in relation to the format you have chosen (landscape or portrait, square or rectangular). A well-composed picture is likely to look more accomplished and professional and there are certain principles, explained on these two pages, that will help you achieve that.

It can also be helpful to examine the composition of paintings you like, and try to analyze why they work. You can then apply the same approach to your own work.

LEADING THE EYE
A good composition should contain visual passages that lead the viewer's eye into and around the entire painting. A great way to create a visual passage in a painting is to incorporate diagonal and curved lines that lead the eye to the center of interest. In this photograph, the diagonal rows of lavender lead the eye directly to the distant sunlit village.

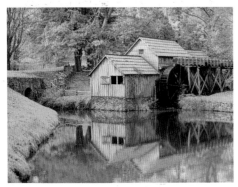

DETERMINING THE FOCUS
Every composition needs a focal point, or center of interest. A focal point can be something obvious like a person or an object, or it can be more subtle, like gleaming highlights on the side of a hill or a pattern of shadows on a street. In this photograph, the colorful reflections are so compelling that they become the focus of the painting.

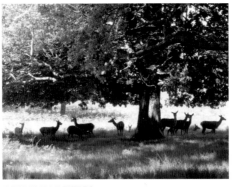

THE RULE OF THIRDS
Once you've established a focal point, it's important to place it correctly within the scene. A good way to do this is to follow the rule of thirds. Divide the painting surface into thirds horizontally and vertically; then place your focal point (in this case, the tree) at or near one of the points where the lines intersect. This keeps your center of interest away from the extremes—corners, dead center, or at the very top or bottom of the composition.

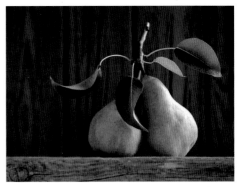

CREATING CONTRAST
The eye is drawn toward areas of strong contrasts in tonal value as well as to pure color, so your composition should include a variety of light, medium, and dark values to help direct the viewer's eye. In this photo, the brightly lit side of the right-hand pear contrasts with the dark background, attracting immediate attention.

Cropping a picture

Sometimes a picture works better if you "crop" or frame the image differently—rather like zooming in or out with a camera lens. This example, of a photo of a man reading in a café, shows how cropping the picture differently strengthens the composition.

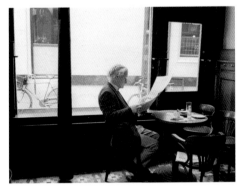

WIDE VIEW

1 In the original photo the view is quite wide. The eye is drawn to the man at the table because this is the most interesting part of the picture, but there is a lot of space to his left that is distracting and adds nothing to the composition.

2 The red square imposed on the photo shows how it could be cropped more effectively.

3 Eliminating the left side and most of the background of the original photograph makes the scene tighter, closer, and more intimate, and focuses in on the part of the image that the eye is drawn to anyway.

MAKE A VIEWFINDER

A viewfinder is a useful tool for identifying a good composition and is easy to make. Cut two L-shapes from cardboard and paperclip them together to form a square or a rectangle. Look at your scene through the viewfinder—bring it closer and hold it out farther, move it around the scene, and make the opening wider and narrower until you find a pleasing composition.

ENLARGING YOUR DRAWING

IT IS NOT ALWAYS NECESSARY TO BEGIN A PAINTING WITH A DETAILED DRAWING, BUT SOME SUBJECTS, SUCH AS PORTRAITS, CALL FOR A CAREFUL, METHODICAL APPROACH IN THE EARLY STAGES.

One way of avoiding too much drawing and erasing on the paper, which can spoil the surface, is to make a smaller study of the subject first and then transfer it to the watercolor paper by squaring it up to the size desired. A photograph can be used instead of a drawing, but photographs do tend to flatten and distort perspective, and sometimes present an insufficiently clear image, so try to use them only in conjunction with sketches, observation, and imagination.

Squaring up is a slightly laborious process, but it isn't too difficult and really does pay off when the effect of the painting depends on accuracy.

Using a ruler, draw a measured grid over the study or photograph, then draw another grid on the watercolor paper, using light pencil marks. This must have the same number of squares, but if you want to enlarge the drawing, they must obviously be larger. If you use a 1in (2.5 cm) grid for your original drawing and a 1½in (3.8cm) one for the painting, it will be one-and-a-half times the size, and so on. When the grid is complete, look carefully at the drawing, note where each line intersects a grid line, and transfer the information from one to the other.

USING A SQUARED-UP GRID

1 The method shown here avoids damaging the original drawing or photograph. A grid is drawn with a fiber-tipped pen on a sheet of acetate. The grid is traced from a sheet of graph paper beneath it, which saves time and is very accurate.

2 The next stage is drawing an enlarged version of the grid on the working paper. Pencil, T-square, and ruler are needed for this, and the pencil lines of the transferred grid should be as faint as possible.

3 The acetate sheet is then placed over the photograph or working drawing (far left), and the image is transferred to the working paper square by square (left). This process should not be rushed and the work should be checked carefully as it progresses, or part of the composition could be placed in the wrong square.

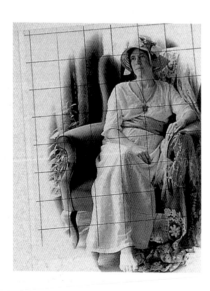

DIVIDING A SQUARED-UP GRID INTO SMALLER UNITS

Dividing the squares up diagonally into triangles breaks the original image up into even smaller segments, thus providing an even more exact grid to work from.

TIPS: OTHER METHODS OF TRANSFERRING

There are other methods you can use to transfer your preliminary drawing.

• You can photocopy it, enlarging or reducing it to the size you want. Trace the copy, then trace this onto the sheet or other support on which you will be painting. This will work for paintings up to A3 size.

• Use a pantograph—a handy instrument available from art supply stores. The arm of the pantograph consists of crisscrossing strips or wood or other material that can concertina up or down, rather like garden trellis, allowing you to reduce or enlarge your drawing in exact proportion to the original.

USING A GRID TO DRAW A LANDSCAPE

In this example, an acetate grid is laid over a photograph of a woodland scene. A grid is lightly drawn in pencil on a piece of paper. The information in each square of the acetate grid is copied across one square at a time. As long as your grid lines are faint, they will be covered by your paint or they can be erased when the painting is complete.

ORDER OF WORKING

BECAUSE THERE ARE NO RIGID RULES IN WATERCOLOR PAINTING, IT CAN BE HARD TO KNOW HOW TO BEGIN. THE DIAGRAMS INDICATE A POSSIBLE ORDER OF WORKING, STARTING WITH THE LIGHTEST AREAS AND FINISHING WITH THE DARKEST.

It isn't always easy to decide where and how to begin a painting. The standard advice about watercolor is that because the colors are transparent, you have to work " from light to dark." This means that when putting color on in layers, you must begin with the lightest ones, because you can only make colors darker by adding a layer. But it does not mean that you must always start with the palest bit of picture.

Suppose you're painting a bunch of white flowers in a dark blue vase against a light blue background. The conventional method would be to lay a light blue wash over the vase and background, reserving the flowers and any highlights as white paper, let this

dry, and then paint the vase on top. But you could begin with the vase, and paint the background around it. Some artists prefer to put down areas of dark color first, because this gives them a point of reference for the rest of the picture.

Whichever method you choose, your first task is to anaylze your subject in terms of light and dark blocks of color. Look at the photographs on these pages and see whether you can figure out which colors you would put on first. Then compare this with the sequences in the numbered diagrams which give a suggested order of work.

PAINTING BUILDINGS

1 First make a drawing, then lay a flat or graded blue wash for the sky and leave it to dry. Lay a very pale wash, perhaps Yellow Ocher with a touch of Alizarin Crimson, over the rest of the painting.

2 Paint the shadowed side of the building, then begin to darken the colors in the central area and foreground shadow. Paint the lamp post over the colors.

3 Add further dark washes to the central area and the foreground shadow, and then begin to build up detail on the buildings.

4 Continue to add detail and strengthen colors where necessary.

PAINTING A LANDSCAPE

1 Draw the main shapes. Lay a pale wash for the sky and a slightly darker one for the distant hills. Lay ocher washes over the main areas of the painting, but not the river. If blue is painted over ocher it will turn green.

2 Paint the river with a mid-blue wash.

3 Start on all the green areas, painting over the ocher washes. Begin in the distance with pale washes, building to darker color in the foreground.

4 With all areas blocked in, gradually add detail and strengthen colors, reserving ocher highlights in the foreground.

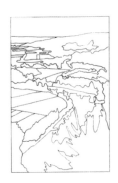
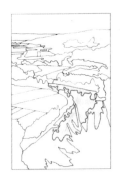

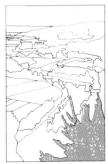

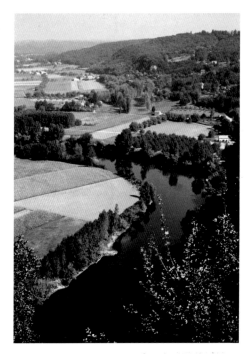

PAINTING A STILL LIFE

1 Make an outline drawing, then lay a light yellow-brown wash over the background, reserving the white flowers, and leave to dry.

2 Lay separate washes for the vase and the blue pot.

3 Block in the checked cloth with blue, reserving white squares. Block in the main shapes of the leaves, painting individual leaves over the background wash.

4 Begin to add detail and continue to darken color where necessary.

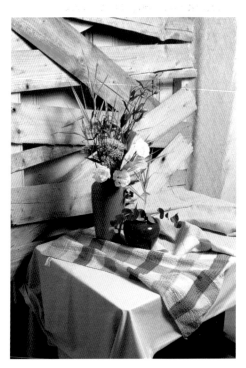

INDEX

ACKNOWLEDGMENTS

Quarto would like to thank **Winsor and Newton** for supplying materials for photography. We would also like to thank the following artists for kindly supplying images for inclusion in this book:

Denny Bond www.dennybondillustration.com

Catherine Brennand www.catherinebrennand.co.uk

Clare Brooks Member of Islington Arts Club

Allan Brown

Julia Cassels www.juliacassels.com

David Castle www.davidcastleart.com

Moira Clinch www.londonart.co.uk

Marjorie Collins www.marjoriecollins.com

Paul Dawson

Linda Kooluris Dobbs www.koolurisdobbs.ca

Joe Dowden www.joedowden.net

Ray Evans www.manorhousegallery.co.uk

D.R Ganthorpe BWS, FIGA www.northorpe-watercolour-society.co.uk

Sarah Garvey sarah@sgarvey.co.uk

Elizabeth Haines www.elizabethhaines.co.uk

Tracy Hall www.watercolour-artist.co.uk

Jan Hart for her contribution to the color articles

Lisa Hill www.lisahillwatercolorist.com

Shari Hills www.sharihills.co.uk

Moira Huntly www.manorhousegallery.co.uk

Brian Innes

Terry Jarvis www.terryjarvis.com

Ronald Jesty

Sue Kemp www.suekemp.com

Keith M. Kennedy

Charles Knight RWS, ROI

Jeanne Lamar www.jeannelamar.com

Heather Maunders www.heathermaunders.com

Adrienne Pavelka www.adrienne-pavelka.com

Roger Pickett www.rogerpickett-artist.com

David Poxon www.davidpoxon.co.uk

Sally Robertson www.sallyrobertson.com

Mary Ann Rogers www.marogers.com

Katrina Small www.katrinasmallstudios.com

Ann Smith www.annsmithwatercolors.com

Jake Sutton www.jakesutton.co.uk

Carolyn Wilson www.carolynwilsonartist.com